Marga

Saint Catherine of Siena and Her Times

✢

SOPHIA INSTITUTE PRESS
Manchester, New Hampshire

Sophia Institute Press
Box 5284, Manchester, NH 03108
1-800-888-9344

www.SophiaInstitute.com

Sophia Institute Press® is a registered trademark of Sophia Institute.

Library of Congress Cataloging-in-Publication Data

Names: Roberts, Margaret, 1833-1919, author.
Title: Saint Catherine of Siena and her times / Margaret Roberts.
Description: Manchester, New Hampshire : Sophia Institute Press, 2017.
 Originally published: New York : G. P. Putnam's Sons, 1906. Includes
 bibliographical references.
Identifiers: LCCN 2017034696 ISBN 9781622824540 (pbk. : alk. paper)
Subjects: LCSH: Catherine, of Siena, Saint, 1347-1380. Christian women
 saints — Italy — Siena — Biography.
Classification: LCC BX4700.C4 R6 2017 DDC 282.092 [B] — dc23 LC
record available at https://lccn.loc.gov/2017034696

First printing

✤

Saint Catherine of Siena and Her Times

✤

Contents

꙼

Chronology

Some dates are approximate.

1347　Catherine is born on March 25.

1353–1354　Catherine has a vision of Christ.

1359–1364　Catherine lives an ascetic life at home.

1363–1364　Catherine becomes a Mantellate, or Dominican tertiary.

1364–1367　Catherine continues her life at home as a religious recluse.

1367　Catherine reenters social life.

1368–1369　Political strife engulfs Siena.

1370　Catherine's reputation as a peacemaker grows, and a group of disciples forms around her.

1372　From Avignon, France, Pope Gregory XI launches war against Milan, which seeks to incite Tuscany to join on its side.

1373　Italy is devastated by strife, secular and religious, with many deaths.

1374 Catherine's superiors summon her to Florence for cross-examination; she returns to Siena to minister to the plague stricken. Florence takes up arms against the Pope.

1375 Eighty Italian cities join the League of Tuscan Cities in battle against the Pope's army. Catherine travels to Pisa to try to prevent Pisa and Lucca from joining the League.

1376 Catherine ends the feud between the Maconi and the Tolomei. Bologna joins forces against the Pope, and the papal nuncio is flayed alive in the streets of Florence. Catherine works to end the war by reconciling Pope Gregory and the Florentines, going first to Florence and then to meet with the Pope in Avignon. Gregory entrusts her with the peace negotiations. She convinces the Pope to return to Rome, and herself returns to Siena.

1377 Catherine converts Belcaro Castle into a monastery and heals the Salimbeni family feuds.

1378 Pope Gregory sends Catherine again to Florence, where enraged antipapal mobs nearly kill her. Pope Gregory dies, followed closely by a schism caused by the cardinals electing first Pope Urban VI and soon thereafter Pope Clementine as antipope in opposition to Urban. Urban summons Catherine to Rome, where she becomes his trusted adviser and advocate, appealing on Urban's behalf to the kings of France and Hungary, to the Queen of Naples, to the magistrates of the rebellious Italian cities, to

those cardinals who support the antipope, and to countless others. Her health begins rapidly failing.

1380 Catherine succeeds quieting the revolt of the Romans against Urban. On April 30, she dies, just thirty-three years old.

Saint Catherine of Siena and Her Times

Chapter 1

ᴊᛊ

A Saint's Girlhood

In 1348 Siena lay in the grip of the Black Death. It had been brought some months earlier to Genoa by certain galleys "full of the corruption of overseas," according to the chronicle of Agnolo di Tura, who goes on to relate how

> great pestilence fell on the city, sent by Heaven in those accursed galleys, because the Genoese had dispatched them to the Turks, and had committed cruelties on Christians worse than those done by Saracens. For this reason the great destruction spread from town to town, and slew three parts and more of all Christian folk. And the father scarce stayed to look on the son, and the wife abandoned her husband, for it was said that the sickness could be taken by mere looking on those stricken, or breathing their breath.... And none were found to bury even for hire.
>
> Relations went not with the dead, nor friend, nor priest, nor friar, nor were prayers said over them, but when any died, whether by day or night, he was straightway borne to a church and buried, covered with a little earth that the dogs might not eat him. Ditches very great and

deep were dug in many parts of the city.... And I, Agnolo di Tura, buried five of my children in one of them with mine own hands, and so did many others.... And no bell tolled, and no one wept for any matter, for all expected death, since things went so that folk believed none would remain, and many thought and said, "This is the end of the world."

Some months before this terrible moment, Lapa, the wife of Giacomo Benincasa, a well-to-do dyer in the ward of Siena known as the Contrada dell' Oca, or Ward of the Goose — so called, as some say, from the flocks of geese kept there — gave birth to twins, who were named Giovanna and Catarina. The former lived but a short time; the latter grew up to be the pride of Siena, and the most distinguished woman saint of the great Dominican Order.

Early biographers, to whom all connected with Saint Catherine seemed touched by the supernatural, regarded her survival of the plague as the first of many miracles connected with "*la beata popolana,*" as the Sienese lovingly call her, one of many fond names by which she is known in her native city.

Of her childhood there is little to tell. Born on Palm Sunday, she would certainly be carried on Easter Eve to the Duomo to be christened, with all the other children whose birthdays fell after Whitsunday in the preceding year, for though sickly babies might be baptized at home, the custom was to christen one and all at Easter or Pentecost. Thus, while some were newborn, others would be almost a year old, as is shown in the graffiti on the pavement before the Baptistery, where some of the children are represented as infants, while others hang back, or walk beside their mothers. At one time there was but a single Baptistery for

the whole diocese, "conformable to the saying of Saint Paul, 'One Lord, one faith, one baptism,'" and even when the extreme inconvenience of this arrangement caused fonts to be introduced into country churches, all the children of Siena were carried to the Duomo, as is still the case. The first boy christened there in Catherine's day was always called Giovanni, and the second, Martino, after one of the patron saints of the city, while the first girl was named Maria, after which the infants received whatever names their relations chose.

Very curious they sometimes were. Noble families who claimed descent from an ancient Roman stock would take classic names, such as Ascanio, Scipione, Tullia, and Livia. The middle class often chose them from romances of chivalry; registers and pedigrees give Alicander, Rinaldo, Biancafiori, Diamante, and others of the same sort, together with names more difficult to account for, such as Uscilia, Cameola and Leggiera.[1]

The Benincasa contented themselves with everyday names for their twenty-five children, common sense rather than sentiment distinguishing both parents. Lapa seems to have been an active housewife, affectionate, but sharp-tongued and imperious, with little sympathy for anything beyond her own range of thought, but unwearied in doing her duty as far as she saw it. Her hasty temper was sometimes gently checked by her husband, who is described by Catherine's confessor and biographer, Raimondo da Capua, as "good, simple-minded, just, nourished in the fear of God, and over and above other virtues, gifted with gentleness and meekness of heart," severe only if in that household of many sons, daughters, and apprentices, anyone spoke a loose or profane word. This he never passed over, though an almost incredible

[1] Zeekaner, *Vita privata del Dugento*.

license of speech prevailed among both men and women, and in spite of the statute against blasphemy, imprecations were heard on all sides such as shocked and grieved the right thinking. So strongly was Benincasa's rule impressed on his family that when his young daughter Bonaventura married into a family in which oaths and coarse talk were common, she drooped so that her husband, Nicolao, asked the cause of her saddened looks. "I never heard this kind of talk before," was her explanation, and to his credit be it said that he accepted the innocent reproof and put a stop to light and profane conversation in his house.

Some of Catherine's biographers assert that her family was poor, but this was certainly not the case at her birth. Lapa had money of her own, for we find her standing surety for a son who hired a shop, and besides what trade brought in, like most of his fellow citizens Giacomo owned land. His *podere* (farm) was at some distance from the gates; it later passed to a widowed daughter-in-law, that Lisa so loved by Catherine, who calls her "my sister-in-law after the flesh; my sister in Christ." The little property still bears her name.

Another proof that the Benincasa were in easy circumstances is found not only in the assertion of Raimondo, who must have known all about it, that for their station Catherine's family were abundantly provided with temporal goods, but in the fact that no one who begged at the Fullonica — the dyer's house — was ever sent empty away. Though until after the Black Death there could have been no great poverty in Siena, since almost everyone could pay an income tax, from that date there was much want in the city, besides which outsiders came in whose cottages had been burned by Free Lances, and their cattle driven off, or misfortune overtook some home, and the strain on private charity was great. Far from being ill off, the Benincasas were so prosperous

that Catherine prayed they might become less so, for fear their hearts should be set on earthly things, a prayer for which perhaps they were hardly grateful when misfortunes came and dispersed the family. Large as it was, it became extinct rather more than a century later, and one of the descendents of Giacomo Benincasa was supported by the city.

He and his wife belonged to that race of plain, honest citizens whom Dante praises,[2] the salt of any city, self-respecting and respected, sensible and religious, but, as far as is known, there was nothing in the Benincasa family to account for such a woman as Catherine. Imagination she may possibly have inherited from her maternal grandfather, Muccio or Puccio di Piacente, a forgotten versifier of the fourteenth century, but the ballata by him that Crescimbeni quotes in his *L'Istoria della Volgar Poesia*, addressed to a certain disdainful Gualtera, is exactly like numbers of others by Trecento writers, without a spark of originality. From both father and mother Catherine would inherit the practical good sense that served her so well, but in truth, like Dante and Leonardo da Vinci and Shakespeare, she seems to be without spiritual ancestry, nor any more than in their case did her genius reappear in a later generation. In every way she was accurate when she said, as she did more than once, "My only teacher was God," words that are curiously like those of an earlier mystic, the nun Mechtilde in the convent of Helfta, who referred all her knowledge to the direct teaching of God, and in this and many other ways resembled Catherine of Siena.

It is remarkable that one of so large a family should have been so dreamy and fond of solitude as was Catherine, especially as she led a free and happy life, and that joyousness that never

[2] *Paradiso*, Canto 15, lines 112-17.

forsook her made her a great favorite with the neighbors in her *contrada* (ward) and with her child contemporaries. Already she exercised the gift that all who came in contact with her felt, that mysterious, indefinable power, that, for want of a better word, is called charm, a gift more powerful than beauty itself, and far more lasting. Education she had none; it was thought objectionable even for girls in a much higher class. "Set them to sew, not to read; it befits not a woman to know how to read, unless she is to be a nun," says Fra Filippo d'Agazzari; and San Bernadino, who was born on the day of Catherine's death, and from whose sermons so much of the views and tendencies of her century may be gathered, says hardly less grudgingly, "If thou knowest how to read, read good and holy things; learn the office of our Lady, and delight thyself therein." "*Dio ti guarda da nobil poverino, O di donna che sa latino,*"[3] says the Tuscan proverb to this day. When, after she was grown up, Catherine's efforts to learn to read and write were crowned with a measure of success, it seemed a miracle to those about her. There was, of course, no thought of a girl of her station learning the accomplishments of playing on the lute or the harp, for which girls of noble birth had masters when they came to a marriageable age, making up for beginning late by taking lessons twice a day, and, as San Bernadino declares, often having love letters slipped into their hands by their teachers, a use of reading and writing that went some way to justify the general suspicion of feminine education.

As far as Catherine was concerned, she never attained readiness of penmanship, and always dictated by preference, but in her later life books were read to her, and as a child she saw the

[3] From a poor noble and a woman who knows Latin, Heaven keep thee!

paintings in the churches of Siena and learned the legends con-
nected with them, and heard discourses from the pulpit. And at
that time painting and preaching had great importance, standing
in a measure in the place now held by literature and the press, and
though preaching had very generally become dully conventional,
and, in spite of the admonitions of popes and councils, was much
neglected, it was carefully cultivated among the Dominicans and
Franciscans, the former bringing learning to bear upon it, and
the latter using all means to gain the ear of the uneducated.
Catherine had also other means of education. She would hear
city politics and the relationship of Siena to other towns, friendly
or hostile, discussed in her home, where her brothers and the ap-
prentices brought in news, and traders came to do business with
her father. She listened eagerly to the friars, always welcomed at
the Fullonica, and heard them speak of the need of reform in the
Church, of the measures taken against heretics—Siena had its
tribunal of the Inquisition, which sat in San Francesco, and ruled
even beyond Sienese territory—of the desirability of a crusade,
and above all, of the injury done to the Church and to Italy by
the absence of the popes from Rome.

Friars played a great part in Catherine's life from the time
when as a little child she would run out and kiss the traces of
their passing footsteps. Her first confessor, Della Fonte, was a
relation, and partly brought up among the Benincasa household,
and a document still existing shows that for benefits received,
her mother's family had a right to special prayers in one of their
communities. The respect shown them in the Fullonica speaks
well for the Preaching Friars of Siena, but they were not so well
treated everywhere. San Bernadino relates how a woman flung
the bread that he had asked for so hard that it hurt him sharply,
and that stale scraps were often tossed contemptuously out a

window. In fact, that decadence of the mendicant orders that Dante noted merely a century earlier had become recognized. In early days their influence had been entirely for good, and Sir James Stephen justly asserts that "nothing in the histories of Wesley or Whitfield could be compared to the enthusiasm which everywhere welcomed them, or with the immediate result of their labors." One of the most unexpected testimonies of their merit comes from high authority. When a Consistory at Avignon loudly demanded the suppression of the Preaching Friars, Clement VI answered with scorn:

> And if the Friars were not to preach the Gospel, what would you preach? Humility? You, the proudest, the most disdainful, the most magnificent among the estates of men, who ride abroad on your stately palfreys! Poverty? You who are so greedy and set on gain that all the prebends and benefices will not satiate your avidity! Chastity? Of this I say nothing; God knows your lives, and how your bodies are pampered with pleasure.... Be not surprised [he added, with a shrewd guess at the cause of the outcry] that the Friars received bequests in the time of the fatal mortality, they who took charge of parishes deserted by their pastors, out of which they drew converts to their houses of prayer — houses of prayer and honor to the Church, not seats of voluptuousness and luxury.

Agnola da Tura must have written in too great bitterness of heart to be just when he declared that no friars were found to attend the dead and dying in the great plague, for Bernardo Tolomei came down with his white-robed Olivetans from their monastery among the olive trees and, with many of his community, died among those whom they had come to nurse and comfort.

A Saint's Girlhood

But though the fearless devotion of the Friars in Siena and other places had reawakened gratitude and admiration, there was an increasing distrust of them. Many, no doubt, were like Fra Niccolo Tino, "whose face was like that of Moses, so did love and charity burn in his heart when he washed the sores of the poor with warm wine, or faced a cruel foe," or whose life ended as beautifully as that of another, who after a life that was a long hymn of love and goodness, feeling death approach, thankfully knelt down, laying his tired head on the Gospels, and so passed away. Others there were who called high and low fearlessly to repentance, like Fra Filippo d'Agazzari, or the Friar of Bergamo, who caused a great revival of religion and led his following to Rome, penitents orderly and good, white robed, with red and white hoods and a dove with an olive branch embroidered on their breasts, and a silken banner, green and long and wide, which was laid up in Santa Maria sopra Minerva after he had preached to all Rome at the Capitol.

All those friars who were Catherine's friends were saintly men such as these, yet the old fervor, the first eager striving after holiness was dying out, and from the rhymes of Bindo Bonichi, urging the need of keeping away from friars, no matter what habit they wore, "men who one and all take the left way while praising the right," and describing how in life, Avarice and Gluttony held a meeting presided over by Satan to settle what friars each should have as vassals, to the chronicle of Salimbene of Parma, himself a friar, we find the same accusations, the same warnings to the laity to beware of the mendicants.

Catherine herself in after years shared the general view. We find her writing to a young niece, who had taken the veil, bidding her leave the church the instant that her confession was made, and to avoid encounters with monk or friar, but as a child

she could regard one and all with happy reverence, and they had very much to do with shaping her life and character. From them she heard the praises of Saint Dominic, for it would seem that those who came to the Fullonica were chiefly of his order — how he went about teaching and preaching; how he abhorred heretics; how kind he was to his community, even leaving prayer to visit the dormitories and lay his mantle over anyone who was cold; how careful he was as to personal cleanliness and neatness. Catherine's later life shows how deeply she was impressed by what she heard; it is evident that she took Dominic for her model and that her mind constantly dwelt on his life, divided almost equally between prayer and work, and on his view that the ideal Christian life consisted primarily in love of God and one's neighbor, and secondarily in discipline, fasts, and ceremonies, not as meritorious in themselves, but as aids in reaching an exalted spiritual ideal.

Although Dante highly praised Dominic, he clearly preferred Saint Francis, but Catherine was a woman, and the robuster character of the Spanish monk appealed to her. She constantly prayed in the church dedicated to him, which overlooks the Contrada dell' Oca, a great, austere building that the architect was bidden to make of the greatest possible size at the least possible cost, with no piers to hinder the preacher from being heard or hide the congregation from him. This church, like that of San Francesco on another hill, belonged to the Preaching Orders, and was for use, not beauty, since the orders were "principally and essentially designed for preaching and teaching, that they might thereby communicate to others the fruits of contemplation and procure the salvation of souls."[4] Yet, changed and modernized though

[4] Dominican Constitutions.

both churches are, they have a solemnity and grandeur that is most impressive.

Catherine's devotion to Saint Dominic and her desire to lead a life under rule began very early, and as a little child she planned that when older she would disguise herself as a man and enter a monastery, an idea probably suggested by the wild legend of Saint Euphrosyne, which must have been familiar to the Sienese, since her name was often given by neighbors to the little girl on account of her grace and gaiety.

Another scheme was partially carried out, namely, to find a cave and lead a hermit life. Hermits abounded in Sienese territory, and the self-devotion of the Olivetans was still a recent thing. She actually set out with this purpose, but with the practical sense that was always combined with her mysticism, she took a loaf of bread in case the angels should delay coming to feed her. It would seem as if she surely would have taken the path from her father's house that leads past the dark arches of Fontebranda, in whose waters the werewolves that were reported to haunt certain streets of Siena bathed to recover human shape, for but a little way beyond rise wooded sandstone cliffs with miniature caves just fitted for a child hermit. But instead she went all the way to the now closed gate of Saint Ansano, a road familiar enough, being the one that led to the house of her brother-in-law Nicolao, who lived in the district known as Vallepiatta, "because it was neither high nor low, but pleasantly sloping." She found her cave in rocks some way below the high red walls of the city and stayed there till evening, happy in the belief that she had reached the place where once dwelt the Fathers of the Desert. But with coming night and its solitude her mood changed. She thought of the Fullonica, and of her parents' grief when they could not find her, and became convinced that God did not mean her to

leave them. To run home was obviously the right thing to do, and she got back before anyone had grown uneasy: she was apt to wander, and her family had supposed her with her sister. How in such times of street brawls children could be allowed to stray about is difficult to understand, but that it was so is again shown by her returning from Vallepiatta with no companion but her little brother Stefano on the evening when she had that first vision that was followed by so many others.

The two had come to high ground whence they could see San Domenico stand dark against the sky, and looking up there Catherine seemed to see our Lord above it, in miter and pontifical vestments, accompanied by three Apostles. Stefano, suddenly perceiving that she had stopped behind, turned and saw her intently gazing at the sky, and called her. She took no notice until he ran back and shook her roughly, on which, weeping in childish fashion and wrath, says her biographer Raimondo, she exclaimed, "Oh, if you could have seen the beautiful thing which I saw, you would not have done that."

And thenceforth she became much graver and loved to escape to quiet places where she could say her little prayers undisturbed, or gather her small companions and make discourses to which they listened as later did crowds of grown-up people. Raimondo tells of miracles related to him concerning her childish doings, but we may conclude that these stories sprang up after she became famous; otherwise her family would have regarded her as marked out for conventual life, too holy, too blessed by Heaven for aught else. Instead of this, by the time she was twelve years old, they were planning a marriage for her, unaware that she had vowed herself to a heavenly Bridegroom, and her mother was both distressed and angered by her aversion to the project and her indifference to her personal appearance. "She was not beautiful; nature

had not given her a face over fair," Raimondo admits reluctantly, but it was so bright and sweet, her smile was so lovely, her expression so sympathetic and frank—she always looked everyone in the face, "even though it were a young man"—in short she was so winning that no one ever thought her anything but delightful. She had a blessed gift of good spirits, sang at her work, laughed with all her heart, could scold too if necessary, and was most unlike the drooping, conventual, nun-like figure that painting mostly gives as her likeness. And she had one undoubted beauty in her long, golden brown hair. Perhaps, however, it was not of the then-fashionable shade, such as Sienese ladies sought to attain, as their Venetian sisters did, by sitting on their roofs in the blazing sunshine to bleach their locks, burning their brains at the same time, according to Fra Filippo, who denounces this folly in one of his terrible *Assempri*, or else using a recipe still preserved in the public library of Siena. It was this recipe that Lapa urged Catherine to try, and when she refused, her much loved sister Bonaventura was called in to persuade her to take more pains to set off her person.

To some extent she yielded, but soon came to look on the concession as such a falling away that never after could she speak of it without tears, and when her confessor pointed out that as she had not acted from any desire of admiration, the fault was venial, the girl exclaimed in deep distress, "What a ghostly Father is this who excuses my sins!"

It was not the special failing over which Catherine grieved, but because when she had set herself to give up worldly things, she should never let herself be drawn aside at the very outset, and her remorse was deepened by the early death of her sister, which Raimondo takes as a token of divine displeasure. "Observe," he writes,

> O reader, how displeasing and hateful it is to God to hinder or turn aside those who would serve Him. This Bonaventura was in herself of very right life, both as to words and ways, but since she sought to draw back to the world her who desired to serve God, she was smitten of the Lord, and chastised by a very painful death.

He adds however that through Catherine's prayers she was soon delivered from Purgatory, but if such a point of view as his was placed before Catherine, her grief for her sister's loss must indeed have been cruel.

A time of tribulation for Catherine followed. Her family was urgent that she should marry a man who would be a useful connection, a plan, Raimondo observes, prompted by the enemy of souls. And as, singularly enough, she had no vocation for the cloister, her opposition to the married life, which then seemed the only alternative, could only appear flat disobedience, and disobedience to parents was then a high crime. In the pathetic epitaph over Petrarch's daughter Francesca in the Duomo of Treviso it is recorded among her merits that she was "absolutely submissive" to her father. And we need only read the chronicle of Salimbeni to see to what perils unmarried girls were exposed, so that any husband seemed better than none, besides which, sons and daughters were still regarded as the property of their fathers, and marriages were but a move in the game that their elders were playing. Choice had usually nothing to do with marriage on the bride's part, and very little on that of the bridegroom. If love did enter in, it usually brought tragedy, as in the case of Imelda de' Lambertazzi, whose lover was slain with poisoned daggers by her brothers: she sucked the wounds and was found dead on his dead body. Public sympathy was rarely with the lovers.

A Saint's Girlhood

When Altobianco degli Alberti was betrothed to Maddalena Gianfigliossi, the two became deeply attached, but the Alberti becoming involved in political troubles, the engagement was broken off. For five years the lovers remained faithful, though the girl received very rough treatment from her father. At length, seeing her health fail, he yielded, but "amid the blame of the whole city."

Very occasionally a girl ventured to reject a suitor, and San Bernadino tells of one whose aspirant came by her brother's desire to inspect her. They certainly did not attempt to set off her charms, for they brought her in bareheaded and barefooted.

"Does she please you?" they asked.

"Much," was the reply.

She looked down on the small man from her stately height. "But thou dost not please me," she said. It is probable that nevertheless she had to accept him.

When a couple had been united in the hope of reconciling two families who had been at feud, the wife's position was singularly difficult and painful, and at the best there was generally indifference on both sides. Yet usually the wife at least was faithful and a good mother, nor were there wanting husbands as considerate as Pietro Pettignano, whose prayers, Dante tells us, helped the unamiable Sapia through Purgatory, and who carefully used to avoid causing his wife any annoyance, saying to friend or customer when due at home, "Go in peace; my mistress awaits me." In Catherine's own home she saw an affectionate and united pair, and her respect for marriage is shown in her letters. There is not a trace in them of that overexaltation of celibacy and belittling of marriage which was so general in her time, nor does she ever encourage a wife to desert her home for the cloister. But for herself she would have none of the married

state, though all her family brought pressure to bear upon her, and to break her spirit she was allowed no room of her own, was constantly and sharply rebuked, and all the hardest housework was put upon her.

That so loving a heart must have keenly felt the displeasure of her relations cannot be doubted, but too much must not be made of what her biographers are apt to call "persecution." Domestic discipline was severe then and long afterward in all countries. Examples of harsher treatment would be easy to find in England even much later; witness Agnes Paston and Lady Jane Grey, the one imprisoned in her room and beaten by her mother for having plighted her troth without leave; the other systematically ill-used for no reason at all except that severity was supposed to be wholesome for the young. Catherine did not meet with exceptional harshness. In that large household, the womenfolk must as a matter of course have helped in the daily work, and she was remarkably strong until austerities broke down her constitution. It is told that she could run from top to bottom of the Fullonica—and the steps are many and steep—"with an ass's load on her back."

Nor can her mother's efforts to check her austerities be fairly called persecution, even if there were hasty words and possibly blows; these are suggested as beneficial for women in medieval sermons and indeed are strongly urged by Fra Filippo as due from husbands to wives who paint their faces. But popular opinion was against this form of domestic discipline. "Only asses should be beaten," says Orlandino, and the *Tractate on Governing a Family* lays down that, with sons, authority, not blows, should be exercised, while servants should not be beaten, but treated with kindness to make them loving and faithful. After all, Catherine was Lapa's favorite child, the only one whom she had nursed, for

even in the class of *popolani* the bad habit of employing a *balia*, or sending babies out to be nursed, prevailed, as it unfortunately still does, and to find that the girl forcibly kept herself awake almost all night, ate hardly enough to maintain life, and scourged herself cruelly three times daily, once for herself, once for the living, and once for the dead, after the use of Saint Dominic, might well wring the mother's heart. "Ah, daughter! daughter!" she once exclaimed with what Raimondo calls a burst of carnal love. "Already I see thee dead. Without doubt thou wilt kill thyself. Alas! who has taken my daughter from me?"

And she would tear her hair and shriek with all the violence of an Italian of the people, deaf to consolation, and vehemently reproach the girl, who listened humbly but unmoved, going cheerfully about her tasks and learning by the way the secret of leading a contemplative life within an active one.

She was debarred from any place that she could call her own, and a strict rule existed in Siena that the rooms of married couples were for them alone and must not be entered by other members of the family, a rule observed in this Fullonica, though with so numerous a family, even if the apprentices slept in the shop, as they probably did, it is inexplicable how they were all housed. Stefano, however, had a little nook of his own, and while he was away at work Catherine found a refuge there where she could pray undisturbed. At other times, she went about doing whatever she was bidden, and full of happy dreams and fancies, as many a maiden has done before and since, only hers were all of a spiritual life. While busy with household work, she would picture to herself that her father represented our blessed Lord, her mother, Mary, her brothers the Apostles and disciples, and that she was working for them in the Temple, "so cheerfully and gladly that the household wondered greatly thereat."

Her father, watching her unperceived, saw this and became convinced that hers was no passing, girlish fancy for a conventual life. He was prepared to let her do as she would even before Catherine, encouraged by a dream in which Saint Dominic bade her take courage and enter his Third Order, called together all her family, and told them how from childhood she had vowed to have no earthly bridegroom. She must keep her vow even if driven from her home.

All listened amazed by the courage and resolution with which she spoke, "and tears came more readily than words." Her father was the first to speak: "Heaven forbid, most sweet daughter, that we should in any way oppose God, from whom comes your most holy design. Therefore, since by long trial we have perceived, and now know for certain, that you are moved by no youthful fancy, but by the Holy Spirit, be free to keep your vow." And, after bidding her pray constantly for her kinsfolk, he added, turning to those present with all the unquestioned authority of the head of a household, "Henceforth let no one trouble or hinder my most sweet daughter in any way; let her freely serve her Bridegroom and pray to Him for us. Never could we find an alliance such as this; neither ought we to lament if instead of a mortal man we receive a God and a man who is immortal."

But Lapa could only answer by tears.

The little room familiar to visitors to the Fullonica was now given up to Catherine, and here, with one interval, she spent at least three years in solitude, broken only by visits from her confessor and her mother, who would not be excluded and sometimes insisted on her leaving the planks on which she slept and lie beside her on a comfortable bed, but as soon as she was asleep Catherine would leave her side and kneel in prayer, choosing, if possible, the hours when the Dominicans in their monastery

overhead were sleeping, so as to fill up, as it were, the spaces between their services.

In her cell she gave herself up to concentrated meditation, such as is hard to realize in the present century, with complex interests rushing in on every side. In the fourteenth century religion permeated the whole of life; it was the one great subject of thought and inquiry, orthodox or otherwise, taking much the place intellectually that science does now, and it satisfied not only Catherine's heart and soul but also her strong intellect. Her austerities were ceaseless, practiced not only to bring her strong young body into subjection, but because she believed that since we are members one of another, her sufferings could help the souls of others. Her view was that by the godly life of one member, all the others were strengthened, but it followed logically that the sins and shortcomings of each react on all, a belief that made her own failings exquisitely painful to her. This explains her otherwise incomprehensible self-accusations of causing misfortunes and failures in the Church. The unseen came very near her; the ardent enthusiasm so early shown was all centered on the supernatural; visions of saints gladdened her; she believed that her Lord stood in her cell and spoke with her; she realized divine things with extraordinary vividness, walking with God as His saints have done from Enoch downward. But it is only honest to say that no revelations are found in her visions; she saw just what it was natural she should see, and added nothing original to the stock of spiritual knowledge. When as a young child she was convinced that she saw Christ in the sky, He wore pontifical robes, the Pope being the stateliest figure she knew by painting or description; and in her strange and materialistic vision of Saint Dominic, it was natural that he should have the well-known traditional features, though to the

naïve imagination of the Trecento it was a proof of the reality of her vision.

Although Catherine had no inclination for the cloister, she ardently desired to join the secular tertiaries of Saint Dominic, called the Mantellate, from their black mantles, who must not be confounded with the Servite Sisters, an enclosed order with the same name. They were the outcome of a lay order, founded by Dominic "to combat heretical depravity, and defend the rights of the Church" even at the cost of lives. The members were at first all men, often married, in which case their wives swore never to hinder their work, and to forward it all they could. At first the order was called the Militia of Jesus Christ, but when "that crowd of little foxes who sought to ravage the vineyard of the Lord" were exterminated by fire and sword and prison, the need for such open warfare lessened.

The order, however, lived on, and many women continued to join it, either of mature age, or working with their husbands, or widows. They lived at home and did not take the three ordinary vows. At a later time these were taken, but after this the number of members declined. They led a retired life, at once contemplative and active, guided by a prioress, elected by themselves, who was responsible for them to the Dominicans. There were about ninety in Siena when Catherine was born, but some years later the plague again swept the city, and forty of these devoted women died while nursing the sick. Naturally, young girls were not eligible among them, and Catherine's request for admission met with a decided refusal. Why, they must have argued, should an exception be made for the dyer's daughter? Jealousies would be aroused; they would be blamed as rash and partial; the thing could not be, and Lapa, who carried the request, did not plead very heartily.

A Saint's Girlhood

Meanwhile Catherine's health broke down. In the absence of dates, which are very rarely given by Raimondo, it is difficult to fix the time at which minor events in her life occurred, and the difficulty is increased by the vagueness of chronology in this century — Siena, Florence, and Pisa reckoning the New Year from Lady Day; Rome and Milan from Christmas; while in Venice the legal year began on March 1 and the ordinary one on the first of January. To add to the confusion, it is never certain that any of these dates are exactly followed, but it seems as if it were during the three years commonly supposed to have been spent in her little cell that the interlude came when her parents insisted on her accompanying them to the baths of Vignona, both on account of health and to see if indeed the world had no attraction for her.

She went, but it must have cost a great effort to break into her chosen life, and the gay and noisy scene must have been most alien to her. It was characteristically Italian. In other countries the middle class rarely left the shelters of city walls, but in Siena nobles and *popolani* alike frequented the baths and mineral springs near the town, the rich traveling on horseback or in some rough vehicle, the aged and sick in litters, while the less well-to-do came in carts drawn by reluctant buffaloes or the great mouse-colored oxen with wide horns, such as are still among the beautiful characteristics of Siena.

Tents and rough lodgings sheltered the visitors, who spent their time in bathing, the women in a place at some distance from the men, with a high wall between them on which the law required to be painted "in good color" a fresco of the Virgin, our Lord, Saint James, and Saint Philip — or in sleep during the hot hours, or listening to minstrels, playing chess and backgammon, or hawking and hunting.

No one was allowed to carry arms, a most necessary precaution, but in the long, idle days not a few quarrels were started or embittered that had tragic results when the disputants returned to Siena, and there was so much vice in these places that it is strange to find good people like the Benincasa frequenting them, especially with a young daughter.

Lapa's hope that Catherine would be attracted by the gaities of the bathing season were vain, nor did Catherine's health improve; with an exaggeration of self-discipline, which when older and more experienced she would have condemned, she scalded herself with the water from a hot spring and returned home only to fall dangerously ill. Lapa was much alarmed, and when Catherine assured her that if she would not spare her to be a Mantellata, God would take her away altogether, the mother pleaded so earnestly with the prioress that four of the most discreet among the sisters were sent to report on the girl, with a promise that if not too pretty, she should be received among them. They found her wasted and disfigured by something like chicken pox; she answered their questions with the utmost modesty and good sense, and was accepted.

As soon as she was well enough, she went with her family to San Domenico, where, in the Cappella delle Volte, she was blessed and invested with the cloak of the Mantellata, and returned, full of thankful joy, to her cell.

Reaction followed, such as many a devout nun has experienced. Opposition over, the spirit is no longer roused to combat, and she realizes how much she has given up, what a long stretch of monotonous days lies before her, and if the sacred laws of health have been outraged, as in Catherine's case, the struggle will be yet more violent. She suddenly found herself beset with evil thoughts; profane words, such as she could never remember

to have heard, rang in her ears; tempting visions, longing for earthly joys, horrified and racked her; temptation came upon her to bethink herself that even now it was not too late to have a glad life like other girls. Her cell seemed swarming with fiends, one of whom she called Malatasca, a name recalling Dante's Malabranche; wild longings seized her to run over hill and dale away from these fiends and fiendish thoughts, which pursued her even in church, tempting her to despair. Her only refuge in this horror of great darkness was to repeat, "I trust in my Lord Jesus Christ, and not in myself."

Out of the depth she cried, seemingly unheard, she to whom prayer had been such joy and strength! But help came. She had a vision of the Savior, stretched on the Cross, saying, "My own daughter, Catherine, seest thou how much I have suffered for thee? Be it not hard for thee to suffer somewhat for Me."

And she, all thrilled by the loving words, "My own daughter, Catherine," asked, "Where wert thou, Lord, when my heart was filled with such impurity?" and the answer came, "In thy heart."

In the *Legenda* of Raimondo da Capua, which is the main source of our knowledge of Catherine, a long discourse is given, supposed to have been spoken by Christ. It could not possibly have been written down at the time and suggests, as in many other instances, either that her vivid realization of spiritual exchange made it seem to her literal fact or that it was a meditation, or possibly that her biographer filled out her recollections.

Chapter 2

એ

Siena in the Trecento

To understand the character and history of Saint Catherine of Si-
ena it is necessary to realize her surroundings and the influences
amid which she grew up. But to us who live in the present cen-
tury, the difficulty of doing so is great. We are perplexed by the
violent contrasts that meet us at every step—unblushing vice
and saintly lives among both laymen and clerics; unbridled ex-
travagance and frugal economy; lawlessness side by side with sub-
mission to statutes that interfered with freedom of action at every
turn; furious revolts and personal quarrels filling the streets with
uproar and bloodshed, and quiet everyday occupations. There
are usurers and gamblers, religious revivals when a crowd of two
thousand persons would stand for five or six hours listening to
the appeals and reproaches of a friar with every sign of contrition.
On the other hand there was the scornful indifference shown in
the verses of a contemporary of Catherine: "Let the mad priests
preach, with their small truth and many lies." Chronicles and
sermons of that day give an appalling picture of shameless wick-
edness, prodigality and crime, often apparently committed for
crime's sake. There were men like Giovagnolo, captain of the
troops of those Conti di Santa Fiore, whose stronghold was on

Monte Amiata, and who brought yearly tribute to Siena, a man "most evil, traitorous, perfidious, merciless and cruel beyond all diabolical imagination, who took more delight in slaying than did many wild beasts," and who would not even make the usual deathbed confession, refusing to listen to a priest, "since he still hoped to take vengeance on several persons." There were others who did not hesitate to remove an enemy by dagger or poison, a means known significantly in England as "the Italian crime," and though the story of thirteen Tolomei invited to a banquet at a place still called Mala Merenda, and there poisoned, is probably mere legend, the fact that it was believed, and the story handed down, shows that such deeds were thought perfectly credible.

On the other hand, Siena had so many holy men and women that she has been called the antechamber of Paradise. There was Nera dei Tolomei, who, like Catherine, could read hearts, and foretold the Great Schism; and the more famous Bernardo of the same family; Fra Filippo d'Agazzari, whose sermons were a trumpet of no uncertain sound, bidding the sinful and luxurious to see to their ways; and Bernadino, born indeed in Massa, but closely connected with Siena, who must not be confounded with another yet more celebrated friar of the same name, but with the addition of "Ochino," being born in the Contrada dell' Oca, a man who deserves a better record than Gigli's in the *Diario Sanese*, as one who would have left behind him great renown in literature and merit in the Church had he not "blackened his name by falling into the errors of heresy." Nor must we omit Colombini, who "espoused most high poverty," and preached with such effect that he was banished from Siena, lest the number who desired to become monks should lessen the population too greatly, and — only no one thought of that at the time — withdraw all the best men into the cloister, leaving lay society without their good influence.

Besides all these there were countless good and religious people who led quiet, honest lives, leaving no record beyond the incalculable effect that such lives have on their own and on succeeding generations. Sometimes, however, we obtain a glimpse of them. It was through the example of his wife that Colombini changed, as Malavolti relates, "to the marvel of all the city from a proud man to one most humble, from a seditious to a pacific, from a miser to an almsgiver, and from a wolf to a meek lamb," and repeatedly in Catherine's letters she writes to mothers and wives who ruled their households wisely and well and reaped their reward. Her own family show the sound, healthy life in the middle class of Siena, industrious and godly, keeping aloof as far as might be from civil strife, yet taking due part in the affairs of their city, or when Giacomo Benincasa accepted office in the government.

One of the problems that is hard to solve is how everyday life goes on in times of revolution and unrest; yet it does. It did so in the very heart of the French Revolution, when, with the Terror prevailing, and no man's head safe from the guillotine there still was marrying and trading, and dancing and playgoing, and it did so in the Middle Ages in spite of violent changes of fortune and the calamities involved by feuds all the more envenomed because they were penned into such narrow bounds, where families who had hated one another for generations lived on opposite sides of the street and could never get out of one another's sight; when there were no intellectual interests, and a man's country meant his native town.

Probably the dullness of life had much to do with the turbulence and crimes of the time. It was distinctly dull among the upper class, especially when they were excluded from the magistracy. And the Sienese had a craving for amusement, and were

a lighthearted race; their neighbors called them crazy madcaps, an accusation rebutted by Della Valle, writing in 1782. "I do not deny that the Florentines are firmer and more constant in their matters," he says with an acrimonious touch, which recalls the long grudge between the two cities, a grudge by no means dead even in a united Italy,

but that comes from their climate, or to speak plainly, from the heavy, turbid air which oppresses them in the hollow where they lie, while the greater quickness and lighthearted gaiety, and the amenity of Siena comes from the pure and ever-moving air which they breathe; moreover, one can be crazy [*pazzo*] either from extreme gaiety or extreme seriousness, so the Sienese, in spite of the name given them by the Florentines, have often reduced the latter to receive laws and conditions of peace from them. Nor am I sure that if the Florentines had gained the battle of Monteaperto they would have shown such kindness of heart as did the Sienese, who, content with what they had gained, pardoned even the men of Montalcino who had rebelled against their sworn fealty.

Not content however with calling the Sienese *pazzi*, the Florentines taunted them with vanity, and when Dante speaks of "vain folk" he is repeating a popular Florentine saying, "Vainer than the French," and the taunt rankled, for Tomasi, in his history of Siena, alludes to him with amusing indignation as

a writer who proceeds very arrogantly to blame and praise all things after his own manner, nor did it suffice him to deal with the living, but he also spoke of those who are beyond man's judgment, assuming more power than the

fables of the ancients gave to Radamanthus, by filling Hell and Heaven with persons as pleased him best.

Certain it is that notwithstanding feuds, pestilences, wars, and popular tumults Siena was never long without amusements. The upper class hawked and hunted, and the whole population, high and low, were passionately interested in certain games that became so much of a free fight that they had to be prohibited by law. Such was *elmora*, played with wooden swords and lances, and *pugna*, so beloved of the people that it was played long after an edict forbade it, in consequence of the number of people killed and wounded when the players' blood got hot, and fisticuffs no longer contented them as the old rivalry between the *terzi*, or triple division of the city, blazed up. Siena is a Hill Queen, built on three heights, with deep depressions between them, and the inhabitants have their rivalries to this day, and keep distinct, though they have long abandoned the costumes that distinguished their male inhabitants, red for the Terzo di Citta, green for San Martino, and white for Camollia.

Pugna was all the dearer to the Sienese because after that great victory over Florence that dyed the Arbia red and made the name of Farinata degli Uberti and his descendants abhorred in Florentine ears, it was held to represent the defeat of the rival city. Urghieri, however, shows that it had a much earlier origin, writing thus:

And that it may be known how this game arose in Siena we must remember that our chroniclers say among the streets of Siena there is one … where formerly various things were sold, especially victuals, and even yet the pork butchers keep food to sustain man, such as cheese, sausages, and so forth, though in process of time traffic in nobler things has mixed with them. And when people

of the City ward passed that way, they were full often hindered by others who would not that they should come and sell in their district. From words they would come to quarrelling, and from quarrelling to fisticuffs and to battle, people running from every side to help their own friends, and the conquerors carried off cheese, eggs, hens, and all that had given rise to the strife. This would be chiefly in the last days of Carnival, when such things are most consumed, and dearest. And these scuffles were represented in Carnival as one of various games, all forbidden except at that season, and in the Piazza

— namely the Campo, whose historic name has been changed to the commonplace Vittorio Emanuele, with the incomprehensible indifference to ancient associations that distinguishes modern Italian municipalities. "And at that time it was lawful for any who found his adversary to assail and strike him," but it was understood that even if wounds or death ensued, no vengeance must be taken, and for many years *pugna* was encouraged as making men ready in war, and more disposed to fight for their city. "And of this game heroically has sung the noble poet Vittorio da Campagnatico of Siena."

Pugna and *pallone* have had their day, but the *palio* races survive, as all know who have visited Siena in July or August. It is still an interesting sight, though shorn of its medieval splendor. The races are said to have been instituted in honor of the Virgin Mary, whose figure appears on the banner (*palio*) which is the prize of the winner, and from the excitement that they still arouse, we can imagine how keen it was in Catherine's day.

Everyone takes the side of his own contrada; the wife, if not of her husband's, returns home for that day to work or

weep according to the success or nonsuccess of his banner. That day, the Sienese do not eat, nor have they slept the previous night, but spend the time in going from house to house, shops, streets, piazza, to consult, take counsel, encourage one another, and intensify the hatred between ward and ward. At the hour of the race all the city is afoot, men, women and children, old patricians, plebeians, peasants from ten miles round come into the city. They crowd the platforms erected round the piazza, terraces, windows, roofs and towers. And while the horses gallop round for the first time not a whisper is heard in all the crowd, but during the second and third rise mingled shouts, everyone encouraging and applauding his own rider, and cursing the rival one, and when the horse reaches the goal, a great howl of joy from the victorious side fills the air. Horse and rider are taken into the church of Provenzano, where the latter is blessed, as were all the jockeys before the race, and thence he is borne to the church of his own ward, passed over the heads of the people from hand to hand and set on the altar, while all the building echoes with a great inarticulate thanksgiving.

As a child Catherine must have seen the *palio* run and shared in the anxiety that her Contrada dell' Oca should win, but in her time the races were run on foot.

Spring, summer, and autumn each had its diversions, but time must have hung heavily on the hands of the upper class in the long hours of winter when out-of-door occupations were uninviting. The merchant and artisan had his business, or was engaged with the affairs of his city, or went on journeys, but the noble, unless he became a trader, as was often the case, had no

sedentary occupation, rarely traveled, and had no indoor amuse-
ments except chess, backgammon, and zara, a game in which at
every throw of the dice a number was called out, success depend-
ing on having chanced to name the ones thrown.

Gambling was one of the great vices of Siena, and of Tus-
cany in general, though medieval legends abound in warnings
that gamblers will have their souls carried off by demons, and
their bodies dragged by them out of holy ground. Was there not
a soldier whose habit it was not only to play games of chance,
but to accompany each throw of the dice with curses on all the
saints of life eternal and their heavenly Court, and did not two
forms, exceeding dark, suddenly appear and carry him off, body
and soul, to the place whence they came? And was it not seen
by all present? But such tales were beginning to lose their effect
in Catherine's time, and though preachers still often used them,
she never once alludes to them in any of her writings.

Statutes were vainly passed to restrain gambling; the love
of it was in the blood, and the Sienese threw away their money
on games of chance just as their descendants do on the lottery.
Intellectual interests were absolutely wanting; reading has never
counted much in Italian households, and, in the fourteenth cen-
tury, books were scarce and dear, existing, of course, only as
manuscripts. In certain homes there would be some religious
works; we hear how the wife of Colombini offered him the *Lives
of the Saints* on one occasion in his unregenerate days to fill up
the time when dinner was late, and how he threw it at her. A
few women learned Latin enough to read the Vulgate and the
Fathers, but usually fathers and brothers were suspicious of female
education, a woman's vocation being to look after her maids and
keep the family wardrobes in good order, taking especial care
that moths did not get into the clothes. She had also to lay out

carefully the money that her husband gave her for household expenses, and submit to his better judgment in all things.

Though devotion to the Virgin was increasing by leaps and bounds, and poets praised their ladies to the skies, women counted for little in daily life. Agnolo Pandolfini expresses the general view when he states complacently that although his wife was endowed with all graces befitting a gentlewoman, good habits, intelligence, and industry, all this came from his teaching and discipline. Nor did he ever, under any circumstances, tell her anything about his business, "for," he writes, "much doth it displease me that any husband take counsel with his wife," and on principle he never talked with her on any matter but such as concerned his household. This was the burgher view; we find the ecclesiastical in one of the earliest books in Italian, written by a friar, one Fra Paolino, who quotes Theophrastus to strengthen his position. A grievous thing it is, he declares, for man to enter wedlock, for no one can attend both to learning and a wife. Moreover, it is no small matter to satisfy her longing for costly garments, gold adornments, precious stones, maids, and diverse other things. And she is full of laments and says:

> Such a one goes more fairly decked than I, and such another is more honored, while I, poor wretch, am despised by all. Why do you talk with your neighbor, or the maid? ... A grievous thing again it is to spend for a poor woman, and a grievous thing again to support the pride of a rich one. And there is nothing in which a man can be more lightly deceived, for all others that he would buy he tries beforehand, but till he has her he cannot tell if a wife please or displease, and only after marriage can he learn if she be good or bad, meek or wrathful, and so forth.

Again, be she ugly, hard it is to love: be she fair, hard it is to guard her.

And though Petrarch sang Laura, no one could speak more contemptuously of women than he does in several of his letters meant for posterity. All the reverence for woman set forth in poems of the time seems empty words beside such views of her, and the advice in sermons to beat a wife shows that such discipline was known, but Saint Bernadino uplifts his voice indignantly against it even among the peasants, to whom his exhortations against over-zeal in correcting their womankind of slovenly habits seem addressed, since the pig to which he unflatteringly compares them would not have been admitted to houses of a higher degree. "How is it that thou considerest not thy duty?" he demands.

See'st thou not the pig which always squeals and always clamors, and always befouls thine houses, yet thou sufferest him till the time cometh when he is fit to kill. This forbearance thou showest only that thou mayest have his flesh to eat. Consider, thou pitiful rascal, consider the noble profit of the woman, and have patience. Not for every trifle shouldst thou beat her.

However preachers and husbands regarded them, the ladies in Siena seem to have had more freedom than in many other places. In Venice during the fourteenth century, they were kept in almost oriental seclusion, rarely leaving their palaces except on very special occasions, and often hearing Mass in their private chapels under their own roofs so as to avoid going out of doors. In Rome, too, they were hidden away with jealous care, quite needful in that turbulent city, and were not even allowed to leave their own part of their palaces, lest they should come in

contact with the fierce and lawless retainers and soldiers kept by their male relations. Florentine married women had much more freedom, but this did not extend to girls; as late as the middle of the sixteenth century Grazzini urges that the music at Carnival time should be "large and gay," and the processions as rich and beautiful as possible, accompanied at night with torches so that all should find pleasure in them, even the young girls well hidden behind a shutter or curtain in their fathers' houses. In Siena girls were less confined, and married women had considerable liberty paying visits to neighbors, and chatting to them from windows and balconies in the narrow streets, while to this day no Roman lady would dream of appearing even at a window except at the Carnival. And there was the walk with fathers or husbands in the little Piazza Prusierla or in the Campo, and the daily Mass for the religious, while one and all on a high day would go to the fashionable church outside Porta Romana, where, it is whispered, love letters were not unfrequently slipped into the nosegays so respectfully offered by students and soldiers.

When winter came and snow fell on window ledges and balconies, the ladies rolled it into balls and flung them across the street at one another, just as the boys were doing in the street below, and there were public entertainments where they went, but it had to be done openly and frankly, for if a lady appeared there masked or veiled, the officer appointed to watch over public morals (a thankless task) promptly asked her name, and to give a false name was a grave offense.

Very much time was filled up by matters belonging to the toilette. "You paint yourselves more than any women I know," thundered San Bernadino, "not perceiving that you spoil your looks and make yourselves hated of men," while for the ever-changing fashions of hair dressing, he cannot find words fiery

enough to denounce them. Now it was loose on the shoulders, now towering up like the Mangia—we may be sure that he was preaching in the Campo, under the slender and lofty tower of that name, as he often did—or the locks were false, or stuffed out with silk, or else with hair from the tails of the great Tuscan oxen, or he denounced the use of perfumes, needed partly to conceal the woeful lack of personal cleanliness of which not only peasants in their wretched huts, but the upper classes were guilty. Baths were unknown, and the minute washing basins on their tripods gave the measure of water thought necessary then and later.

In common fairness the men should have been as sharply lectured as the women, for the young fops of Siena were not a whit behind Petrarch, who confesses in one of his letters that in youth he had been painfully anxious to look elegant, changing his attire morning and evening, studying every fold of his robe, building up his hair, and diligently avoiding any touch or hasty movement which might spoil the effect. He owns too that he wore shoes too tight for him, and often got burned by curling irons.

Old pictures show how gorgeous dress in the Trecento could be, but we must not suppose them worn in everyday life. The dresses of a bride were rarely brought out after her marriage; usually they lay in the *cassa*, the great chests found in all old Italian houses, cupboards and shelves being modern inventions in Italian bedrooms. Clothes were regarded as things to be handed down to the next generation, and were received as a welcome gift; a robe of scarlet cloth was an offering for a king, and they are always carefully enumerated in inventories of household goods. In a record existing in the public library of Siena it is mentioned that at the knighting of a young noble, his father wore a grass-green robe,

with a row of golden buttons down to his feet, and that, among the many gifts given and received by the son, the chief were silken robes, lined with squirrel fur and tied with a silken cord, and another of green Douay stuff that seems to have been especially valued, not to speak of furs, hoods, caps, and gloves. There was also a doublet adorned with gold, a coverlet embroidered with shields — probably the arms of the new-made knight, made of very fine crimson cloth, and three pairs of stockings of stout saye.

The extravagance in dress seriously preoccupied the municipality, all of whom were probably husbands and fathers and had to pay the bills, and many statutes were passed to check it. Now only a certain number of gold buttons might be used on a lady's dress; now unmarried girls must not wear cloth or velvet except for a headdress or sleeves, nor might more than a fixed number of yards of scarlet cloth be put into a gown for their mothers, while no woman of the middle class was permitted to wear a train. The archives of Siena record that a heavy fine was imposed on the wife of a pork butcher who appeared in San Cristofero with a long train to her cloth dress. Her husband appeared before the magistrates in her place and pleaded that she had not willfully broken the law, but had carried the train in her hand or hooked it up, and if it had trailed, she was unaware of it. The plea was set aside, and the fine had to be paid.

This is but one of the innumerable instances of the way in which statutes interfered in daily life. It aggrieved no one. A man was a citizen first and foremost, a private individual only in the second place. Personality was little recognized in the Middle Ages. What concerned the city was all important, and, as a citizen, what touched him touched the city. This was why at one time all betrothals took place publicly in the Campo, before the Palazzo Publico. There was something of conventual

rule both in public and private life. Statutes regulated both. Until the Sovrana, the great bell of the Duomo, rang at dawn, no one might leave his house, nor might the gates be opened to the country people, coming to buy and sell, or to the belated merchant who had had to camp with his laden mules outside the city all night at the risk of being fallen on by robbers or the wolves that lurked in the forests sweeping up to the very walls. These forests were strictly preserved, as they were believed to purify the air from the marshes, as well as supplying wood for private use in various trades. Again, no one might go out after curfew rang from the Campo, at nine o'clock in winter and ten in summer, and whosoever was out after dark must carry a wax candle, whose size was fixed by law, a very sensible rule when there were no lights in the steep, narrow streets winding among lofty palaces and convents, except where an occasional lamp was set before a shrine. The nobles usually were accompanied by servants with torches; humbler folk carried a lantern; the one used by Catherine when she went at night to some sickbed is still kept in the Fullonica, so changed from what it was in her time that it is almost impossible to imagine the busy life in it, with Catherine in her little room, praying or listening for the first sound of the Sovrana, eager to carry help to some poor family, and hurry back before she could be recognized.

Bells played a great part in daily life before there were clocks. After the Sovrana had roused the city came the one that at 7:00 A.M. announced that the Palazzo Publico was open for business, and if the officials were not there before the sound ceased, they were fined. The hours of divine service were proclaimed by the bells; the *Misericordia* tolled when a prisoner was led to execution, and the sounds of bells called the citizens to extinguish fire, or to fight.

Another measure of time was a candle, used in case of emergency. When in the beginning of the fourteenth century the furious enmity of the Tolomei and Salimbini set Siena in an uproar, the magistrates put a lighted taper in the Palazzo del Governo, where they then sat and made proclamation that if the men of the rival families had not come to make peace before it was burned out, they would be imprisoned and their property forfeited. The same means was taken on a very different occasion when the enemies of the saintly Colombini prevailed on the magistracy to banish him on pain of death before a small candle was burned out. It was a common way of meting out time to offenders. When Clement VII was induced to expel the Capuchins from Rome in 1534, he ordered that one and all should leave the city before the taper kindled as he spoke should burn down. On receiving the command, they instantly left the monastery where they had been living, and taking only their breviaries and a large wooden cross, went forth in silent obedience. Among them was the Sienese friar Bernadino Ochino.

The years following the birth of Catherine Benincasa saw Siena unprosperous. Commerce had been severely checked by the Black Death; fortunes were lessening, workmen scarce, and many of the wisest and best citizens had died, leaving incompetent men to govern. For a considerable time previous to the pestilence there had been great prosperity, and the change was not immediately apparent. Even private feuds, and the jealous discontent inevitable where a single class governed, and the measures taken that ignored the needs and desires of a great part of the population, seemed more or less dormant. Siena rose to the zenith of her power, though even then, to judge by the comparatively rare occurrence of her name in contemporary chronicles, she had little importance compared with Genoa or Florence,

Pisa or Venice. Yet she ruled over two hundred towns, villages, and castles, who yearly sent tribute of banners and money and great wax tapers to the Duomo, each deputy coming forward with his offering as the name of the place he represented was called by the Chamberlain of the Duomo from the marble pulpit overlooking the crowd of farmers and villagers. They stood side by side with the fierce Ardingheschi, lords of Campidoglio and the Aldobrandeschi, who boasted that they owned more towns and villages than there were days in the year, a stock whence sprang Gregory VII, and who nevertheless did homage to Siena for Monte Amiata. Theirs too was the race of the proud *Latino* whom Dante meets on his way to purification,[5] and besides these was many another great noble, with whom Siena had not a few tough struggles. Each of her own citizens too was bound to bring a taper of a size in proportion to his income, except the very poor, the sick, and — singular exception! — those who had a grave feud with an enemy. The wax thus brought was partly sold for the benefit of the Duomo, partly used there, and in the evening Siena rejoiced; torches gleamed from the Mangia; bonfires blazed below in the Campo and on the surrounding hills, lighting up the dark forests and the wild and tumbled volcanic country. On Monte Amiata an especially great one was kindled, for those who dwelt there were bound to make it visible at Siena. Whoever has been in the city when the *palio* is run can picture something of the mad excitement as one fire glowed out far and near, for this part of the ancient ceremony is preserved on the feast of the Assumption, but in old times there was the exultation of knowing that every one of the fires confessed the overlordship of Siena.

[5] *Purgatorio*, Canto XI, line 58.

During all the earlier part of the fourteenth century her power increased; wealth flowed in from commerce and banking, in which now even the noblest families engaged. Besides home trades, they had imports of Flemish cloth, eastern goods, pepper, ginger, and spices. The profits shared among the sixteen families who formed the clan of Salimbena were in 1337 one hundred thousand gold florins, and the next year their agent made a most profitable venture in "cloth of silk embroidered with golden leaves and fruit, stars and moon, and girdles of silk and gold of Sorian fashion," brides' purses, also of silk and gold, and many other things, all of which were displayed in the Salimbeni palaces before being distributed to the salesmen employed by the family, who by the year's end had disposed of all or nearly all the goods. The purses seem especially to have taken the ladies' fancy, since 180 were sold to brides of noble birth in one month, not to count those bought by lesser folk. "And," comments Malavolti, "this fact is sufficient proof of the great riches and the great nobility then existing in Siena, for I do not believe that in any Italian city there could now be made in one year eighty alliances of great families, or at least of questionless nobility."

This valuable cargo arrived safely, but the obstacles in conveying goods from place to place were great. Those brought by sea encountered storms and pirates and galleys of hostile towns: by land there was the hardness of the roads, swollen rivers, heavy tolls levied by nobles, past whose castles the caravan went; taxes for entering a town, for setting up booths, all hampered commerce. Robbers lay in wait, often men of gentle birth, like that Rinaldo dei Pazzi who is among the thieves in Dante's *Inferno*. Worse still, every time a band of Free Lances was unemployed, they went about burning, plundering, and seizing any merchant with mules or wares whom they met. Froissart gives a lively

portrait of a Free Lance captain who could not forgive himself for having repented too soon.

How lighthearted we were, [he exclaimed] when we rode hither and thither, and found by the way a rich abbot or prior, or a troop of mules laden with Brussels cloth, or fur from the fair of Landit, or spice from Bruges, or silken goods from Damascus or Alexandria! All was ours, and ransomed at our will. Every day we had fresh money. The peasants of Auvergne and the Limousin provided for us, and brought to our stronghold wheat and flour, baked bread, barley for the horses and litter, good wine, fat sheep, and poultry. We were kept like kings, and when we rode forth, all the countryside trembled before us.... Comrades, that was a fair life and a desirable!

Repeatedly goods coming or going from Siena were thus intercepted, and in 1336 it was necessary to place a troop of horsemen in Grosseto to protect the traders going to the port of Talamone. The Free Companies were the curse of Italy, and we shall find Catherine Benincasa anxiously seeking to occupy them more harmlessly. Still, for many years, wealth poured into Siena, but at the cost of rousing keen jealousy in Florence, whose hostility was caused far more by commercial rivalry than by different political interests. Florence was Guelf as long as it suited her, and Siena looked to the emperor for support against the great lords in her territory, but both held loosely to their parties, prizing their prosperity above all, and regarding the prosperity of other towns as a misfortune. If Florence tried to crush Pisa, it was because she barred the way to the sea, if she were jealous of Siena it was because Sienese commerce extended far and wide, and she held one of the chief roads to Rome.

The wealth of Siena did not depend solely on trade. Up to the time when Rome was deserted for Avignon, Sienese merchants had banks in London and many other cities, and lent money on interest; in plain words, they were usurers, known as *Caorsini*, the name being taken from Cahors, a French town famous in the wars of the League, where usurers abounded. Readers of Dante will recollect the scorn with which he regards the miserable group sitting on the edge of the burning plain, and fondly regarding the moneybags slung around their necks, and Matthew Paris shows the same contemptuous dislike of them, complaining that they carried themselves with a high air in London, where the support of the Pope, for whom they collected Peter's pence, baffled all the efforts of the bishop to keep them out of his diocese.

But later the papal banking business was transferred to Florence; the London banks were closed, and the prosperity of Siena never recovered the check, which came when the riches gathered by the fathers were leading their sons to a luxury and extravagance hitherto unknown in the merchant city. It found its most reckless expression in the Spendthrift Brigades, one of which is branded by Dante.[6] Its members met to feast in a house still known as La Consuma, near the gate of San Lorenzo; the dwelling now looks as much out of elbows as did the prodigals when they had wasted all they had under the belief that the world was coming to an end. "They lived amid banquets and delights," wrote Tizio, and flung their gold and silver plate and drinking vessels into the street after each repast, and shod their horses with silver, outdoing Filippo Argenti the Florentine, inasmuch as they ordered them to be loosely shod, and forbade their servants to pick up any shoes that dropped. After ten months of

[6] *Inferno*, Canto XIII, lines 115–129.

riotous living, they were beggared, and two popular songs exist that commemorate their folly. Who the pair on whom Dante conferred a scornful fame really were is now unknown; some old writers identify one as a Salimbeni.

Unlike most Italian cities, Siena counted wealth as nobility. Not till the people governed did nobles pay taxes; the first imposed on them was the hearth tax, paid also by the middle class and the poor, then followed the *Lira,* and the community was divided into the greater and lesser citizens. Naturally ambition awoke to belong to the former class, and there sprang up a number of ennobled families, looked down on, of course, by the older ones, and resentful of their attitude, as was the case in France before the Revolution, and between them was a new cause of weakness in Siena. Patriotism slackened, and, while private feuds were as bitter as ever, the warlike spirit declined; it seemed better to hire mercenaries to fight for the city than to risk one's own life. At one time the ruling thought of the citizens was to make their town great. No sacrifice was counted for that end. When Florence sent as haughty a message as ever did the Thirty Cities to Rome, and the fate of Siena trembled in the balance, Signor Salimbene dei Salimbeni appeared at the head of his kinsfolk and retainers, escorting a car covered with scarlet cloth, and, entering the little Church of San Cristofero, where the magistrates sat in gloomy silence, took from it 100,000 florins, which he poured on the pavement, bidding them spend the money for the defense of the city, and not spare, for more would be forthcoming if needed. But in Catherine's day the citizens thought more of their own welfare than that of Siena, and evil times found an enfeebled generation to encounter them.

With all the luxury, the encouragement of art, the religious revivals, there was a background of almost incredible violence

and cruelty in the fourteenth century that must be realized as part of the surroundings of Saint Catherine. Even allowing for the colors being strongly laid on, what a picture it is that we see in chronicles and sermons! "If there were a thousand Guelfs, and one day a small child were born of a Ghibelline, immediately one and all would hate him," says Bernadino, and in another place he gives an appalling description of the savage cruelty and murders of women and children in faction fights. Dante records the venomous hatred of Sapia for the party who had banished her from Siena, and her exultation at seeing them routed. She is a portrait of the partisan of that day, passionately resenting private wrongs, and triumphing in her opponents' fall. Women in these fights were always ready to egg on the men. "I have heard," Bernadino says,

> of women so bitter against the opposite party that they would put a lance into the hand of their little child, that he might slay and take vengeance. And there was a woman so cruel that when she saw another of the other party escaping she cried to her people, "Such a one is escaping; a certain fellow has set her on his horse, and is carrying her away," and running after them she cried, "Set her down if thou would'st not die," and when she was set down that woman murdered her.

He gives more details, too horrible for quotation, though preached to a great congregation, and then observes, "Verily so great ills have been done through faction that what I have said is almost nothing."

The streets of Siena are quiet enough now, but the city looks so ancient — Taine called it a medieval Pompeii — that a visitor might fancy it unaltered since the days when Catherine lived

in it. But many of the buildings which look so old were then
new, or did not exist. The Palazzo Publico and the Mangia were
there, though a story lower than at present. The Cappella di
Piazza below them was erected only in the year after her birth, as
a thanksgiving for the cessation of the plague, with two golden
florins in the foundation as a charm against earthquakes. The
Churches of San Domenico and Francesco were not completed
for another century. Among buildings already old were the pal-
aces of the Tolomei and Salimbeni, rival families, "filled with
very bloody enmity, on account of their might, their close neigh-
borhood, and their opposite parties," for the Tolomei were a
house more devoted to Florence than any other in Tuscany, while
the Salimbeni were strong imperialists, and their rivalry was so
serious that about 1317 Florence interfered, "to the wonderful
satisfaction not only of the city, but of the Florentine Republic,
who sent ambassadors to persuade them, and used great diligence
to do so, since the hostility of these two families kept all the city
disunited, and might cause great harm not only to the city of
Siena, but to the Guelf cause."

Unfortunately promises of peace between rival families were
what Italians call "mariners' vows," broken as soon as opportunity
offered. "Close neighborhood" was hard to avoid, though at first
each palace stood in a clear space, within which were the shops
of its merchants, stables for the horses of the masters and men-
at-arms, and the mules that carried merchandise. Sometimes
the palaces of allied families were united by a covered passage
high above the street, and many had lofty towers "forming," we
hear, "a spectacle of surpassing beauty," though it must be owned
that a print of medieval Siena, now in the Uffizi, suggests a town
full of factory chimneys. Tomasi says they were built mostly by
citizens who obtained leave to do so in token of proud nobility or

for offense and defense, "when the injured people sought to cast down the power of the great." Sometimes they had a more honorable origin. The family whose name was changed to Incontrati by public decree, because they "encountered" the foe with such extraordinary valor in the fight with Florence at Monte Maggio, had a tower built at public expense, known as the Tower of Victory, and it was decreed that any Sienese who distinguished himself in battle or in civic life might build one. The oldest bit of masonry in Siena is the Rocchetta tower, where Saint Ansano is said to have been imprisoned.

The palaces of Siena look grimly down, but whereas those of Rome have often great dungeons, with an oubliette or perhaps a secret passage to the Tiber, none in Siena had any prisons below them, and even the public jails were small. The prisoners were offenders against the law, or supposed to be such, and were there by order of the magistrates, not at the pleasure of private individuals. Fines played a great part in civic punishments, and only heretics were imprisoned for life. Siena is said to have been less cruel than most medieval towns as to torture, but it was common. Executions took place in the Campo, until, annoyed by the cries of the mutilated and by the sight of bodies hanging from a gibbet or burned at the stake, the dwellers in the nearby houses got the place of punishment removed to the Poggio delle Forche, outside the city, whither the victims were led through the Via dei Malcontenti, a name that has a cruel touch of irony. It is unsatisfactory to find that as time went on, prisoners were treated worse, for whereas early in the fourteenth century they had a chapel and a priest, and the prison was supplied with water, later they lost these privileges. "Justice is a holy thing," wrote Catherine, who was much troubled about them, "but not to be exercised with cruelty."

Saint Catherine of Siena and Her Times

Many palaces were built in the prosperous time before the Black Death, and there were handsome brick houses of the middle class, and wooden ones for the poor, which often caught fire; statutes strictly forbade inflammable matter being thrown into the streets, nor might hay or straw be piled in them. At the first alarm of fire, a great bell rang fast and loud, and the guild sworn to help in such case hurried to the spot, shouting "Fire," while other citizens ran to carry water and save life and property, and while a guard kept order as far as possible and looked after what was saved; but sometimes feuds interfered with help, or malcontents seized the opportunity of making a tumult. If the house belonged to a poor man, it was rebuilt at public cost; if to a member of an art, his guild subscribed to help him.

Fire was the more dreaded because water was scarce. Dante mocks at the efforts of the Sienese to find the Diana, a stream believed to flow under the city, which was supplied with water only by *bottini*, pipes carried underground from a very early time for a great distance to the nineteen fountains in the city. These had a drinking place for animals, and one for washing clothes, as well as a *guazzatorium*, baths that the public could use at stated times. The rich citizens had their own bathing place, and the water was used by various trades. Fontebranda was originally made for the refugees from Milan who brought their art to Siena when Barbarossa sacked their city and sowed the ground with salt. In 1339 the leathermakers also petitioned to use it. The request was addressed to the Operajo del Duomo, who looked after the fountains, each of which had its guardian. Private citizens had water carried to their houses by donkeymen. Though the Diana was never found, at last a plentiful supply of water was discovered, which answered almost as well.

When the "Sixteen" ruled Siena, a real improvement was made; the main streets were paved, and rain rushed down and cleansed them instead of soaking in, but there remained countless lanes and alleys winding in and out among the houses, steep and crooked and very dirty, the city pigs and the half-wild, masterless dogs who probably suggested the idea of *lupi mannari*—were-wolves—being the only scavengers. The filth was great, though slops might be pitched into the streets at only certain hours, and the archives record cases of fine when this law was disobeyed. A hint of the state of the city is found in names yet remaining, such as Via Pantenato (Marsh Street) or Via Infangato (Muddy Street).

The *terzi* were divided into *contradi*, or wards, each with its own church and banner. Catherine's is said to have been called the Oca from the large flocks of geese brought up there, but all the names were taken either from animals or natural objects. Every ward was closed at night by a gate, each with its tower. There were at one time thirty-six gates, and the city is encircled by grand old walls, built as much to prevent anyone from leaving it as to keep enemies out. Had Petrarch been a student in Siena instead of Bologna, he and his gay companions could not have come back late at night, climbing the stockade that served to enclose the town.

No such pranks are recorded of students attending the University of Siena, which was famous long before Florence founded one and which grudged nothing to attract eminent teachers. At the beginning of the Trecento, when most of the professors from Bologna left their posts in protest against one of their number having been very deservedly executed by the podestà, Siena paid six thousand florins to redeem the books they had pledged, paid all expenses of bringing them and their goods to her university, and promised an annual salary of three hundred golden florins

among them and free lodging for six months. But their claims were too exorbitant to be satisfied, and the next year they departed. All universities were subject to these violent changes, and sieges and war often dispersed both professors and students.

Chapter 3

꙳

A Thorny Path

There are Sardinian girls in the present century who lead much the same kind of life as that which Catherine Benincasa had chosen. Taking the three vows common to all monastic orders, they enter no convent but live at home in a little room set apart for them, having no communication with the outer world except when visited by their confessor. Their food is silently handed in to them, and they are supposed to spend their lives in meditation and prayer. Such an existence may end in apathy, or early death, or insanity; or again, where there is the mystic temperament, it may rise to intense devotion, and the happy visionary may be enraptured by heavenly sights and sounds, as was Catherine, after the hard struggle that for a time racked soul and body. The three years spent after that time were a period of exquisite peace and joy, during which she grew more and more in knowledge of herself and of heavenly things. But suddenly on her reluctant mind was forced the conviction that she must renounce this life of contemplation and, returning to the daily round, seek to help and teach her fellow townsmen. It was a repetition on a far larger scale of her childish perception that instead of being a hermit she must go home. She strove hard not to believe it,

praying with tears to be spared this trial. How could she teach and exhort, she pleaded, weak and liable to temptation as she was, of no rank or importance, and only a woman? "I have a mission for thee," the inward Voice answered, "and it is My will that thou shouldst appear in public. Wherever thou goest I will be with thee and never leave thee." Then Catherine submitted, saying through tears, "Thy will be done in all things. Thou art light, and I am darkness. Thou art, and I am not."

And she came among her family, and outwardly lived their life, though in her heart she ever conversed with God.

Thus to resume daily life showed great moral courage. Her apparent renunciation of what she had striven so hard to obtain three years earlier must have exposed her to much unkind and mocking comment, for there would be many to believe that she was simply weary of seclusion and self-denial, and, as she foresaw, her age and sex were a serious obstacle to good works outside her father's house. It was true that before her day there had been women who, though entering no convent, had led lives that caused them to be counted as saints. Such was Donolina Salimbeni, who "lived in the world chastely and religiously, having given herself to a heavenly Bridegroom, with special devotion to Saint Francis of Assisi, and almost all day she spent in the Church of the Minorites, and none spoke ill of her. And thirty ladies of Marseilles," where she lived, "were her disciples, some noble, some of the middle class, whose mistress and lady she was." But Donolina was a great lady and could do what a dyer's daughter could not, except at the cost of affronting public opinion, and that the Church, while allowing women who devoted themselves to the religious life to be called nuns, regarded them doubtfully is shown by the severe tone taken toward them in the *Rule of Saint Benedict*. Catherine, in fact, lived by a rule of

her own that roused not only the inevitable opposition of evil to good, but even caused much scandal. For an unmarried girl to put herself forward in any way was contrary to all custom, and the Mantellate watched her uneasily, though she only very gradually began the work that was to grow so far beyond what she or anyone could have foreseen, content at first with helping poor families near the Fullonica, both with alms and with loving words that induced them to lead a better life. And her influence became so strong that she was several times able to interpose in the violent disputes that began to break out between masters and workmen, every one of which increased the tension between the two parties and drove away trade. Her name gradually became known far beyond the ward of the Oca; her voice, lovely both in speech and song, soothed dying beds; her touch and prayers healed the sick; it was told that the daughter of Giacomo Benincasa cured when the doctor had said there was no hope, and with each sufferer restored to health, her fame grew.

That she had what to herself and all around her appeared miraculous power is beyond doubt, and even if we admit that her cures were made through natural laws, her power was nonetheless divinely given. Nor does it detract from the reverence and admiration due to her to accept a natural explanation of much that could seem only miraculous in a century that knew nothing of laws that even now are only dimly apprehended. It is, however, a safe rule that "we should never convert an event into a miracle when there is a satisfactory explanation within the fixed laws of nature."

Precisely how Catherine was able to cure we cannot tell, any more than we can tell how Father John does so in Russia now, but we all know something of the power of mind over body, and how great a tonic is hope. Catherine was in the most favorable

position possible to effect faith healing; she had herself a magnificent gift of faith, never doubting that, if it were for the good of the sufferer, her prayers would cure him, and she possessed the full confidence of her patients. Raimondo, who witnessed many cases when she healed the sick, gives a remarkable instance in that of Matteo di Cenni, head of the Spedale, the great hospital of Siena, which had been founded in the twelfth century by a noble Sienese and had its own staff of attendants, who wore brown robes and black caps. Catherine constantly visited the sick there, and the little room is still shown where she slept when detained too late to return home. In 1408 the building was made over to the university when all the charitable foundations in Siena were united together, and the Dominicans had the charge of it, but it was less well looked after than in Catherine's day, for a century and a half later we find Bernadino Ochino writing to exhort them to attend better to the sick in the hospital, where they were now "only waited on by hirelings, without self-denying love or exhortation—so that their souls were often more sick than their bodies." And a month later he writes again, in words that Catherine might have used, "Visit the poor sick, or rather, the Lord Jesus Christ Himself in the hospital, doing it as may be easiest to each, and in fixed order."

No such exhortations were needed in Catherine's time, though when Signor Matteo lay at death's door, the self-devotion of its staff was tried to the utmost. For the third time in less than thirty years the piteous wail was heard in Siena, "*Ahimè, sento il grosso*" (alas, I feel the swelling)—the sign that plague was again in the city. All the old, miserable scenes were repeated; a brother and sister of Catherine's died of it, and so did six of the eleven grandchildren whom Lapa was bringing up. Catherine laid them herself in the grave, saying amid her tears, "These I can never lose." The

Dominicans worked unflinchingly, only at first refusing to let young novices visit the plague stricken. This restriction, however, had to be withdrawn as one after another of the older men died at his post, and it is noteworthy that as an encouragement to the young workers, they were told that they should have Catherine as a companion. "Such a reward is splendid!" exclaimed one of them, Simone da Cortona. "Beside Catherine all work is rest." He was one of the few who escaped from the plague, shaking it off through his confidence in her healing powers. "The dead fell like rotten apples," says Tomasi in his *Historie di Siena*.

Catherine had just been through a most painful time of unjust suspicion and calumny; she repaid her fellow citizens by dauntless self-devotion, tending the sick, laying out the dead, encouraging, exhorting, comforting. It was at this time that she became acquainted with Raimondo, who was to be her devoted friend and confessor. He was of the ancient family of Delle Vigne and therefore had as an ancestor the faithful, ill-used Chancellor Pietro, who once "held the keys of his master's heart," until "whispering tongues did poison truth," and Frederic II drove him to suicide by his mistrust, an innocent and slandered servant, as Dante tells in the *Inferno*.[7]

Raimondo had just been sent to the Dominican convent at Siena and worked as fearlessly among the plague stricken as did Catherine herself, though he owns that at this time he was in a cold and indifferent state as to religion, from which his acquaintance with her roused him. He paid daily visits to the hospital, and on one occasion found with consternation that the director had been taken ill, and his case was already desperate. He left the bedside of Signor Matteo in deep sorrow and went to minister

[7] *Inferno*, Canto XIII, lines 58–63.

to others in the wards. Meanwhile, Catherine, who had heard the sad news, walked in bright and energetic. "Get up, Father Matteo," she exclaimed cheerfully, "this is no time to be lying idle in bed," and as the sick man heard her, something of her own vitality seemed to pass into him.

Raimondo, knowing nothing of this, met her as she was leaving the house, and stopped her. "Will you let one so dear to me, so useful to others die?" he exclaimed. Catherine was startled and displeased. "Am I like God to deliver a man from death?" she asked reprovingly. But Raimondo, "beside himself with grief," persisted. "I know that you obtain from God whatever you will," he said.

Catherine stood with bent head, smiled a little, and presently, looking him frankly in the face, she said, "Courage. He will not die this time," and went away, while he hurried back to Signor Matteo, who was no longer lying in bed at death's door, but risen on the way to recovery.

"Do you know what she has done for me?" he cried. A meal was laid for him, of which he partook with most encouraging appetite.

This event forms the subject of one of the frescoes in the Church that is now part of the Fullonica. Raimondo too experienced Catherine's power of healing. Worn out with incessant toil among the sick, he fell, worn out, on her threshold; she took his head between her hands and, refreshed by her magnetic touch, he slept for two hours. "Now, Father, go back to your work," she said gaily when he woke.

This outbreak of plague was in 1374, and Catherine had returned to everyday life and active charity in 1367. The years had been full of trial to her and to Siena. From the day when the magistracy of the Novi were expelled, there had been constant

changes of government and tumults, and the cry was never long silent of "Death to the *popolo grasso*," raised by the *popolo magro*, as the lower bourgeoisie were very significantly called. The word *popolo* included professional classes, traders and artisans, between all of whom and the *popolo minuto*, the lowest class in Siena, there was a sharp distinction, while the peasantry did not count at all. The "common man" had no political rights and hardly any civil rights. In all Dante's great portrait gallery he finds no place, and chroniclers hardly acknowledge his existence or hear a word of pity for his sufferings, though no class endured such misery as the peasants in the Hundred Years' War in France, or the raids of the Free Companies in Italy.

The Novi, who on the whole had governed with good sense and patriotism, were driven out in 1355 by a conspiracy organized by certain noble families who would no longer endure their exclusion from the government, and the excited populace murdered several magistrates, burned the public records, and sought to have their families excluded forever from taking any part in ruling the city. The conspiring nobles gained little by their ill doings, for the Dodici (Twelve) who were now appointed came entirely from what Malavolti calls the *numero medio*, or middle class, and the gentlemen elected to take counsel with them were mere figureheads. The chief alteration was that the officer called the captain of the people, hitherto an outsider, should be a Sienese, his office lasting only two months, a fruitful source of intrigue. Andrea Vanni, a friend of Catherine's, held the offices at one time, and Catherine wrote to him bidding him recollect that if ever the city was to have peace, justice must be observed. It was for lack of this that so much ill had befallen, wherefore she earnestly wished to see him a just and true ruler, a desire repeated in her letter to the podestà, Pietro del Monte:

Saint Catherine of Siena and Her Times

"Be a true judge and lord in the state to which God has called you, and give rich and poor their due, always tempered by mercy."

The year 1368 saw revolution in Siena. On a smaller scale there was an outbreak like the one organized ten years later by the Ciompi in Florence, in which Catherine nearly perished. The Sienese uprising was started by some three hundred of the wool carders, who belonged to the *popolo minuto*, and who formed an association that they called, after the caterpillar on the banner of their ward, *la compagnia del Bruco*. Led by one Domenico, a retail vendor of woolen stuffs, they paraded the city, reinforced by the *Compagnia del Popolo*, "wanting to be masters themselves," and to shake off the yoke of their guild. They seem to have been wretchedly poor, and they went from house to house, threatening and demanding food. Three of the leaders were quickly arrested, tortured, and condemned to death. It was the signal for a rising that for a fortnight kept Siena in uproar, thanks less to the artisans than to the Salimbeni, who did not indeed espouse the cause of the people but fought for their own hand to recover their old power.

The Salimbeni and the artisans alike failed to get what they aimed at, but the city suffered severely, and trade was for the time at a standstill. While Siena was thus impoverished, a severe strain on its resources was imposed on it by the Emperor Charles IV. He had been there when the Novi were deposed; he now returned with a troop of Germans, under pretext of putting down disorders. Siena had no pleasant recollection of his former visit, and though nominally Ghibelline, she never forgot that she was one of the earliest Italian cities to become a free town, and when a rumor — probably not ill founded — spread that Charles meant to seize and sell it to the Pope, the bells instantly called the citizens to arms, and desperate street fighting ensued. They

were led by their brave captain of the people, Manzano, "a man of a great soul and very valorous although a plebeian," says the aristocratic Malavolti with unconscious insolence, and the German soldiery gave way. Charles fled to the Salimbeni palace in abject fear. He wept, sobbed, excused himself, and embraced everyone, declaring that he had been betrayed by the Salimbeni, offering forgiveness unasked, and many more favors than anyone wanted. Trembling and terrified, without power and without money, his soldiers beaten, his prestige gone, he desired only to have Siena, but as soon as Manzano came to terms with him, he resumed his former haughty tone, and demanded twenty thousand florins, to be paid in four years. The first installment was paid at once, on condition that he should immediately leave the city, which he gladly did. Siena had small reason to love Charles IV. He left behind him an impoverished town, families mourning their dead, stagnant trade, and a great hatred of the nobles who had sided with him, more especially of the Salimbeni.

Catherine's tender offices were needed on all sides, so she had to put private sorrows aside, but they were heavy. Her good father died in the autumn of 1368, and the fall of the Dodici, which came soon after, caused a new sedition and an onslaught upon their supporters. Her brothers were among them, and a friend hurried to warn them that they were in danger, advising them to escape to the Church of Sant' Antonio, where others of their party had taken refuge, but Catherine hastily interposed.

"They are not to go, and sorry am I for those who are there," she said, and, putting on the cloak that marked her as a Mantellata, she led them out into the midst of their enemies. Had they gone alone, they would have risked death, but Catherine was at once recognized by the crowd, who bowed respectfully to her and made way for them to pass.

All who took refuge in Sant' Antonio were murdered or imprisoned; the Benincasa escaped with a heavy fine, but their means were so crippled and their position so uncertain, though none of them seem to have taken a prominent part in public events, that three found it advisable to emigrate to Florence, where they already had a branch trade. And with her husband went Lisa, the favorite sister-in-law of Catherine, not to return until she was a widow. A niece seems to have continued the business in Siena, but poverty now came upon the family, and the brothers in Florence neglected their old mother. Catherine's letters remind them of their duty toward her as undone, and there is a hint of family dissensions in her urgency that they should be at peace together. Although one at least, Benincasa, who is always called by his family name, and indeed seems to have been christened by it, returned to Siena from time to time to see those of his relations still there, the brothers in Florence renounced their native city, and were enrolled as Florentine citizens. And this branch remained as members of the rival republic until a century later, when they petitioned Siena to take them back.

Soon after this the name disappears, and the family apparently became extinct. Families were apt to die out, however numerous, in days when war and feuds put an end to men so readily, and when convents absorbed so many of both sexes, as in the case of the De Beaufort, whence sprang Gregory XI, with whom Catherine was to have so much to do. He belonged to a family in which an uncle had already been Pope, and another uncle, two nephews, and five cousins, cardinals. Two or three early deaths among those left might easily extinguish such a family.

Another trouble that fell on Catherine about this time was the illness of her mother, with its attendant circumstances, for

the stout-hearted old woman maintained that she should re-
cover, would see no priest or receive the last sacraments, and told
Catherine that she would do better to pray her back to health
than to exhort her to make a pious end. She did recover, and
lived to be over eighty, surviving her daughter by many years,
and becoming a Mantellata. Raimondo is greatly scandalized by
her determination to live and points out how many trials and
sorrows came upon her as a chastisement, but Lapa was still full
of life and energy, had grandchildren to bring up, and a daughter
to care for who she must have felt needed someone to look after
her as far as she would allow anyone to do so. Nor could she wish
to leave her unprotected after the cruel slanders that had been
spread concerning her. Popular though she was in the city, that
very popularity roused jealousy and ill will and even dislike. Her
austere life was a reproach to more easygoing members of the
Mantellate. Her fasts were disbelieved in; "she eats well enough
in secret," said her enemies. Her frequent communions were a
thing very unusual at that time, and roused especial disappro-
bation. Her long prayers were held as a sign of hypocrisy, and a
sneering disbelief was shown as to the ecstatic states in which she
stood or knelt insensible to earthly sights and sounds. So high
ran the feeling that once, at some time between 1370 and 1374,
she was dragged while in trance out of San Domenico, kicked,
and flung into the burning sun, unconscious of what was done
to her until she at length came to herself and found her friends
weeping over her.

Even the friars seem to have sided against her at this time,
ordering that as soon as Mass was over she should leave the
Church, and her confessor, Della Fonte, alarmed and perplexed,
advised her to modify her austerities rather than cause scandal,
but finally admitted that she was right in paying no attention to

the storm raging against her. All her life there were those who slandered and taxed her with hypocrisy; even Raimondo, who, as he says, had had to do with many visionary and silly women, was at first doubtful of her.

In the early days of her work in Siena, other very dangerous charges were brought against her. Outside Porta Romana stood a leper house that she visited, though not only was leprosy dreaded as contagious, but those afflicted by it were supposed thus stricken on account of some great sin, and so were doubly shunned. Leprosy was terribly common, and the lazar houses provided were quite insufficient to contain the sufferers. Those who found a refuge there were the least unfortunate; the rest wandered about in parties, dreaded, ill used, driven away, yet still returning. If an epidemic broke out, the lepers were accused of poisoning the fountains that all might be as miserable as themselves, and a burst of savage fury was the result.

Among the inmates of the Sienese lazar house was a certain Francesca or Cecca, a mass of loathsome sores. When all others shrank from her, Catherine would wash her wounds with fearless tenderness, while trying, as she always did, to awaken repentance and faith in her patient. Possibly the woman resented her exhortations or wearied of them; Catherine was still very young and inexperienced, and may have pressed them too much upon her. In any case, this Cecca persuaded herself that "the Benincasa attended her merely to expiate some secret and grievous sin." Her foul suspicions found vent in taunts; if her kind attendant came a few minutes late, she was greeted with, "Welcome, Queen of Fontebranda! Oh, the fine queen who stays all day long in the Friars' church! Look me in the face, my lady; have you been spending all this time with the Friars? One sees you cannot have enough of friars."

A Thorny Path

The venomous words were, of course, heard by the other inmates of the lazar house, and how venomous they were we understand only on realizing what was the popular belief as to the immorality both of the mendicants and the priests. Fra Bernadino, himself a friar, strongly warns his female listeners to beware of them. Even respectable widows should "talk neither with good nor bad ones, but stay at home, and not go too often to church. If a widow be seen talking to a friar, seven will murmur against her." Catherine knew well what was meant, but she continued to nurse Cecca until she died and went to her own place, as Raimondo significantly puts it.

Her kindness cost her dear, for her hands became for a time affected by what was called leprosy, and the verdict of her enemies was "Served her right" (*Bene le stava ogni male*). The disease was probably cutaneous; every skin infection was apt to be classed as leprosy in the Middle Ages, just as all forms of lunacy were held to be demoniacal possession, and she entirely recovered.

A yet crueler enemy was Andrea, a Mantellata whom Catherine attended she was when dying of cancer. She circulated slander against Catherine's fair fame to such purpose that she was called before a meeting of the Sisters and sharply reproached and questioned. She answered very briefly and simply and escaped being expelled, but there are indications of her having been called before a Chapter of the order at Florence to defend herself. In the Strozzi Library in that city exists a manuscript that notes that in May 1374, a certain Catherine of Jacopo of Siena, a member of the *pinzochere* of Saint Dominic, was summoned before a Chapter of the Friars Preachers, but she was not yet famous, and the tantalizing notice tells no more. Nor does Raimondo speak of it. She seems to have visited her brothers, and after this several letters are addressed to a young niece, Nanna, the daughter of

one of them, and apparently it was at this time that she made the acquaintance, afterward so important, of Soderini, who remained her firm friend.

Lapa, furious at Andrea's accusations, vehemently forbade Catherine when she came home to have anything more to do with her. "How often have I told thee not to serve that wretched old woman?" she cried. "She has foully slandered thee among all the Sisters, and God knows if thou wilt ever clear thyself." Catherine thought it over and presently came to her. "Sweet mother," she said, "do you think our Lord would be pleased with us if we left works of mercy undone because our neighbor is unthankful? When our Savior hung on the Cross and heard the ungrateful talk of the people around, did He for their cruel words abandon the work of their redemption? Good mother, you know very well that if I left the old sick woman, she would die of neglect, for no one would come and do such things as one in her condition needs, and so I should cause her death."

And she added with joyful confidence that in the end Andrea would own that she had lied, which indeed she did, with deep repentance, but calumnies do not easily die out, and the jealousy of the Mantellate, together with their readiness to believe evil, is not a pleasant picture.

A new enemy sprang up in Palmerina, a Sister who had bestowed her property on the order, and who bitterly resented her importance being lessened by Catherine's rising fame. She could not hear Catherine's name without an outburst of angry spite and constantly spoke against her. Catherine could only pray with all her heart that she might not be an occasion of sin to one of the Mantellate, and, to her deep and thankful joy, Palmerini sent for her and, weeping, asked her forgiveness, publicly confessing her jealous injustice. Mr. Jameson suggests that the nun in

Sassoferrato's picture who kisses Catherine's hand is meant as Palmerina.

Nonetheless, slander continued. "They who surrounded her measured her words and deeds not by God's rules, but their own," exclaims Raimondo. "Ah, Lord my God, how often was it said of her, 'She casts out devils through Beelzebub, prince of the devils,' in other words: these visions come not from God, but from the evil one." Even her patriotism was questioned, and at a much later time, when her character had long been established. Rarely indeed does she allow personal feeling to appear in her letters, but it is shown touchingly in one written to a friend who had warned her of the reports spread in consequence of her friendship with the Salimbeni of Rocca d'Orcia. "She is assured," she says, "that she is doing right, though for well doing she receives evil; for the honor she seeks to do her fellow citizens she receives shame; in return for life, they give her death."

Catherine must have been moved indeed when she allowed herself to write this. Usually she tried to ignore slander and keep her partisans from taking her part too vehemently. A letter to some Florentine ladies in 1376 after a visit to their city shows that again ill tongues had not spared her, and that her friends showed more zeal than discretion in defending her. "I shall scold you well, my dear daughters, for forgetting what I told you. I bade you have nothing at all to say to those who might speak against me. Now recollect, I will not have you begin it all over again."

It is bravely written, with a ring of gaiety in it. Catherine is said to have had a French ancestor, and had a blessed gift of cheerfulness that may have come down from a Gallic source, and she was very human, though a great saint. She sang over her work. She loved making nosegays and gathering flowers. She had a special affection for the mantle with which she had been

invested in San Domenico, and patched and mended it to make it last. She took the pain caused by her wrecked health gaily, but she was hardly more than a girl, and fatherless when the worst storm of calumny broke upon her, and the courage and patience she showed during a time made doubly hard by the distress it gave her mother cannot be overestimated.

By degrees the storm died down, and admiration and respect surrounded her. Legends began to be told exalting her charity and showing with what favor she was regarded in Heaven, some trivial, some poetic. One of the latter was the story of how, while she was praying in San Domenico, a poor man asked alms, and she gently answered that she would go home and fetch him some help. He answered that he could not wait, and she cast about for what she could bestow on him, and finding nothing but her little silver cross, gave it, and he went his way. That night she had a vision of Christ holding the Cross, but now it was adorned with many gems, and He said, "Daughter, knowest thou this?" "Yes, Lord," she replied, "right well, but it was not so adorned when I had it." Then He said, "Yesterday thou didst give Me this with a cheerful heart and a great love, and these stones signify them. And I promise that at the Day of Judgment I will show it before men and angels to the increase of thine everlasting joy and glory, for I will not let such deeds of charity be hidden as are done by thee."

Raimondo relates this as actual fact, but we cannot imagine Catherine telling a story so redounding to her own honor even to her confessor, and it may safely be classed among the many legends that gathered round her lovely memory.

As yet her work had lain among the poor, but an event happened destined to bring her into general prominence. A young knight named Tuldo was condemned to death for small cause.

Furious at the injustice of his sentence, he refused to prepare for death.

Catherine begged leave to see him, and her sympathy and loving words brought him to another mind. The story must be told in her own striking words, as related in a letter to Raimondo, now her confessor, but absent from Siena.

> I went to see him whom you know [some correspondence must have passed between them about the unfortunate man] through which he was greatly comforted, saw Fra Tomaso, and confessed in a very right state of mind, and he made me promise to be with him at the hour of execution, for the love of God. I promised, and did so. In the morning, before the bell of the Campanile rang, I was with him to hear Mass and communicate, which till then he had not done.[8] He was quite resigned to the will of God, only fearing that he might not be strong at the last, but the Savior in His boundless mercy so strengthened him, and so filled him with the longing for His presence that he kept saying, "Lord, be with me; Lord, do not leave me; if Thou wilt be near, all will be well with me, and I shall be content." As he prayed thus, he leaned his head against my breast.... The longing of my soul increased to shed also my blood with him for my beloved Savior, and perceiving that he still feared, I said, "Be comforted, sweet brother; we are soon going to your marriage; you will go bathed in the precious blood of the Son of God, with the dear name of Jesus on your lips.... I will await you at the place of execution." Then—think of it, dear

[8] "At this time" must be implied, or "since his first Communion."

Father! Every trace of fear seemed gone, and a great light came into his heart; he who had so rebelled now called the place of execution holy; he seemed to exult and asked, "How comes such grace to be shewn to me? And will you, joy of my soul, indeed await me at that holy spot?"

Before he came I laid my own neck on the block.... Over it I prayed, and said, "Mary!" for I wanted to obtain the grace that at this moment light and peace might enter his heart, and then I saw him coming. My soul was so filled that though there was a great crowd I saw no one.... And he came like a meek lamb, and seeing me he began to smile, and bade me sign the cross over him, and then I said, "To the bridal, gentle brother; soon you will attain eternal life." He knelt down with great meekness, and I bending low, laid his neck in place and reminded him of the blood of the Lamb. His lips spoke no word but "Jesus," and "Catherine." And therewith I received his head in my hands, and closing my eyes in God, I said, "I will" [meaning, says Tomaso, that she joined in submission to the Divine will, but the passage is obscure].

And as she knelt lost in fervent prayer that this soul might enter Paradise, it seemed to her that she saw it pause as a bride might do on the threshold of the bridegroom's house, to look back and sign her thanks to those who had accompanied her thither.

And clear as daylight I saw the Son of God receive into His bosom that sweet soul; full of love and mercy He received him who had so meekly accepted a criminal's death, not for aught he had done, but only out of love.... So dear was his blood to me that I could not bear it to be washed off my dress.... I envied him who had gone before.

A *Thorny Path*

This letter is especially valuable, not only for what it reveals of Catherine's work and character, but because it is one of the very few in which she tells of anything that concerned her personally. Nearly four hundred letters dictated or occasionally written by herself have been preserved. They are addressed to all sorts and conditions of men; to her own family; to the Queen of Naples; to Sir John Hawkwood, the leader of Free Lances, who appears in Italian chronicles as Giovanni Aguto or, with a desperate effort to get the name right, as Haukebbode; to cardinals and hermits; to Dominican friars and Mantellate. No less than twenty-four are written to a Florentine tradesman and his wife, friends probably made during her visit to Florence. Another, especially noteworthy, is addressed to the terrible Bernabò Visconti, the scourge of northern Italy, who boasted that in his own domains he was pope, emperor and king, for there not even Heaven could do contrary to his will. And there is one to his wife, so proud that she claimed to be addressed as queen, exhorting her to patience and humility, for Catherine could be frank to bluntness, though never needlessly so, since, as she says, "Truth is mute when it is well to be mute, and her silence cries with the cry of patience."

The many letters to Gregory XI treat of matters that concerned all Christendom, while others are addressed to obscure individuals, whose souls were as valuable in her sight as those of the greatest of her correspondents. Her loving interest in all with whom she came in contact appears in such letters as those to a father of a family, to a friar who had deserted his convent, or to a poor sinner of the class of women who sat by the stream of Bulicame, and how tenderly she could write to her friends is shown by such counsels as she sends to the highborn young Tuscan Neri di Landoccio dei Pagliaresi, a man of a sensitive, self-tormenting character, the antipodes of her other young follower,

the harum-scarum and delightful Stefano Maconi, but equally devoted to her interests.

There is an astonishing combination of lofty spirituality and practical sense in Catherine's letters; they are a striking example of the peculiar quality of Italian mysticism, which, like Words-worth's lark, while soaring "to the last point of vision and be-yond," still kept its nest upon the ground in mind.

German mysticism is touched with gloom; French mysticism often runs into vagueness and sentiment; Italian mysticism com-bines the Leah and Rachel of Dante's vision. It took indeed many forms and was found in characters as different as light and dark in the Trecento, and sometimes those have been called mystics who had small right to the name. Catherine lived in ineffable communion with the unseen, that true communion that consists not only in rapturous prayer and meditation, but in perception of being heard and answered. To her, to die seemed gain, because she would so come nearer to Christ. Petrarch has been counted a mystic, too, and in certain moods he also wished to die and be free from temptations and weaknesses, but nothing could be less like true mysticism than his occasional fits of nervous discomfort as to how his account stood with Heaven. He knew nothing of that inner life, that contemplation of God that the real mystic exists in, which breathes through Catherine's letters, side by side with excellent common sense that must strike even those to whom their spirituality may not appeal. For instance, writing to a friar troubled in mind by having read an unorthodox book, she shows no displeasure at his weak faith, but simply bids him, if he is incapable of meeting the arguments, to turn his thoughts elsewhere, and not afflict himself, since there had been no in-tentional sin in reading the book. Again, though herself full of enthusiasm, and knowing well how valuable a quality it is, when

she saw danger of it running riot she checked it at once, as in her letter to Donna Agnesca da Toscanelli, who appears to have been of a hysterical temperament, craving visions and revelations and exaggerated penances, a mood common enough in the Middle Ages, where she warns her almost sternly to control herself. Nor did she recommend pilgrimages, nor go on any herself. She was emphatic on home duties; we find her reminding her friend Alessia dei Saracini to plan out her day, talk with moderation, and, whatever she did or did not do, to come in of an evening and look after her old mother, "without negligence, providing what she needed."

Gossip is strongly condemned by her; she must have approved of the statute forbidding women to stand at their doors with their distaffs, the aim being to prevent chatter, though no statute ever framed can bridle tongues, whether male or female, unless indeed it were to prevent distaffs being used as weapons in a quarrel.

She is equally frank in writing to great potentates as to her own disciples, and how much courage this implied it is now hard to realize. Giovanna of Naples was quite capable of having anyone who offended her assassinated, and her support of the crusade, which was one of Catherine's dearest hopes, was all important. Yet the letters to her, though courteous, for Catherine does not forget that she is addressing royalty, have a note of warning worthy of a prophet of Israel. And some to great and formidable ecclesiastics are as severe as Dante's memorable epistle to the Conclave of Carpentras. All the letters are counsels and exhortations; they deal with souls, not accidental circumstances. Catherine tells nothing of her impressions in her voyage to Gorgona, though that her first sight of the sea impressed her deeply is evident from the many metaphors taken from it that appear in her writings after that time; nothing of what she saw in Pisa

or Florence; there is no word of what she thought of Avignon, or the Pope, who to her was "the Christ on earth." We look in vain, and are tempted to regret that it is so, for any of the personal details that her contemporary the B. Colombini freely gives in such letters of his as have been preserved. He tells of the troublesome enthusiasm of his women disciples; of his ill reception on the lands once his; of ill health, of his escape from ruin; of his want of faith in rubbing his feet with pitch to make walking barefoot less painful, and how he was deservedly pricked with thorns, while his companion, who had greater faith and used no precautions did not feel them at all.

But for a feminine grace and tact in them, Catherine's letters might have been written by a man, and Colombini's by a woman. In him we have the revivalist, with the fervid ejaculations, the emotional appeals that the personality of the man made at the time all powerful; in hers there are arguments and thoughts, infused at times by a passion the more felt because it is restrained. Her mind was full of her two beautiful dreams of a reformed Church and peace in Italy. She not only forgets personal matters, but alludes to politics only when they concern these great hopes. Possibly, however, letters on less weighty matters were not preserved or went astray, like those entrusted to the careless hands of Alexander VII by the Certosini di Pavia. It is difficult to believe that one described as constantly gay and smiling should never relax into playfulness with any correspondent, but on the other hand her time was so overfilled, and she was so constantly appealed to by high and low that she might have forestalled the humorous complaint of San Bernadino, who exclaims,

You will have me be Pope, Bishop, Rector, Officer of Mercanzia—do everything that is other people's work!

I cannot do everything, not I! I might be studying, and composing a fine discourse to the honor of God, and here are you stopping me so that I cannot study, and all because I have to listen to you!

But perhaps the chief reason for lack of personal details in Catherine's correspondence was indifference to what concerned herself, and absorption in the important matters of which she wrote. Moreover, letters were taken seriously in her day and were seldom written unless there was a real call to do so. It is true that Petrarch's are full of small details, but the admiration that surrounded him induced both him and his friends to believe that nothing that concerned him could be trivial. And his letters were, in fact, compositions intended for posterity, touched and retouched as carefully as were his poems, while Catherine did not study composition at all; she only sought to convey her meaning in the clearest, most forcible way, with the result that they count among Italian classics. She dictated, and here and there the secretary may have shaped a sentence or suggested an allusion, but the stamp of individuality is on all her letters. If ever a thought was taken from something she had heard or read, she made it her own. Another great mystic with whom she has much in common had written, "Thou hast created man for Thyself, and he cannot rest until he rests in Thee,"[9] but it was out of her own energetic conviction that Catherine declared, "Man is placed above all created beings, and therefore he cannot rest nor be satisfied save in something greater than himself. But there is nothing greater than man save God, and therefore it is that God alone can satisfy him."

[9] Saint Augustine, *Confessions*.

Saint Catherine of Siena and Her Times

It is uncertain whether occasional coincidences between passages in her letters, and others in the *Divina Commedia* imply a knowledge of the poem. Her secretary, Neri di Landoccio, was a student of Dante, and in spite of the hard words flung by the great poet at Siena, the city was proud of having sheltered him, and preserved the tradition that he had leaned for long hours on the window ledge of a shop in the Campo, absorbed in a book he had found there, all unconscious that a great tumult was going on around him. But probably such coincidences arise merely from a likeness in the line of thought of the two great mystics. To both came celestial visions; both felt, as men now have almost forgotten to feel, the sinfulness of sin; both were keenly aware of the greatness and responsibility of the gift of free will. To both, God was the sea that surrounds all things, itself motionless; the food that satisfies yet never satiates. Both were profoundly convinced that He can do as He will and can will only what is good. Each denounces simony, the vices of the clergy, and the decadence of the mendicant orders with equal passion, and to both the absence of the Popes from Rome seemed fatal to Christendom. They are alike, too, in their want of political foresight, both looking back instead of forward. Each was in certain ways singularly emancipated from the prejudices of the day, yet each was shackled by them.

But there is one remarkable difference between these lofty spirits, alike in so much. We look in vain in Dante for that intense personal love of Christ that was the mainspring of Catherine's life. There is acknowledgment of the Savior throughout the *Divina Commedia*, and of His work for man, but Dante does not feel Him walking in daylight beside him, the Lord of love, nor recognize the guiding, prompting, restraining spirit in all events of life as does Catherine, though both belong to the noble company of mystics.

A Thorny Path

It is impossible to calculate the influence exerted by Catherine's letters, but if we would measure something of the distance between the fourteenth century and our own, let us imagine how a modern statesman would feel on receiving such an epistle as she addressed to the king of France or the magistrates of Siena—the astonished amusement, the careless contempt, if even it were read through, the impossibility of its stopping a war or causing a change of policy, even though another Saint Catherine wrote it! It is very difficult to throw our minds back to a time when such things were. And though it may be possible to realize the active side of her character, no one to whom mysticism is alien will ever comprehend or believe in that contemplative side of it, which made her what she was, all earthly things being hushed for her, as with Augustine and his mother in their ever memorable conversation at Ostia, so that, like them, she would hear the divine voice speaking, though not through any tongue of flesh, nor angels, nor sound of thunder, nor in the dark riddle of a similitude, till, passing through all things bodily, even this very Heaven whence sun and moon shine upon the earth, soaring as it were beyond her own mind, she touched divine wisdom, and returned to earth with a sigh.

Chapter 4

ᴊᕀ

Catherine as Peacemaker

No address or discourse made by Catherine has been preserved, but that at times she spoke in public is certain. Raimondo mentions having seen her surrounded by a crowd of over a thousand people, citizens of Siena and others, come in from the surrounding country, sometimes from distant places, listening entranced by the sweet full voice that, in common with most speakers who have moved great audiences, she possessed. So eloquent and persuasive, too, were her looks and gestures that even those on the skirts of the crowd who heard only imperfectly were often excited to confession and repentance by the mere sight of them.

We also hear of her running out of the Fullonica, holding up a crucifix in times of popular uprising, and calming the angry mob by her expostulations, and Stefano Maconi relates that when she visited Florence at the time that it lay under the interdict that roused such furious resentment that the city all but forestalled the schism of Urban VI's time, on the very day she arrived, she wrote three "noteworthy and most beautiful discourses, and all the city was moved, and admired her wholesome counsel. And those who had despised the interdict began to observe it."

But if she had habitually preached to the Sienese, surely some
of her followers would have recorded something of what she
said, especially as sermons had then a weight and importance
lessened only when printing made books generally accessible.
The sermon of a popular preacher was an event that stirred a
whole city. San Bernadino preached in the Campo four hours at
a time to an unwearied audience, who stood around to hear him.
Fra Filippo's *Assempri* were listened to with equal eagerness, and
no one seems to have been startled by them, though the crude-
ness of speech and topics is such, even for that age, that when
he rebukes mothers for letting their daughters lie in bed instead
of bringing them at dawn to hear him, we incline to think that
it was the best thing they could do.

We can hardly imagine Catherine denouncing the vices of
her fellow townsmen as mendicant friars might and did. Plain-
spoken as her letters are, there is a dignified modesty and wom-
anly restraint in them that forbids such a suggestion, though she
did not shrink from the frankest remonstrance when occasion
called for it, nor did she speak in vain, and she became more and
more of a peacemaker in public and private matters, following
the good example of the order to which she belonged, and which
was honorably renowned throughout the Trecento as using every
effort to reconcile families at feud and check the civic tumults
that perpetually broke out in every city. So widely did her name
become known that Gregory XI sent her permission, unasked,
to go through the Sienese territory attended by three friars, who
had special privileges of absolution, to speak to the people who
flocked to hear her and beseeched her to cure their diseases.

To one of these friars special interest attaches, for he had
begun by altogether disbelieving in Catherine and was a man of
great weight and importance, being prior of Lecceto, the very

ancient Augustinian monastery at some little distance from Siena, built among the ilex woods, whence it took its name. By birth he belonged to the noble Sienese family of Tantucci. "This ignorant woman goes about misleading people with her false expositions of Holy Scripture," he said to his friend Fra Gabriello of Volterra, also a man famed for learning, and one of the best preachers of his day. "She is leading other souls with her own to Hell, but we shall take such order in the matter that she shall see her error."

"So," says Francesco Malavolti, "after many such talks, they determined to go together on a certain day and by hard questions in theology close her mouth and shame her. But the Holy Spirit, who spoke by that virgin, disposed things otherwise." And he tells how the two—Tantucci, commonly called Giovanni III, because he was the third of that name who had been prior of Lecceto, and Fra Gabriello, who held no less an office than that of minister provincial of the Minorites, went to the Fullonica, where, as it chanced, were a number of Catherine's close friends, Della Fonte, Landoccio, Alessia and Lisa Benincasa among them, together with Malavolti himself, standing round her and listening to what she said. Suddenly her face lit up, and she exclaimed, "Blessed be Thou, O sweet and eternal Bridegroom, who findest out so many new ways to lead souls unto Thyself!" The startled company stood wondering, and Della Fonte bade her explain what she meant. "Father," she answered, "you will presently see two great fish caught in the nets," and almost at the same moment the two theologians were announced. She went to meet them with great respect, begging them to be seated, while all the rest stood anxiously waiting to see what would happen, well aware that this visit implied something serious. Without delay "the two masters, like raging lions," began to ask the most

Saint Catherine of Siena and Her Times

difficult theological questions in the most difficult way they could devise. Catherine paused to collect herself before replying, looking up to Heaven; then she spoke, and they sat amazed at her pertinent answers.

Finally she turned on them, with justifiable indignation, thinking perhaps how her Master had been questioned by those who came not to learn but to seek to ensnare Him, and told the two that they were utterly indifferent as to what truth might be and sought only to win praise and honor from men. "My Fathers, do this no more for the love of Jesus crucified," she concluded, and they sat conscience stricken.

Nay, more, Gabriello of Volterra, who was living in luxury, absolutely contrary to his Rule, snatched the keys from his girdle, exclaiming, "Is there any here who for the love of God will go and give away all I have in my cell?" and two present accepted the commission, going straightway to Lecceto and distributing his books to the students there, while his bed with its silken curtains and other things were given to the poor. All that he kept was his breviary.

Prior Giovanni showed his change of mind even more unmistakably, for he became Catherine's firm friend, accepting, as we have seen, the office of constantly attending her in her missionary labors, following her to Avignon, and going with her to Rome when Urban VI called her thither, and he was moved to wrath that he could hardly restrain when certain prelates who believed in her as little as he had once done himself tried to entangle her just as he and his companion had done. It is impossible to read the account of the scene without a smile.

Another very special privilege was granted her while at Avignon—namely, to have a chapel in her house where she and any others who desired it might hear Mass and communicate, a very

unusual permission, probably granted that she might avoid the notice and comment excited by the rapt, ecstatic condition in which she would fall at such times. As the altar at which Mass was celebrated was portable, she could have it with her if she left Siena.

The room in the Fullonica where it stood is still shown, but it and the whole house is so changed from its old state that it is very difficult to imagine it inhabited by Saint Catherine and the busy family of Giacomo Benincasa.

It may be asked how a woman with no education in child-hood, and who learned to read only after she had grown up, at a time when books were rare and costly, could have acquired knowledge enough to encounter men like the prior of Lecceto on his own ground. Some explanation is found in her remark-able memory and a mind extraordinarily susceptible to spiritual things, and free from any distracting interests until the sphere of politics claimed her against her will. And she had learned friends who talked to and read to her. What she read to herself we do not know; it is doubtful if she owned a Bible; if she read the Scriptures to herself, it was probably in one of those selections of passages from them that were familiar to the Middle Ages; the ex-Dominican Ochino of her own contrada speaks of using one even at his later date, but that she was more or less acquainted with them, and with the writings of the Fathers is clear. But her thoughts are not borrowed ones; she drew from her own experi-ences and revelations — revelations that gradually seemed to her to be given by her Lord in person. At first she says herself that she knew her visions were framed by her own mind, but her intense realization of them gradually embodied them in visible shapes. She so dwelt on the goodness and tenderness of her Master, and desired so passionately to have communion with Him that soon

it seemed perfectly natural He should come to her, and speak face-to-face. Such experiences are found among other mystics; they exactly correspond with those of an earlier follower of Saint Dominic — also a striking personality — Henry Suso.

Neither Raimondo da Capua nor Caffarini, who helped him to compile his biography of Catherine, and wrote this *legenda minore* himself, explain the rapid rise of her influence. We see her ill-treated, disbelieved in, slandered to the point of nearly being expelled from among the Mantellate, then, almost without apparent transition, one of the most powerful influences in Siena, with an enthusiastic following, called in to mediate in trade disputes, family quarrels, and even in the bloody feuds that were destroying Siena. Her missionary work is so well known that from Avignon come special privileges to forward it. One of her best biographers, it is true, places this honor after her return from that city, but as far as we know, she made no journeys in Sienese territory except in early days. No doubt her healing powers had been talked of throughout Siena, as would be the story of Tuldo, but she seems to have become almost at once famous far beyond her native city. Her letters show how many women, and of what various ranks, looked to her for counsel and guidance, but far more striking is it to see how in a day when women were of so little account, eminent men held it an honor to call Catherine their mother and mistress. She had a link with the Gesuati, an order founded by Giovanni Colombini, and so called because the name of Jesus was ever on their lips; her sister-in-law Lisa was of this family, and so was B. Catarina, one of her dearest friends, of whom it was told that as she lay dying she exclaimed, "O blessed Catherine! O Giovanni, father of my soul, my sweetest patrons, I come to you," and with a great joy on her countenance, she passed away.

Catherine as Peacemaker

That Catherine should have had many friends among the Gesuati is, then, natural, but besides these we see her looked up to by monks and hermits all over Italy. Besides the hermits of Lecceto, there was the good abbot of Saint Antimo, whom we find her defending from injustice at the hands of the magistracy of Siena; the monks of Oliveto; the rough-spoken hermit Don Giovanni delle Celle, who lived above the monastery of Vallombrosa; the Englishman William Flete, who would do anything for her except leave his ilex woods; the Spanish director of Saint Brigitta, the prior of the rocky islet of Gorgona, who asked her to address his Carthusians; and many more.

Even more remarkable is it to find learned laymen seek her as adviser and guide, men such as the rector of the Hospital of La Scala, Vanni; Captain of the People Guidini, who held an important post in the magistracy; together with outsiders from Lucca and Pisa, Milan and other places at so early a time in her career. They, no doubt, were the more struck by her because in the Middle Ages women in religious orders were rarely intellectual. Indeed, study at that time formed no part of the life of either the Dominicans or the Franciscans, though naturally they had more knowledge in how to deal with their fellowmen, were more in touch with new ideas and were less conservative than the monks. When Catherine sends two novices to the prior of San Benedetto, we find her asking as a favor that they may be allowed to study, assuring the prior that he will find this concession repaying. There were no medieval nuns in Italy like the Benedictine Saint Hildegard, who in her time was almost as highly esteemed as Catherine; no Dominicans like Mechtilde of Magdeburg, whose strictures on the clergy brought her into such trouble and whose writings, collected under the title of *The Flowing Light of Divinity*, ranked high in medieval religious literature.

But it was not through a reputation for learning that Catherine gained her ascendancy. It was not by what she wrote, nor even mainly by what she said that she impressed those around her. Her astonishing spiritual vitality made itself felt on all who came in contact with her, sometimes indeed rousing opposition, but oftener calling out a sympathetic response, and the excellence of her advice was soon recognized. The women of Siena quickly learned to turn to her when members of their families were difficult to deal with.

Among those who early sought her help was the young widow of noble birth, Alessia dei Saracini, who lived with an old father-in-law, and who became Catherine's chosen friend. Hoping that Catherine's influence might soften the old man and induce him to live at peace, Alessia invited her to stay some weeks with them, and Catherine consented. That he liked her may be assumed, since he let her live under his roof, and no doubt she met his rough mockery gaily and tactfully, for after a while he rejoiced both her and his daughter-in-law by listening attentively to what she said and finally declaring himself disposed to confess and attend Mass, but with the reservation that he must be allowed to kill a certain prior whom he hated with all his heart. Catherine could by no means consent to this, and in the end her remonstrances prevailed, and he went in a peaceable spirit to the church where his enemy officiated, with his hawk on his fist. Seeing him enter, the prior fled, and even when assured that he was alone and unarmed would see him only in the presence of a number of friends, and watched his approach suspiciously as he advanced, courteously bending his head, and declaring that he had come to make friends, in token of which he offered him his favorite hawk. This was a real sacrifice, the more that he was a poor man, and the prior, also devoted to falconry, accepted the

bird joyfully. Returning to Catherine the old noble asked what he should do next, and she bade him confess to a certain friar, which he did. In consideration of his repentance and great age, no penance was set him, but this did not quite please Catherine, who bade him rise early for a certain number of days, and go to the Duomo, where he must repeat a hundred *Aves* and *Paternosters*, counting them on a knotted cord, which he obediently did.

Perhaps a more difficult case was laid before her by Donna Onora of the great Guelf house of Tolomei, a good and religious woman who had small comfort in her son Giacomo or her daughters, girls who belonged to the fashionable class, whom San Bernadino denounced as going to church "bedizened, bedecked, begarlanded like a madonna Smeraldina," though one hopes they did not deserve his concluding words, "while at home they were slovens." Troubled by their worldly life, their mother asked Catherine to use her influence with them — the *popolana* and the daughters of one of the proudest families in Siena! What passed is not recorded, but so strongly were they moved by what she said that, shortly after, they became Mantellate. Giacomo was at this time absent from Siena; on learning what had happened he was as furious as was Corso Donati on hearing that his sister Piccarda had taken the veil,[10] and he hurried back to take vengeance on all concerned, especially Catherine. His mother in great alarm sent to warn her, but she calmly replied that she should pray for him and begged two of her friends to reason with him. At first, blind and deaf with rage he would hear nothing that they could say, but to their astonishment his anger suddenly cooled, and finally he agreed to let his sisters follow the way that they had

[10] *Paradiso*, Canto III, lines 103–108.

chosen. Late in life he became a tertiary, and another brother became a Friar Preacher.

We find Catherine also called in by the Salimbeni, as a friend and honored guest, not to the satisfaction of the magistracy, for though the head of that powerful family had given proof of his loyalty to Siena, all the members were not so trustworthy, nor was it forgotten that the emperor Charles IV took refuge in their palace at the time of his abortive attempts on the liberties of Siena. The chief of the *consorteria*, or clan, Giovanni Agnolo, though head of the Ghibelline party in the city, had caused himself to be enrolled among plebeian families so that he might take some part in the government from which, as a "grande," he was excluded, and he was regarded as a great and illustrious man who had served his country, i.e., city, well. Unfortunately for Siena and his family, he was killed sometime later by a fall from his horse as he returned from an embassy to Lombardy, and the want of his sense and strong hand was soon felt. Quarrels arose between different branches of the family, an especially trouble-some member of which was Cione di Landro, whose jealousy had been excited against the chief of his house by the Republic hav-ing given him several important castles in token of confidence and gratitude for his services.

Cione was a born plotter, and one of the least estimable of a family in which were found great virtues and great vices. At the time when Catherine was called in, he had endangered himself by claiming certain lands that his family were resolved to keep, and his wife, Stricca, implored Catherine to come to their castle at Castglioncello di Trinoro and mediate between Cione and the present head of the clan, Agnolino, knowing that she had great influence with him. Catherine came, heard all that there was to say for Cione, and then mounted her donkey, and, attended

by some of her "college," as she would call those friends and followers who went with her on her journeys, took the steep way to Rocca d'Orcia, then called Rocca di Fontennano, where the great stronghold of the Salimbeni stood on a rock overlooking the valley of the Orcia, with the river of the same name flowing down to join the Ombrone.

She was warmly welcomed by the widowed Contessa Bianca, "a lady of great virtues and gifts, devoted to Saint Catherine," now mourning not only her noble husband, but a murdered brother, lord of Foligno, whence his family had been driven out. Here too was her son, head of all the Salimbeni, the fiery Agnolino, whose sword was never long in the sheath, and his two young sisters, Benedetta and Isa, both widows and both with sad histories, as indeed most women had in those days.

Catherine was welcome to all, and her pleading brought peace between Agnolino and his troublesome kinsman, but her influence was less welcome when it took the form of encouraging Benedetta to take the veil instead of making a new marriage. Isa was already a tertiary of Saint Francis, but her admiration for Catherine led her to propose changing to being one of Saint Dominic's instead. Catherine threw cold water on this suggestion. "Better stay under one rule than change about," she said. Nevertheless we find Isa later as a Mantellata. That she, like her sister, had difficulty in gaining permission to renounce the world may be gathered from a letter of Catherine's that seems to be addressed to her, though Isa or Lisa was too common a name to prove that it was sent to the daughter of the Salimbeni. The burden of it is: "They say. What say they? Let them say." There was a third sister, Pentasilea, happily married to one of the Farnese family. To her Catherine writes in a different strain. Her she bids not to make idols of her children, but to reprove and chasten

when needful, taking them regularly to Mass and confession, and caring both for their souls and bodies. As Catherine grew older and her experience widened, she laid comparatively little stress on those austerities that in the first enthusiasm of youth she had thought so valuable. She continued them for herself but often warned others not to exaggerate them, nor think they were worth anything in themselves, but only as means to an end.

Such practices indeed are no necessary part of the mystic life, though suffering always is, together with the will to suffer. There was a time when morbid fear of all that had given her pleasure turned the most innocent things into temptations, when she shrank from even the caresses of her mother, and her one thought was the desire to be chastised for her sins, a state perilously near insanity, but her call to active life saved her, together with her robust common sense, and while seeking purity as fervently as ever, she recovered mental balance, and saw good where good was, and that there was no one measure for persons.

And now she bids Pentasilea bring up her children health-ily, and look after their physical needs. "Even the beasts do that much," she writes, but above all things she must keep God be-fore her eyes, and do her duty in the holy estate of matrimony. Catherine never cried down marriage, but upheld it as sacred, though less blessed than celibacy, a nun's life being more desir-able for the soul. Certainly the convent was often a harbor of safety for both soul and body, lax as the discipline was in many. Ochino, who had left the Roman Communion and wrote in an even laxer day, could declare when old, exiled, and treated as a heretic, "To this day I do not regret having spent part of my life in a monastery, for there I was preserved from sins into which as a layman I should probably have fallen," and he goes on to say

that "grant there are errors in the scholastic teaching, and that pupils waste much time on things which do not lead to salvation, yet many seeds of truth are planted which may open their minds to a right understanding of Holy Scripture."

While at Rocca d'Orcia Catherine cured many sick, and the great courtyard was crowded with those who came to seek her aid. Among these was a case of lunacy, or possession, as all such were then held to be. It is remarkable that the only occasions mentioned on which she shrank from exerting her healing powers was in cases of madness, whether because she thought that she came in contact with fiends or that some instinct of danger lurking in her own highly wrought and imaginative temperament made her recoil it is impossible to say, but she showed both horror and anger when forced to deal with lunacy or hysteria, though three cases are recorded which she treated successfully. To satisfy the modern mind, these should have been studied and followed up, but that was not the method of the Trecento, and there is little evidence as to whether these and other cures were permanent.

She passed from the Rocca d'Orcia to the abbey of Saint Antimo, where the abbot was her close friend, and a valuable helper when she came to found her convent of Belcaro, but he was a reformer of morals, and consequently unpopular among his monks and fellow priests, and Catherine wrote with some indignation to the magistracy of Siena:

> I hear from the Archpriest of Montepulciano and others that you have passed an unjust judgment on the Abbot of Saint Antimo, a great servant of God. He has been here a long while, and if you knew him better you would not suspect him. I beg you therefore not to trouble him, but

rather, if need be, to help him. You complain that priests and clerics are not corrected, and then when you get someone ready to do it, you complain and hinder him.

The archpriest was an enemy of the abbot and probably had told of the unfavorable judgment with satisfaction. Catherine knew him well, for she often went to Montepulciano, a place not far from Lake Thrasymene, where in afterdays two famous men were born, Poliziano and Cardinal Bellarmine.

Two nieces of Catherine were in the convent there, one of whom seems to have needed a good deal of advice.

Her letter goes on to touch another knotty point. The magistracy of Siena never liked her to be away from the city, where she was all important, least of all when she was among those whom they suspected; they had sought to recall her from among the Salimbeni, and instead of returning, she was spending six weeks at Montepulciano. Her mother, too, alarmed by the discontent in the city, and always dissatisfied when left behind by Catherine, wrote to desire her to come back. Catherine was distressed but answered that she could not come. "I beg, though I may stay longer than you like, yet you will be content, for I can do no otherwise. I think, if you knew all, you yourself would send me here. I am going to end a great scandal if I can."

But she gives no explanation beyond this, and we can only guess that there was something beyond the quarrel among the Salimbeni, as this was public news. Perhaps it had to do with the business concerning the nuns of Saint Agnes, in whose community her nieces were, to which she alludes in writing to the magistrates. To them she takes an almost imperious tone, which shows how strong her position was, for under the rule of the Reformatori, short work was usually made with any who disobeyed

their orders. But Catherine was beyond their power. "As to my return with my college," she writes,

> I hear there are murmurs and suspicions on that head too, but do not know whether I ought to believe it. If you care as much about your affairs as we do, you and all the citizens of Siena should shut your ears to such things. We labor ceaselessly for your benefit, sparing ourselves no fatigue. I have so little virtue that I do nothing perfectly, but others, better than I, are doing their utmost. . . . I see that the devil is very wrath at the loss of souls which he will suffer by this journey. I have come here only to feed souls and take them out of his hands, and would sacrifice a thousand lives if I had them. I shall therefore go and act in whatever way the Holy Spirit may inspire me. Be not weary of my letters, but read them with patience.

This is a very high tone for the dyer's daughter to take with the worshipful Signoria. The usual want of dates makes it impossible to fix the date of these visits, but they probably took place before Catherine's first visit to Pisa in 1375. As a general rule, she put accusations and calumny aside as not worth noticing, but suspicion of her patriotism hurts her keenly, and there is an unusual note of irony in other words written to the magistrates: "I am sorry that my fellow citizens take such trouble to judge me; it really seems as if they had nothing to do but to speak ill of me and my companions," and then, with her usual humility she says, "In my case they are right, for I am full of faults, but wrong in the way they judge the others. However, we shall overcome all things with patience."

She tells one of her followers in Siena who wrote begging her to come back that she will do so as soon as she can and reminds

him that it must have been hard for the Apostles to cease living together and with Mary, and go different ways, "yet did they renounce that happiness to seek the honor of God and the salvation of souls, and when Mary left them, did not suppose she loved them less or forgot them." The lamentations of her disciples in Siena and elsewhere when they were deprived of her charming presence added not a little to her difficulties.

A reconciliation even more important than that among the Salimbeni was effected by Catherine in Siena itself, and though it took place at a comparatively late date in her public career, it finds its appropriate place here. In the very heart of the plague in 1374 one of those feuds so ruinous to Siena and all concerned had broken out between the Maconi on one side and the formidable Tolomei, backed by the Rinaldini, on the other. Friends of both the hostile parties vainly tried to reconcile them; the feud raged on. At length, a hope of peace appeared, and, as usual in such cases, the hand that held out the olive branch was that of a woman, and it belonged to the mother of Stefano Maconi, a gay and very popular young noble, the lifelong friend of Caffarini, who had been dragged unwillingly into the feud but felt it a point of honor to keep it up.

Despairing of other help, his mother suggested calling in Catherine Benincasa; up to this time Catherine had had no acquaintance with the Maconi, but her success in making peace was known, and her intimacy with the Tolomei gave reason to hope that they would listen to her, and where they went the Rinaldini would follow. The proud young noble did not approve of the suggestion. "A woman of no rank or authority, who had got a reputation for sanctity by sitting in churches and telling her beads!" He was persuaded to visit her, however, and the effect of her gracious charm was immediate. He felt that "the finger of God

was there." She appointed a day for a solemn reconciliation of the hostile families in the Church of San Cristofero, which stands in the little square close to the grim Tolomei palace, with the wolf of Siena looking down from its column. But though the Maconi duly appeared, neither the Tolomei nor the Rinaldini were there. This was a new insult, and it speaks unmistakably for the honest desire of the Maconi to make peace that they did not depart at once. "They will not listen to me," Catherine said on finding what had happened. "Well, then, they shall listen to God," and she knelt before the altar in fervent prayer, her upraised face illumined by a heavenly light. Moved by an impulse that they could not understand, the members of the other families who had been deputed to treat with the Maconi came from their palazzi and entered the church, sullen and ready rather to offer insults than to give and accept pardon. And as they came in, their eyes fell on Catherine, praying for the city dear to them all and for goodwill and brotherly love among the citizens, so lost in supplication that she was unaware of their entrance and that the Maconi were gazing at her. Moved and touched, these others too looked, and were ashamed of their thoughts of vengeance, and held out friendly hands to their late enemies, and for a time Siena had peace.

Many other private enmities were stayed by Catherine, but this was the greatest, and one unexpected result there was not altogether welcome to Stephano's parents — there was a father alive, but the mother seems to have been the leading spirit — the brilliant young nobleman devoted himself to Catherine, acting as one of her secretaries, helping her in every way he could, careless of all else so that he could be near her and help in her good works, and quite indifferent to the mockery of his friends who laughed at him as "be-Catherined," and sought to draw him back to his old careless life in their company. It was well for him that

he resisted. The singular power, call it thought reading or what one will, that Catherine undoubtedly possessed, enabled her to discover that he had been led through sheer thoughtlessness to join in a conspiracy against the government by contemporaries of his no older or wiser than he. "O Stefano, my son, what evil are you plotting in your heart? Is it thus you make God's house into a workshop for treason?" she asked. The conspirators were accustomed to meet in a vault under one of the churches; the plot was discovered, the vault closed up, and Stefano's family had reason to thank Catherine for having detached him from them. After this time, he appears at almost every step of her career, gay, loving, and a madcap, who delighted and shocked the "college" by turns.

Chapter 5

⚜

Catherine as a Politician

The life of Catherine Benincasa was interwoven of three distinct threads: contemplation, active charity, and self-immolation. The first and last are constant in the histories of mystics of all creeds, the latter often in an extraordinary degree, as in devotees of some of the sects of India, in the medieval saints of whom Peter of Alcantara may be taken as a type, or the German mystic Suso, in Catherine's own century, or the much later founder of the Sacré Coeur, devoured, as she would declare, by an unassuageable fever for suffering. The present century revolts from pain, and the tortures that minds like these inflict on themselves appear absurd and grotesque. To those who were or are possessed with the longing for them, pain appears in quite another light, and their self-immolation, though it may break physical laws that are now recognized as much God's laws as are moral ones, and is apt to lead to perilously morbid conditions of mind, has a claim to veneration and a right to be understood. Should they not, they argue, seek to enter into something of what their Lord bore for them? Is it not possible to come nearer to Him there? Might it not be that voluntary suffering expiates sin in themselves and others? Can it not help to free the soul from the shackles of the

flesh? Again, in the Middle Ages when men's passions were so strong and so unbridled that the body might well be regarded as a wild beast that must be subdued by force lest it should kill the soul, mortification had its necessary place. Dante, who soared above his contemporaries like an eagle, meditated on the mystery of the Incarnation and thus could speak of "the honorable body," but to almost everyone else in the Middle Ages, it was either a master or slave.

Had Catherine never left her cell, it is impossible to say into what state of mind she would have slipped, but her obedience to the call to an active life kept the balance even, and shielded her from two great dangers to which the visionary is exposed: such sensuousness as shocks us in the rhapsodies of the nun Gertrude[11] and others of that school, both medieval and modern or, on the other hand, the equally painful prudery of saints who thought that the very presence of a woman, even were she their mother, threatened their purity.

There was a noble large-mindedness in Catherine. Thrown into a world of flagrant vice and crime, she faced it as fearlessly and as unharmed as did Beatrice within the gates of the Inferno, and moved in it pure as a lily. She could realize that there are many ways of coming to God, and good in all men, a conviction that gave her a wonderful power over sinners. She knew too that no one system has a monopoly of perfection. Devoted as she was to the Dominicans, she by no means thought their rule desirable for all who chose monastic life, and often recommended another order to those who sought her advice.

Again, almost alone in that day she held the word "country" to mean Italy, not merely her own city, and when appealed to by

[11] *Révélations de Ste. Gertrude*, Paris, 1898.

Florence or Pisa she was just as ready to help them as if they had been friends instead of enemies to Siena. This was a view that exposed her to suspicion, and during the first years of that public life that was so short and contained so much, she was obliged more or less to take account of this feeling. The Mantellate of Pisa repeatedly urged her to visit them, but at the time there was great tension between their city and Siena, and she found an only-too-valid excuse for refusal in her ill health. Her splendid constitution had given way under the fatigue and anxiety that she endured while the plague lasted.

Her austere life tried her, and she had so accustomed herself to live almost without food that now, when finding that her abstinence provoked comment and suspicion that she ate in secret, she would fain have eaten like other people, but she could not do it. There was a moment when she seemed dying, and the thought was joy to her, but there was much work to do, and she set her will to recover and did so to a considerable degree, though thenceforward she lived and labored in constant pain, which she could not always hide. Though accepting it gladly, she was learning that health and strength are gifts from Heaven, not to be cast away, and she who in girlhood had forced herself to drive sleep from her now wrote to Alessia dei Saracini, "The night is for vigil, after thou hast paid the debt of sleep to thy body." To the end of her life Catherine was growing in wisdom and spiritual experience.

Hesitation as to going to Pisa was cut short by a command from Pope Gregory XI to go there and undertake certain negotiations with the magistrates, and no difficulties were raised by the authorities in Siena, who could hope that at the same time she might dispose the Pisans to restore a castle in Sienese territory unjustly occupied by them, together with the important port of

Saint Catherine of Siena and Her Times

Talamone. This journey was a far weightier matter than anyone guessed at the time, for with it Catherine stepped from private to public life and became a leading factor in the sphere of politics. How early in her career she had had any direct communication with Gregory is uncertain, but that much earlier than would be supposed from Raimondo's life of her she must have been recognized as important may be gathered from the remarkable fact that as soon as 1372 Gregory asks advice from her through his legate and apostolic nuncio in Tuscany, a kinsman of his whom he had made governor of Perugia. His letter has unfortunately disappeared, but as she says, "In reply to the three questions which you ask on behalf of our sweet Christ on earth," it is clear that the legate wrote to her at the Pope's desire. These questions were apparently as to what measures were most necessary for the new Pope to make, amazing as it is to find the head of Christendom asking such advice not from his cardinals or his bishops, but from a woman, and a woman of the people. Her reply is that he must look to two great evils that are corrupting the Church: firstly, excessive nepotism, but this, she hopes, is beginning to disappear, thanks to the prayers offered up that it may cease; secondly, slackness in checking the vices and luxury in the Church. "In urging you to work for Holy Church," she writes,

> I was not thinking of temporal matters; care for them is all very well, but what you ought chiefly to labor at, together with the Holy Father, is to do everything possible to drive out of the sheepfold those wolves, those demons incarnate, who think only of good cheer, splendid feasts and superb equipages.... I conjure you, even if it cost your life, urge the Holy Father to stop these iniquities, and when the time comes for choosing pastors and cardinals,

let not money and flattery and simony have anything to
do with their election, but beg him as far as may be to
look only to the good qualities of those proposed, heeding
not whether they be nobles or peasants.

The overtenderness of Gregory toward his relations was al-
ready patent, and Catherine's outspoken allusion to it must have
startled the legate, who had just benefited by it. Whether the
Pope was allowed to hear the whole of her letter we do not know,
but until the last months of his life, her honesty never offended
him. In the same year she wrote to Cardinal Pierre d'Estaing
on his appointment as legate of Bologna, not Ostia, as by some
strange error he is called in the heading of the letters addressed to
him, added, of course, later, by some unknown hand. There is an
authority in her tone that confirms the view that she was already
accustomed to be heard with respect. "Be strong in Christ, not
negligent," the dyer's daughter writes to the cardinal legate, "and
thereby I shall see that you are a true legate, if you long to see
the banner of holy cross at last displayed on high."

Catherine went to Pisa accompanied by her mother and a
number of her college. She was received with almost royal honors
by the archbishop and the head of the republic, Pietro Gamba-
corta, a man of whom historians give very opposite estimates.
But Catherine must have met him with the recollection of how,
some years before, when he and his family returned from poverty
and exile brought on them by their patriotism, even while he
knelt before the altar in the Duomo, vowing to live as a good
citizen and forget all injuries, some of his party excited the mob
to set fire to the houses of his enemies, and how he had rushed
among them, and stayed the tumult and destruction, calling to
the crowd, "I have pardoned with all my heart — I, whose father

and friends died unjustly on the scaffold. By what right then do *you* refuse to forgive?"

He had earnestly desired Catherine's arrival, hoping that she would quiet the factions in the city, and requested her to live in his palace, but she was too prudent to identify herself with any one party, and declined. Nor did she accept the eagerly offered hospitality of the nuns who had so often pressed her to come to them, since a convent would not have been convenient when she had secular visitors, and the *palazzo* of the Buonconti, some of whom she already knew, and who had a cousin held in high honor among the Dominicans, was the place where she and her companions took up their abode. Here lived an old mother with her four sons, who proved strong and faithful friends. Their *palazzo*, near the little old Church of Saint Cristina, is still pointed out as the residence of Catherine when in Pisa, but it has passed out of Buonconti hands and has been altered out of all likeness to its old self. Here Catherine lived during the six months she spent at Pisa, and it is pleasant to know that often of an evening her friends came there and enjoyed quiet talk and sang and played sacred music as a relaxation from anxious and heavy duties.

Gregory had sent her to Pisa to use all her influence to keep the town loyal to him, for disputes between Florence and the papacy had already begun, and much uneasiness was felt in Avignon. On her way, she had paused to strengthen the wavering allegiance of Lucca and had succeeded. To her, the right course of action seemed clear, but she experienced at once that difficulty in making Gregory take a decisive step, which was so often to vex her heart. In what was the very first letter, as far as is known, that she ever sent him directly, she found herself obliged to stir him on:

I beg you to send the Lucchesi and Pisans whatever brotherly words God may inspire you with. Help them all you can, and encourage them to stand firm and faithful. I am here, doing all I can with the offenders who are Leagued against you, but they are in great perplexity, receiving no encouragement from you, while threatened by your enemies. However, so far they have promised nothing. I earnestly implore you to write without delay and kindly to Signor Gambacosta.

Delay was indeed most unwise, for both Pisa and Lucca stood in fear of Florence and were tempted to side with the city that was close by, while Avignon and the Pope were far off. Had Catherine's advice been followed, had Gregory listened to her instead of to his cardinals, the impending war and the miseries of the interdict might have been averted, at all events for a time, but Gregory XI might well have said with the despair of one who saw what his duty is without the strength to do it, "The time is out of joint, O cursed spite that ever I was born to set it right." Very young for his position — barely indeed forty years of age — feeble and of "petite complexion," as Froissart has it, pious and devout and learned, with a sincere wish to do right, he was nevertheless one in whose time Italy suffered as she had rarely yet done, both from that misrule by foreign Legates that drove Tuscany into rebellion and drew some of the hardest words from Catherine that she ever uttered, and from the atrocities of mercenaries hired by order of the Pope himself to coerce his Italians. A fruitful source of weakness was also that over-affection for his family that so early called forth her warnings. In earlier life he had been archdeacon of Canterbury, and a close friend of William of Wykeham, and English prelates were always welcome at Avignon, but naturally

French influence was paramount there, and this fact worked disastrously for Italy. One cardinal had asserted publicly that it was unadvisable for the world that that country should be at peace, words that Petrarch in hot indignation reported to Rienzi, then in the height of his brief triumph in Rome, bidding him tell the Roman people "in what kind of way these magnates thought of Rome and Italy." Many Italian princes agreed with the cardinals, and rival commercial interests kept the cities at enmity.

"All the world was a place of shadows" of the valley of death, wrote Neri di Donati in 1373, and the prospect had rather darkened than cleared in 1375 when Catherine went to Pisa, but she set herself undaunted to avert the threatening disasters, though the fatigue of her journey, with the reception in Pisa, and the heavy responsibilities that met her there exhausted her afresh, and hours were spent in simply enduring pain.

All that tender care could do for her was done in the house of the Buonconti, and on one occasion, according to Raimondo, one of the family bethought himself that her racking headaches might be relieved by bathing her forehead with wine. Accordingly he went to ask some from a merchant famed for having the best that Spain or France could produce. "My cask is empty," was the regretful answer, "come and see." But on tapping the cask, wine flowed out, to the surprise of the owner, and the report that Catherine had wrought a miracle ran through the city. The first time she appeared afterward in the streets, a crowd gathered; curious faces appeared at every door and window. "Let us see this woman who drinks no wine, yet can fill empty casks" was the cry. Catherine, who even if she could have done so, would certainly not have worked miracles for her own advantage, was extremely annoyed: she stood trembling, leaning on her mother's arm, and exclaimed, "Lord, why dost Thou let me be put to confusion,

before the people?... I beseech Thee, put the matter straight, so that all this folly may cease." Raimondo adds that almost at once the wine came to an end, and that the dregs were almost undrinkable.

Perhaps a suspicion that they had been self-deceived arose among the people, for, according to usual popular justice, a reaction of disfavor set in that same day that spread and increased. The austerity of Catherine's life, unchanged in spite of illness and new surroundings, roused disapproval just as at Siena; it would have been admired in a nun, but Catherine was not cloistered, and why should she make herself singular? What business had a woman to put herself so forward? The matter was thought so grave that the university took it up, much as Prior Giovanni had done, and sent two of its members, one an eminent physician, the other an equally eminent jurist, who came with the preconceived certainty that they had an impostor to deal with whom they should easily unmask. The physician was the well-known Guttabraccia, "who lectured at Pisa with a salary of two hundred gold florins," says Catherine's biographer with some awe. Raimondo's style of writing is generally dry enough and to spare, but of this scene he gives a description touched with unconscious humor. The defeat of any who questioned Catherine's saintliness was very sweet to him.

Arrived at the Buonconti Palazzo, the two learned professors asked for her, and with a feigned humility that she perfectly understood, Guttabraccia began by saying that he and his companion, Signor Pietro Albizzi, having heard of her virtue and learning, were come to seek instruction, after which he put various questions of the kind familiar to the schoolmen, such as how to take the statement that God spoke in order to create the world. Had He then organs of speech? Such questions seem now

too trivial to have been seriously asked, but in the Trecento an unadvised reply might very easily have been twisted into heresy, and heresy meant being brought before the Inquisition, perhaps to the stake. Catherine answered with a touch of irony:

> I am astonished that you, who you say teach others, should come to a poor woman whose ignorance you should rather enlighten. But since you wish me to speak, I will, so far as God enables me. What good is it to either of us to know how He spoke to create the world? He is a Spirit, and the essential thing for you and me to know is that our Lord, the Son of God, took our nature, and lived and died for our salvation.

She went on speaking so simply and earnestly that at last Albizzi took off his crimson velvet cap, knelt down, and with tears begged her to forgive the treacherous intent with which he had approached her. At his earnest request she stood godmother to his child, and he was ever after one of her warmest supporters. How his companion was affected we do not hear, but had he been equally penitent, Raimondo would surely have mentioned it.

Catherine was inclined to be amused rather than troubled by the attacks on her, but to her friends they were very grievous. On one occasion, she noticed that Fra Bartolomeo and Raimondo were talking apart, angry and disturbed. She asked the cause, and they reluctantly read aloud part of a letter from a man well known as religious, which went over the old ground, bidding her go home and live quietly; only hypocrites sought renown; and much more, couched in rude and wounding terms. They refused to read the whole, but she insisted on hearing it, and then said the writer had given good advice and must be thanked. Raimondo indignantly said that he undertook the answer, but

Catherine, assuming the authority that she could use rather star-
tlingly toward the man, while showing all respect to the confes-
sor, bade him beware of seeing evil where none was meant and
would not allow it. She lived by the rule that William Flete
declares had been given her directly by her Lord, who bade her
be very careful in judging others, not considering anything sinful
unless it were manifestly so, in which case she must hate the sin
but compassionate the sinner. Nor was she to judge actions by
her own inclinations and views, but according to His judgment,
since in His Father's house are many mansions, and many roads
lead thither.

Illness again struck her down, and she lay so long unconscious
that all around wept over her as dead. As before, she revived,
but with bitter tears, for it seemed to her that she had come
back from Paradise. Bodily pain continued, hand in hand with
such spiritual experience as she found no words to tell. At an
earlier time, Raimondo had heard her murmuring awestruck,
"*Vidi arcana Dei*" and had asked her to try to describe some of the
glorious things she had beheld. Then as now, like Dante before
her, she had said that it was impossible. So too that Spanish
mystic Saint Teresa had said, who while relating how in a sud-
den "sovereign clearness" she had for a moment been permitted
to see how all things were contained in God, though retaining
the impression, could not convey it to others, "the view being
too subtle and delicate for the understanding to grasp it." Such
illuminations are in their very nature inarticulate, though to
those who experience them they are revelations into "unbounded
depths of truth," and they are known to many who are mystics
unawares.

When well enough to do so, Catherine spent long hours in
the Church of Saint Cristina, and it was there that to her inner

consciousness she received the Stigmata, invisible to human eyes, but to her awfully real.

As soon as some strength returned, she began to labor for one of the great objects of her life, a Crusade against the infidel, detestation of whom was hardly less strong in the fourteenth than it had been in the eleventh century, when the monkish writer of a chronicle expresses burning indignation because Beatrice, mother of the famous Countess Matilda of Tuscany, was buried at Pisa, a city defiled by unbelievers who had come there to trade from the East and Africa, while among the merits of Gregory XI an ecclesiastical writer counts his causing to be buried "the vestiges of idolatry" in the shape of ruins of a temple of Hercules, "preferring zeal for religion to the study of antiquity."

Pisa was the very place to stimulate thoughts of a Crusade; wherever the eye turned, something recalled achievements against the infidel or association with the Holy Land. In the Duomo hung fragments of the chain that in 1063 had closed the harbor of Palermo, but through which the Pisans had broken, capturing six Saracen vessels. The Duomo itself had been built as a thank offering for the victory with the money obtained by the sale of the merchandise seized on the galleys, and the Church of San Sisto had been erected to commemorate no less than four more victories. The lovely little church of white marble now called by the name of the Madonna della Spina, built some years before Catherine came to Pisa, contained, as legend told, a thorn from the Savior's crown, brought by a Pisan merchant from the Holy Land. When she visited the Campo Santo and its hermits, she stood or knelt on earth that Ubaldo dei Lanfranchi had conveyed from Palestine, which is why, as the old sacristan used to tell the modern visitor, the violets that bloom there are sweeter than any others. Catherine often went there and looked at Orcagna's frescoes of

death and judgment, and she would linger by the baptistery, then in progress, and talk with the workmen employed upon it.

In the Trecento the dread of invasion by the infidel was ever present, especially in the eastern states of Christendom. Catherine found at Pisa the ambassador of Eleanora, regent of Cyprus, waiting for a favorable wind to sail to Avignon and implore aid for his royal mistress and her young son, whose island was so threatened that she had placed the boy under the shield of the Knights of Rhodes. "Today," Catherine wrote to a correspondent in Siena, "the ambassador of the Queen of Cyprus visited me; he is on his way to the Holy Father to beg his help for the Christian lands under the infidels." Her heart burned within her as she heard him speak of the progress that Mohammedanism was making, of the peril in which Constantinople and Hungary were lying, and of the horrible fate of any Christian who fell into the hands of the unbelievers.

There were many arguments in favor of a Crusade besides that of driving back the infidel. Were all Christian princes united in a holy League, wars among them would cease, and with the Pope at their head, his prestige, sorely lessened by his dependence on France, would be restored, and the bands of mercenaries that were wasting France and Italy might be employed in a holy warfare in which they might expiate their sins under the gonfalon of the cross, as Catherine said, using one of her many metaphors from battle and tourney. She longed to free Italy from them with a fervor to be understood only when we read what contemporaries tell of them. There was no power in the towns to deal with them; their existence was a proof that though every burgher was still trained to arms, the martial spirit was dying out in Italy and France. In Dante's time, when the citizens went out to fight, it was on foot, though there might be a picked band of

feditori on horseback, such as the one in which he is said to have fought at Campaldino. But the Free Lances were heavy-armed cavalry, Bretons, Germans, Englishmen, many of them trained from boyhood in the Hundred Years' War, who simply rode down the infantry opposed to them. They were hired by some city or despot as a kind of standing army, or to fight in some campaign, and when dismissed, unless they found another employer, preyed on the surrounding country. Their approach caused the utmost consternation. From the watchtowers built along the roads near a city warning lights blazed out, such as Dante describes as flashing from those beside Dis; the church bells clashed in response; the citizens flew to defend their walls, and the peasants gathered up such poor property as could be carried away, and drove their cattle before them to the nearest castle or town. Then there was "smoke of blazing villages," murder, and plunder. On a small scale, the scene of the flight from the Campagna to Rome as described in Macaulay's "Horatius" was repeated at short intervals throughout Northern and Central Italy.

Chronicles make small mention of "the common man," and even Dante thinks so little about him that he does not once appear in the *Divina Commedia*, nor has Froissart any pity for him during the Hundred Years' War, but it was above all the peasantry who suffered in the warfare of those days. Catherine knew it well; it was not only in Val di Chiana, but in many other parts of Sienese territory that the Free Lances "took very great spoil of prisoners, and left neither flock nor herd, whether oxen for ploughing, cows, sheep, swine or horses … so that in Torista there remained scarce three yoke of oxen."

Writing somewhat earlier, the Parmese chronicler Salimbene gives a yet more graphic description, telling how even near towns the laborers dared to work only when protected by an armed

guard, for the Free Lances would swoop down, take men, and carry them to their dungeons, and those who did not ransom themselves they would hang up by feet or hands, or pull out their teeth. For they were crueler than fiends, and in those days to see an unknown man coming was as if one saw the devil. For every man suspected the other, lest he might capture him and carry him to prison, and the land had become a desert wherein was neither laborer nor traveler.

The rustic population was forced to take refuge in towns, and great tracts of land went out of cultivation; birds and beasts alone increased, the wolves growing so bold that they constantly carried off children, slinking in the dusk into towns, and even attacking grown men who, having arrived too late to pass the city gates, had to sleep outside the walls, in or under their carts.

Catherine's conviction that there was good in all men was never more strikingly shown than in her confident appeal to the leaders of these soldiers of fortune to join the Crusade. When Palmerina repented of her slanders and publicly owned her offense, Catherine had recognized the nobility latent in her character and prayed that she might be enabled to see souls as they really were. That the discernment of spirits, whether they were good or bad, was hers in an extraordinary degree there is ample evidence. Raimondo, good simple man, was repeatedly deceived by fair appearances, but Catherine never. If there were anything to appeal to in those with whom she had to do, she seized upon it and therefore could write as she did to one of the most formidable leaders of the Free Lances, known in Italian chronicles as Giovanni Aguto, Hawkwood, Sir Giovanni del Falcone, and other varieties of his name. He led the White Company, composed of "devilish and infernal men, of whom the Captain was a very wicked English knight," wrote Fra Filippo d'Agazzari. In

1367 Siena had sent out troops to attack them, only to be driven back in headlong flight, and it cost the city many golden florins to be rid of him and his company. Florence too, with all her advantages over Siena, found it advisable to have him as friend rather than foe. His equestrian portrait may be seen on one of the walls of the Duomo, painted by Paolo "Uccello," a proof that he served the fair city faithfully. And in the English College at Rome a small fresco placed in the chapel shows Catherine giving a letter intended for him to Raimondo, while in the distance appears the mounted figure of the *Condottiere* himself.

Catherine's associations with him could not have been pleasant, but there is no bitterness in her letter; on the contrary, it is full of tender exhortation and encouragement to lead a new life. She sent it by Raimondo, addressed "to Signor Giovanni, soldier of Fortune, and head of the Company that came in the time of the famine," and so great was its effect that Hawkwood and his officers vowed on the sacrament that they would take the cross, "and they signed it with their hand, and sealed it with their seal." And the effect was lasting, for though there was no Crusade, Signor Giovanni not only protested against the atrocious sack of Cesena, when Cardinal Robert of Geneva treacherously seized that most unhappy city, but thenceforward only fought in "regular warfare," whatever that may mean.

A stronger proof of Catherine's power could hardly be found.

The Pope fully approved of the projected Crusade, and the hope of freeing France and Italy from the mercenaries was very welcome. If only they would go! But already they had on an earlier occasion been hired to fight the infidels, and set out to do so, but found the way longer than their scanty knowledge of geography had led them to expect. They came back, and, to keep them safely employed, they were engaged to fight for Pedro the

Cruel, with the ultimate aim of driving the Moors out of Spain. This too was called a Crusade, on the strength of which name they went to Avignon, led by Duguesclin, to ask the blessing of Urban V, with absolution for their sins, and a contribution of 200,000 florins. Urban recollected how in the time of his predecessor, Innocent VI, the *Grandes Compagnies* had wasted the country, laughing at excommunication, and were induced to depart without burning the newly built papal palace only by the gift of 60,000 florins, absolution, and an engagement to fight the Visconti, lords of Milan, and he sent a cardinal to parley with Duguesclin. "As for absolution," said the cardinal, "that you shall surely have, but as for money I cannot say." "Sir," replied Duguesclin, "there are many here who say nothing of absolution, and love money much better." The Pope had to yield. Duguesclin asked if the florins came from the papal treasury. "Nay, in sooth," was the answer, "the common folk of Avignon have all paid their share that the treasure of Heaven be not lessened."

"By the faith I owe to the Holy Trinity," exclaimed the great captain, "not a halfpenny will I take from these poor folk. The Pope must give what is his own." And again Urban submitted.

With such recollections Gregory XI, even had he not been timid by nature, might well desire to be free of these terrible mercenaries. Policy and religion combined to make a Crusade appear urgent. Then and long after, the fear that Saracen or Turk might overrun Europe was a nightmare possibility, and it is significant that in a painting by Dürer of the Crucifixion, the soldiers below the Cross are represented as Turks. He caused letters to be sent to the princes of Christendom, calling them to take up the cross, and bade Catherine do the same throughout Italy. Her most trusted messengers were Raimondo, who not only had the dignity of her emissary, but was a man of good birth, being

descended from the family of Delle Vigne, as has been stated, and also of learning, who would appeal to the upper class, and, as a voice to the lower, the rough old Giovanni delle Celle, whose name appears frequently in connection with hers.

Born of a noble Pisan family, he would seem to have taken the monastic vows too young, and fell into vice, expiated by a repentance of some forty years in a hermitage above the convent of Vallombrosa. The description of him is not attractive. "Mean in stature, with a bristly face and tangled hair," wrote a fellow hermit, yet, as the old man lay dead "he was the fairest corpse that eye ever beheld." Like Catherine he was a great letter writer, but his tone is less lofty and much more conversational than hers. His letters are chiefly addressed to a Florentine noble of the Palagio family, and, amid serious meditations and exhortations he tells how he has seen the bone of a huge serpent, a bone as large as a pig and weighing five hundred pounds, hung up before the Church of the Batia, but which the abbot had had buried, and he could tell other things concerning the serpents of that region, if he did not fear that his correspondent would disbelieve him and think he was joking. And he has not told his friend Guido about it, lest he should be afraid to come to Vallombrosa. Then there is an allusion to the fiery serpents of the wilderness, and the letter ends with some good advice. Others are earnest exhortations to a holy life, and others again show the high esteem in which he held Catherine, and are important, because her detractors sought to show that he doubted her, and even blamed her. Had this been the case, he certainly would not have carried her letters, yet it was the Crusade that gave opportunity for the charge.

His nineteenth letter has a peculiar value as bearing on this question. It is addressed to the venerable virgin Domitilla, of most pure life, wisdom and the knowledge which is of the saints,

but the contents cannot be said to show that Don Giovanni
esteemed either her knowledge or her wisdom, and it is easy to
see how Catherine's detractors could use it against her as well
as Domitilla. This "venerable virgin" desired to accompany the
crusading force to the Holy Land, and the hermit admits that it is
a pious wish, yet in fact it is the door of perdition and dispersion
of all virtues, and the enemy of souls is in it, seeking to drive her
and all the women who want to do the same from the paradise
of innocence and purity.

Perhaps you will reply that Holy Catherine preaches that
we should go over sea. I answer that if she counsels this
as a means of finding Christ, I deny it with all the saints
who speak thereof. Firstly, Christ says that the kingdom of
God is within us. And Saint Antony says that the men of
this world go hither and thither, to sea, by land, to learn
wisdom through many perils, but we to learn virtue and
gain God need not gad about, for in every part of the
world one can win paradise. . . .

Tell me then, I pray thee, the reason of thy desire.
Maybe thou wilt reply, to see the Promised Land, and
visit the Tomb, and gain pardon of sins. I answer that
thou dost call that country the land of promise, but I,
the accursed land, for there Christ died, and God cursed
country and people. . . . True worshippers, as Christ said,
neither in Jerusalem nor in Mount Canzin adore the Fa-
ther, for God is a Spirit, and they who worship Him must
do so in spirit and in truth. Wherefore the Lord said in
the Temple, "Let me go hence." So saith Saint Jerome,
Saint Antony and all the monks of Egypt and Mesopo-
tamia and Cappadocia who never saw Jerusalem, and yet

Paradise was opened to them. . . . Dost think to live better there than here? Full is the city of men and women and so great is the crowd that what thou didst flee elsewhere, there thou must endure. Perhaps thou sayest, I go to seek pardon. And wherefore risk becoming the food of fishes and of losing thine honor and being the slave of Saracens if our knights were discomfited by them when thou canst find pardon in thine own land? . . . Is not Rome full of pardons? . . . O most simple among all the simple, does not Christ say that where two or three are gathered, there is He? Thou hast Christ already. And if thou dost put more faith in that Saint Catherine of thine rather than in the holy doctors, go again to her and ask her how she came to such perfection, and thou wilt clearly see that it was through silence and prayer, for it is said she kept silence eight years [the partial silence of three had already been multiplied to eight] — remaining in her chamber and praying. Do thou this, and when thou hast attained to her perfection, certainly I will give thee leave to go overseas, but if thou dost go imperfect as thou art, thou wilt lose the little thou hast.

And he concludes with the plainest statement of the risks that women run in traveling with an army, even a crusading one.

Don Giovanni was an impulsive and emotional man who did not stop to weigh his words or think how they might be reported, and when the *Bacceliere*, William Flete, heard in his retreat the tale that he had blamed Catherine and had even written sharply to her, he fired up and wrote to him on the subject. The epistle is lost, but to judge by the reply, it filled his fellow hermit with dismay, and he sent two very long ones to Flete, assuring him

that never had he ventured to write to Catherine, much less to use rash or jesting words about one whom he held to be the angel who sounded the sixth trumpet! He reverenced her beyond words, and—to tell him a secret—treasured a lock of her hair, given him by a virgin who had cut it off undiscovered while Catherine was rapt in ecstasy, as if it had belonged to a saint in Paradise. And he relieves his feelings by a sly little hint that the Englishman had no great knowledge of Tuscan and had probably misunderstood what he had heard about him. From his second letter, in answer to one in a more amiable tone from Flete, it appears that Catherine had written to him. This letter too is lost, but it would seem that she had learned of Flete's action on her behalf, and wanted to put an end to the matter; she constantly had to hush her overly vehement defenders. It is amusing to find Don Giovanni turning the tables on Flete by attacking a brother of his community who had calumniated the hermit of Vallombrosa by asserting him to be at heart a Fraticello, and Catherine a presumptuous person, venerated in Florence no doubt, but then Florence abounded in fools. Surely the prior and Flete must have crushed this recreant; certainly Don Giovanni replied with an energy that left nothing to be desired.

The shaft launched against him was a poisoned one, for by some strange misconception his followers were often confounded with the Fraticelli, or Poor Brethren, one of the many sects that, in spite of the Inquisition, abounded in Florence, and against whose errors Catherine, while there, publicly protested. Don Giovanni and she had much discussion about how to deal with their teaching, and it was very grievous to him to have his *spirituali* thought to hold their doctrine.

To judge by his view of women going on pilgrimage, he was a man with common sense, and Catherine would have agreed

with him. As has been said, she herself made none, for her visits to Leccato and Montepulciano or to the Dominican monastery of San Quirico, to whose abbot, Don Martino, several of her letters are addressed, hardly come under that head, and though she sometimes refreshed herself with a daydream of a time when she might visit the Holy Land, she certainly would not have followed in the wake of an army. And though in some of her correspondence with women friends, she may suggest that, were peace definitely made among the Italian Republics, they could join her in a fair company and go against the infidels, this must not be taken too literally. Besides the pious longing to see Palestine in Christian hands, she hoped that Christianity would be forwarded by a Crusade. "Souls and the place" must both be precious in the eyes of the invaders, and far more important than delivering the Holy Land or staying the onward march of the unbelievers was the effort to bring them into the fold of Christ, where one day all should come. She, almost alone in her time, one not prolific in great men or great ideas, had inherited the ideal of a very different Gregory from the one who now bore the name, and she had yet to learn how times were changed since that Pope, or Innocent III, sat on the pontifical throne. Full of hope, rejoicing in the bull issued by Gregory, announcing the Crusade, she wrote to friends in Siena, "Affairs are going better and better for the Crusade," and for a time all promised well.

But always, when some great hope seemed on the point of fulfillment, Catherine was called to renounce it, and though in her case as in that of many other great souls, her failures were nobler than most men's successes, the cup was a very bitter one to drink. Venice went to war with Genoa. Florence, though Guelf when it suited her, was no meek daughter of the Popes, and now was showing signs of active discontent. So did Perugia, maddened by

the conduct of her governor, a papal legate. Raimondo tells how, when the news reached Pisa that the latter city had driven out legate and priests, he went "drowned in grief" to tell Catherine. At first she was almost equally depressed, seeing clearly that these discords would be fatal to the Crusade, perhaps to the papacy, and then, bracing herself, she said, "Do not weep before the time; there will be far more cause by and by; this is but milk and honey to what will follow." Raimondo asked in wonder what more could come, unless a general apostasy. She answered that it was now the laity who rebelled, but as soon as the Pope tried to reform the clergy, there would be a great schism. He recollected her words with awe when the drastic measures of Urban VI brought about the result she had foreseen. On being asked what would happen to the Church, she said that after much tribulation God would purify it by means unknown to man. "Give thanks," she added, "for the great peace He will give when the tempest is past."

All hopes of the Crusade died away; trouble in Italy occupied the Pope and the cities; only a few enthusiasts such as Catherine herself could not believe that never again would the Christian nations combine in a holy war. But, in fact, interests had become too complex for united action among them; the time had gone by for such to be possible. Catherine, like Dante, was making the mistake of looking back instead of forward. She had not experienced enough of the world or of politics to take wide views and regarded all things too much as if they concerned the Church alone. Statesmanship was not, and could not be, one of her gifts.

Chapter 6

৵

Friends and Followers

Catherine's long absence caused great discontent in Siena, and it
seems that even Signor Matteo, the good rector of the Spedale,
was among the malcontents, for there is a letter written in a tone
of displeasure in which she bids him and all who found fault with
her for remaining so long away look at the saints, against whom,
whether they traveled or stayed at home, there were certainly
plenty of murmurs. No one need think that she was leaving the
ninety-nine for the sake of one; for every one whom she has left,
there are ninety-nine known only to Heaven, and the knowledge
of this is what enables her to bear the fatigue of the journey, her
ill health, and the harassment of these murmurs. "Whether I
go or stay," she concludes, in the same tone she took when the
magistrates sought to bring her back from Montepulciano, "I
shall do it to please God, not man. I have been delayed by ill-
ness, but still more because it is the will of God. We shall return
as soon as we can."

Pisa, however, was as reluctant to let her go as Siena was to
let her stay, and the archbishop applied to the general of the
Dominicans for permission to keep her yet a while. One of her
late biographers notices this as a proof that she took no journey

without leave from him, but had this been so, she would have surely brought the fact forward as a valid excuse for that going hither and thither that was such a cause of offense, and indeed of scandal. She always writes as if perfectly free to go and come as she feels best, and no difficulty ever seems to have been made as to any Mantellata whom she selected going with her, although it was understood that recluses and sisters of penance stayed at home and came rarely into society.

Before leaving Pisa, Catherine took a journey that was a refreshing interlude in her stay there, and a memorable experience, for she saw the sea for the first time. Thenceforward metaphors constantly appear in her letters showing how deeply she was affected by it. On the rocky little island of Gorgona, which rises steeply from the water about eleven miles from Leghorn had stood from very early times a monastery that had passed in the Trecento from the Benedictines to the Carthusians. The prior had repeatedly invited Catherine to visit him, an honor as remarkable in its way as any ever offered her. She hesitated, but Raimondo had been won to the prior's cause, and persuaded by him, she went. There had been monks settled there as early as the fourth century, though the island was terribly exposed to the attacks of sea rovers, who, a few years after Catherine's visit, murdered nearly all the community, or, worse, carried them into slavery. The few who escaped left the island to a handful of fishermen and the wild goats.

Riding through the pine forests that then covered the country between Pisa and Leghorn, she would come to Porto Pisano on the seacoast with its watchtowers, which could not defend it from that assault of the Genoese, twelve years before Catherine saw it, that had almost destroyed it. There she embarked for Gorgona, with Raimondo and Neri di Landoccio, and some

others of her company, twenty in all. They reached the island at sunset and were met by the prior. As a woman, however much of a saint, Catherine could not be harbored in the monastery and was lodged in a house about a mile distant, but the next day the prior assembled his monks in the open air and begged her to address them. It is strange that none of those who have painted events in her life, not all historical, should have overlooked so picturesque a subject as that assembly when the young Mantellata "with the light of peace celestial in her eyes of olive grey," spoke to the white-robed monks of the lonely little island with the blue sky overhead, and the sea lapping softly on the rocks, while her companions stood behind her, watching the effect of her words on the Carthusians. Some at least of these, it is lawful to suppose, bred up in the contempt of women inculcated by monastic teaching, must have inwardly protested against the action of their prior in showing one of that sex such unheard-of honor.

It was not willingly that Catherine addressed this audience; she felt and said that "it was fitter for her to listen to God's servants than to speak before them," but the prior entreated her to do so, and she looked at the monks awaiting her words, and her heart was full, and she began to speak of the "illusions and temptations" that beset the life of the cloister with such knowledge and sympathy as filled even her own company, who knew well what her power of speaking was, with wondering admiration and pride in her. She had had her own experiences of the dangers as well as the blessings of a solitary's life; in several of her letters there are allusions to them, and no doubt many of the faces before her told a tale that she was quick to read. When she paused, the prior said to Raimondo, "Dear brother, I am the confessor of all these, and know the hearts of each, and I assure you that if this

saintly woman had heard all their confessions, she could not have spoken more fitly."

The Mediterranean is a treacherous sea, and the return journey was dangerous. All the little company of land folk were alarmed, especially Raimondo, whose strong point was never courage, but Catherine smiled at their fears and "continued in prayer." They reached the land at the hour of Matins, "singing *Te Deum* as they touched shore."

After this break in the anxieties and disappointments crowding upon her, among which must be reckoned the complaints and jealousies of some of her friends and Mantellate left in Siena, Catherine returned home in the autumn of 1375 and took up her usual life of prayer and good works, among which must be counted the great pacification of the three families of Tolomei, Rinaldini and Maconi already mentioned. From this time her life was brightened by the love and devotion of Stefano, and her affection for him was so marked as to rouse some jealousy among her other followers. After her death, he made a collection of her letters, which were kept in the Certosa di Pavia, where he became prior.

It was her dying charge that he should become a Carthusian. Up to that time no such thought had crossed the mind of the brilliant young nobleman, whose parents intended him to follow quite another career, but what was, in fact, a command, given at such a time, could not be gainsaid, and he found comfort in following out her wish. "Had all the world opposed him, he would not have done otherwise." Catherine's influence was even stronger over him in death than in life.

Stefano seems to have had a genius for friendship and to have chosen friends the opposite of himself, such as Caffarini, and the serious young Neri di Landoccio, another devoted disciple of Catherine. To him he wrote frequently when he was in Siena

while Neri was in Rome, and to him he wrote shortly after he commenced his novitiate at Pontignano, beginning his letter, "To my sweetest and most beloved brother in Christ and in the holy memory." There was no need to say whose; Neri's heart would supply the beloved name. Another letter to his friend tells how, much against his will, he had been elected prior, though he had taken the habit only in the preceding year.

One more is preserved. Neri had become a hermit, and Stefano was general of his order. He relates that he had been inspecting various monasteries and had dined at Genoa with Caffarini and Raimondo, and had seen Orietta Scotti, "who with great lovingness recognized him as her son" — he had been sick almost to death in her house when there with Catherine, fourteen years before — "and many other things he could tell that no doubt Neri would like to hear." It is good to know that Maconi made it a special work to reconcile enemies, as did Flete.

No greater honor could have been done to Catherine's memory than to continue her labors. The thought of her was always with him; he always kept at hand a gold reliquary given to her at Avignon, and then to him, and we read with a smile of tender amusement that his Carthusians always had beans at dinner on Easter Day, in memory of a meal that he and Catherine had once eaten on that festival, when she had nothing else in the house. In old age he saw much of San Bernadino, born the year of Catherine's death, who would come to visit him in his beautiful Certosa di Pavia and hear him talk of Catherine. Her name was the last word uttered by his dying lips.

The cell that Neri di Landoccio occupied was just outside the Porta Nuova of Siena, whence he diffused considerable influence, dying in the hospital of La Scala, perhaps choosing to do so because Catherine had so often gone among the sick there.

He was a scholar and wrote verses, many of them lauds in her honor, and he read the *Divina Commedia* and did not always return books that he had borrowed, for his friend Giunta di Grazia asks him to send back *quello pezzo di Dante*, which he had lent him. All his books and writings he bequeathed to the Olivetans, together with a portrait of Catherine that he had had painted. What became of it is not known.

Among those who were among the closest of Catherine's circle of friends and followers must be counted the three men who at different times held the office of her confessor. The first was Tomaso della Fonte, a relation of her family, a simple, unlearned, good man, much perplexed by such a penitent and inclined to check and suppress her unusual ways, but gradually he became convinced that she was led by heavenly impulses, and when after her death he became prior of San Domenico he took every opportunity of showing his reverence for her. There is a mysterious passage in one of her letters to Raimondo that hints at backsliding and repentance in one time of his life. "I have good news to tell you of my Father Tomaso, for by the grace of God he has vanquished Satan through his virtues. He has become quite another man to what he was. Pray write to him, and open yourself to him. Rejoice that my wandering sons have come back out of darkness to the hearth."

Other letters show that if at this time something had come between the two good men, later there was only friendship, but della Fonte seems to have felt that Raimondo could understand Catherine better and had more time to give her than he did. Catherine shared this view and fully believed that the Virgin Mary had promised her a Father of her soul who should be far more valuable than him whom she had hitherto had—which, however true, was uncomplimentary to poor della Fonte.

Raimondo was then Lector of Holy Scripture in Siena, an office that he must have given up when he became the companion of Catherine's journeys.

We trace the development of the relation between them in her change of tone; she first writes to him as "Reverend Father in Christ," but later as "Dearest Father and my son"; and he, from an attitude of suspicion, for he had known a great many silly and hysterical women, and had the poor opinion of the sex that the confessional is apt to produce, became so wonderstruck by her gifts and sanctity that everything she did seemed a marvel to him, and he accepted rebuke as if he had been the penitent and she his superior. And Catherine was not sparing of rebuke on occasion. Good man as he was, he sometimes found it difficult to live up to her ideal. "I am certain," he writes, with a kind of rueful admiration,

> that if she could have had a chance of speaking of divine things with people who understood her, she would have gone on for a hundred days and nights without food or drink, and never would have been weary, but rather refreshed. I may say this, though to my own confusion, that often when she spoke to me of God and His deep mysteries for a long while together, I, who was far from that fervor which she possessed, would grow tired, and overcome with the heaviness of the flesh, and sometimes fell asleep. Then she, absorbed in God, would go on talking without finding out that I was asleep, and when at last she discovered it, she would awaken me by exclaiming loudly: "Alas! Father, why for a little sleep do you lose the profit of your soul? Am I speaking the word of God to you or to a wall?"

He honestly says that, writing when his memory was somewhat failing, he could not always be sure that he recollected Catherine's very words, though as he wrote, they often came back vividly to him, but there are sayings such as the above that one is very sure are hers and no one else's.

Sometimes, even in the later days of their friendship, he was puzzled and uneasy at her course of action and would question it and disapprove, but as far as appears, he always ended by believing that she knew best. One such occasion arose either when she was in Pisa or had just returned to Siena—in 1375. He heard so much criticism of the way in which she received without protest the honor and respect shown her that he called her to account in the presence of Fra Bartolomeo. "See'st thou not what honors are shewn thee?"—kneeling to her and kissing her hands being among them—"and because thou lettest it be, many think thou hast pleasure therein, and are angered thereby, and speak against thee."

"God knows I heed little or nothing what position of body those about me take," she answered. "I look only on souls. If they so greet me, I think of the good intent wherewith they came, and thank Divine Goodness that moved them thereunto, and pray in spirit that He who impelled them to come may fulfill the desire with which He inspired them."

"But, my mother"—so her disciples called her, even those older than herself, Raimondo among them—"the high honors that so many show thee—may they not move thee to vainglory?"

"I marvel that a creature, knowing that it is a creature, can feel vainglory," said Catherine.

Neither Raimondo nor Fra Bartolomeo fully understood her meaning at this time. Thinking it over, they saw how deep a humility really inspired her, but perhaps the suggestion troubled her

sensitive conscience, for it is a curious coincidence that suddenly, on her deathbed, as if repelling an accusation, she exclaimed, "Vainglory? Never, but the true glory of Christ crucified."

When Raimondo was absent, Catherine took for her confessor Bartolomeo di Domenico, another good man, devoted to her, but one who perhaps sometimes felt her strenuous life "too high for mortal man beneath the sky"—at all events, for the ordinary one. He was of a morbid nature, full of scruples that his brethren laughed at, and Catherine gently and wisely silenced.

The list of the monks and friars who were Catherine's friends would be a long one, but of the secular priests, few if any were among her intimate followers. Perhaps this arose from the strong ill feeling between the seculars and the friars, or from her attack on the low moral condition of the parish priests. In Siena both seculars and religious seem to have needed reform; what effect Catherine had on the former is not known, but it appears that she roused the Dominicans into observing their rule in its pristine strictness. Between the two mendicant Orders was a rivalry not always friendly, but Catherine had many disciples among the Franciscans and is known to have written letters to them now lost. One, however, remains, to Fra Lazzarino of Pisa, who came one Lent to preach at Siena. A sentence in it casts a touching light on her own inner history. "Nothing," she writes, "should meet with such a reward hereafter as toil of heart [*fadiga di cuore*] and mental suffering." She knew what she was saying, from long experience, yet all the time "there was a royal song of triumph in her heart because her Lord was there," as a mystic of our own time has said of himself.

Among laymen Catherine had friends as devoted to her as were any among her ecclesiastical followers. Of Neri di Landoccio and Maconi, mention has been already made, and there were

a father and son of the great Piccolomini family, a Pope of which was to canonize her.

It went ill for anyone who ventured to criticize Catherine in the hearing of Gabriello Piccolomini. He was a man of holy and honorable life, warlike as were most of his race, and Catherine's letter to him, the only one addressed to a Piccolomini that has been preserved, abounds in martial metaphors, as if she bore this in mind. He is to be armed for the battle between good and evil and fight to the death, and always carry the two-edged sword of hatred of ill and love of virtue, and he is to smite the world with it, and the devil by constant patience. Where there is love the evil one flies as a fly from a boiling pot — a Tuscan locution of course familiar to her correspondent, though not used in the customary sense. These and such like arms he will need when the gonfalon of the most holy Cross is uplifted, and he must not let them get rusty. It is a moral crusade of which she is here speaking, but her thoughts turn to the one that she still hoped to see organized on earth, and she ends by saying that they will all be wanted also, "when he marches against the infidel."

That the young Francesco Malavolti was brought to Catherine by the influence of Neri di Landoccio, he tells himself. He was leading an irreligious and licentious life, and Neri, to whom she was "guide, philosopher and friend," was urgent that he should turn to better things, and begin by visiting her. Neri himself had, at one time, been indifferent to religion, though he had never followed his friend into the paths too familiar to Malavolti, and, in fact, it was his goodness, as well as his charm of manner and gift of poetry that strongly attracted Malavolti, though at first he paid little attention to his words, only laughing at his "be-Catherined" friend. "At last," Malavolti writes,

not wishing to vex him because of the great friendship between us, I told him that I would do as he wished, though in my heart I went out of no devotion, but rather in derision, resolved that if she talked to me of religion, especially of confession, I would give her such an answer that she would not venture to do it again. But when I came into her gracious presence, I no sooner saw her face than such fear and trembling fell upon me that I well-nigh swooned, and though, as I say, I thought not at all of confession, yet with her first words God so wonderfully changed my heart that I went at once to confess, and became the very opposite of what I had been.

He was, however, but an unstable convert. During Catherine's long absence at Avignon, he slipped back into something too like his old life, especially into the vice so common in Siena, of reckless gambling, and on her return must have gone to see her with a quaking heart. Her tolerance of his backslidings and certainty that he would overcome his sins somewhat surprised and almost scandalized some of her circle, but she hoped on, though again and again disappointed. "You keep coming to me, and then fly back like a wild bird to your manifold failings," she told him, "but fly where you will, by God's grace I will one day put such a fetter round your neck that you can fly away no more."

He cost her many anxious thoughts and prayers, however. "I may well call you dear," she wrote, "so many tears have you cost me." He was with her during her visit to Rocca d'Orcia and described her cure of the cases of lunacy there, and was deeply impressed by what he saw. Trouble came on him some years later; his wife and children all died; Catherine, too, had gone to her rest. A document of great interest relates that one of his uncles,

seeing his love for horses and armor, proposed to him that now that he was a widower, unless he would marry again, he should become a knight of Saint John and "so indulge his taste without risking his salvation."

He was at once accepted by a chapter of the order, but on the night before the one on which he was to be received, Saint Catherine stood beside him in a dream and bade him seek Neri di Landoccio and go straight to the Monastery of the Olivetani. "Dost thou not remember," she said in his dream, "how I once said to thee that when thou shouldst think me far away I should be nearer than ever, and subject thy neck to such a yoke that thou shouldst never be able to shake it off?" Malavolti found himself making many objections, but she answered that unless he obeyed, he would fall into great dangers, and she vanished.

A great longing to obey the beloved mother who had come back to guide him filled his heart; he rose at dawn, and sought Neri. He, too, had had the joy of seeing Catherine in his dreams, and she had said to him, "Expect thy friend Francesco Malavolti, and go with him to the house of Mount Olivet." Neri was then a hermit; he left his cell, and the two went together over the tossed and tumbled volcanic hills and through the forests for some fourteen miles, and so came to the monastery. And though usually a long and severe trial was made of any who desired to enter the order, on hearing what had occurred, the prior agreed at once to receive Malavolti, who returned to Siena to dispose of his arms and horses and explain why he had renounced all thought of being a knight of Saint John, after which he went back to the monastery, and the old Malavolti *palazzo* knew him no more.

Not all of Catherine's followers justified her belief in them; among so many there were naturally some who fell away, and of whom she was forced at last to despair. Of one such she writes

with sorrowful decision that even were he to return, she could have nothing more to do with him. Of such as these no record was kept, but they may have been many, for the Tuscan character is easily moved by religion, and as easily cooled, the Sienese especially so. Catherine's frequent absences must have been a test of the reality of her conversions, and there can be no doubt that a great number proved to be genuine, and independent of her personal influence, if others proved unstable. One more of those who became close friends of Catherine's may be taken from the many that might be noticed, a member of the Savini family, known as Nanni di Ser Vanni, or John, the son of Master John, a man fierce and violent, stirring up continual strife in a city of which Aonio Paleario wrote after visiting it, "Siena is situated on charming hills, and the surrounding country is fruitful, producing everything plentifully, but discord sets its citizens in arms against one another, and all their strength is exhausted in party strife."

If this were true in 1531, it was much more so in the Trecento, but Nanni di Ser Vanni sowed trouble, not only as head of a faction, but by being "marvelous subtle." If there were anyone whom he feared in Siena, it was Catherine Benincasa, and he kept studiously out of her reach, but at length the *Bacceliere*, William Flete, wearied him into consenting to go and see her, though declaring that whatever she said concerning peace, he was fixed and would not be moved, and he went, sullenly enough, to the Fullonica, but at an hour when she was away from home, as he possibly knew. Raimondo, however, was there, who invited him into her oratory and did his best to entertain him, earnestly hoping that Catherine would return. Nanni, rejoiced to escape an interview with her, had no mind to stay and presently said, "Father, I promised Brother William to come to speak to the holy maid, but as she is away, and I have work to do at once, I pray

you make my excuses to her, and tell her I am sorry she was not at home," and therewith rose to depart. To gain time Raimondo began to speak about the peace that had been planned only to come to nothing between Nanni and his enemies. Laying aside his usual caution, he said that to Raimondo, priest and monk, and to Catherine, of whom he heard report of great virtue and holiness, he would tell no lies, but admit that, while preparing outwardly to make peace, he was really putting every obstacle he could devise in the way. "To tell you my meaning in few words," he said, with a burst of the fierceness so strangely mingled with his craft, "my peace shall be made and sealed in the blood of my enemies. This is my resolve, and thence I will not be moved. Wherefore, prithee, set thy heart at rest, and trouble me no more."

Raimondo, though much disturbed, still hoped in Catherine, and went on talking till he heard her come in. Nanni very unwillingly sat down again and listened in stubborn silence to all she said. Feeling that her words were useless, she sat silent, and Raimondo knew that she was praying. He began again to talk with Nanni in order to keep him yet a while longer, and with a great joy heard him presently say, "It shall not be said of me that I am so hard and uncharitable that I will relent in nothing. I will do as you wish in some one thing and then take my leave. I have four quarrels in the city, of which I will put one into your hands. Do in it as seems good to you; make you my peace, and I will abide your orders."

He rose to go, but with this first victory over himself came a sense of relief and peace of mind, of comfort and penitence, which quite overcame him, and, bursting into tears, he knelt by Catherine and implored her to advise and help him, and she, full of thankfulness, bade him repent and make what atonement he

could for the past, which he did. But shortly after this, Raimondo came in great trouble to tell her that Nanni, no longer dreaded and formidable, had been thrown into prison on account of the offenses brought up against him. "So long as Nanni served the devil," said the perplexed Raimondo, "so long did all things go prosperously with him, but since he began to serve God, we see the world wholly set against him." And he went on to express his fear lest this should discourage Nanni and cause him to despair. Catherine took his bad news very calmly, saying that this calamity showed that Nanni's sins were pardoned, the everlasting pains due to him being exchanged for temporal afflictions. "When he was of the world, the world made much of him, as one who was its own, but now that he had begun to spurn at the world, no wonder if it kicked at him again. As for falling into despair, He who delivered him out of the deep dungeon of Hell would not let him perish."

And in a few days Raimondo could tell her that Nanni had been released, though with a heavy fine, "whereof the noble maid was nothing sorry, but rather glad, thinking that his wealth might have been a snare to him."

"Our Lord has mercifully taken away that poison wherewith he had before poisoned himself, and might again," she said.

Three miles from Siena stood a castle that belonged to Nanni, and, in token of gratitude for what Catherine had done for his spiritual welfare, he made it over to her to be used as a convent. He could not, however, do this without the consent of the magistrates, as no fortress might either be built or destroyed near the city for obvious reasons. But this castle of Belcaro was already old and in disrepair, and could not, as they thought, in any way either advantage or endanger the state, so at the desire of Nanni and the petition of "Catherine, daughter of Monna

Lapa of the Contrada of Fontebranda," when the matter was put to the vote there were, only 65 black beans against 333 white ones,[12] and Belcaro passed into the hands of Catherine, who found great delight in turning it into a convent that was known as Santa Maria degli Angeli.

That the rulers of Siena were wise in their reluctance to let strong places pass out of their jurisdiction was shown by the fact that this very Belcaro became a source of danger when seized and garrisoned in the fatal siege of Siena by Cosmo de Medici in 1554. The convent was soon afterward changed into a dwelling house by a rich banker of Siena, one of the Turamini family, but the ilexes that covered the hills around are so old that Catherine may have walked under them.

Raimondo relates how all "her spiritual sons and daughters" assembled when the work of turning what he calls "a most beautiful *palazzo*" into a convent was begun, and that the papal commissary present was that abbot of Saint Antimo, whom she had so bravely defended to the magistrates of Siena when she was at Montepulciano. So great a change had Catherine worked in Nanni, that he who had loved money too much, now, when comparatively poor, made over his castle to Catherine, and, says Raimondo, "I, who for many years was his confessor, know that for the most part he amended his ways, at all events during that time that I had to do with him."

That Catherine had most loving and true friends among women as well as men is evident, but very little is told of them. Some of them acted as her secretaries, and messages on their own account often mingle quaintly with her letters, when written to any of her college.

[12] Archives of Siena.

Now it is "Cecca the laughing," or "the waster of time," or "*Giovanna pazza*" ("madcap," unless indeed she makes a feminine of her family name of Pazzi), or "Alessia the plump," or "the neg-ligent," who would gladly put herself into this letter, and go in it to her correspondent. Or "a hundred thousand remembrances" are sent, all which is in curious contrast to the solemn form of words, almost always the same, with which the letters are begun. These ladies must have had an unusual amount of education to act as Catherine's secretaries, but the more important letters are written by her young men friends, one of whom was Barduccio Canigiani, whose family held an important position in Florence and whose friendship with Catherine cost them dear. A female friend, whose name is not given, probably a nun, undertook to teach her some Latin, but she had not the habit of learning, and in spite of the similarity to her own language, she toiled on without making apparent progress.

"Lord," she prayed in her discouragement, "if it please Thee that I may learn so that I can sing the psalms and the hymns in the canonical hours, teach Thou me what by myself I cannot learn; if not, Thy will be done; I will remain in my simplicity, and spend the time granted me in other meditations." Full of hope and energy she resumed her studies and found that the power to understand had awakened in her.

Such an experience is not uncommon after a long mental ef-fort, and would now be described as unconscious cerebration, but Raimondo naturally regards it as miraculous. He considers it also a deep mystery how, though she learned to read very easily, she could never learn to spell, though this, too, is an experience not unknown even in our own day. Writing was an art that, as far as can be gathered, she learned almost ten years later, when at Avi-gnon. Her first letter, in which she evidently took an innocent

pride, was to Stefano Maconi. It cost her far less trouble to learn to write than it had done to learn to read, but either it never became really easy to her, or else that imperfect spelling that so perplexed Raimondo, made her always dictate unless moved by some feeling too strongly personal to be expressed through another person, as when she wrote to Raimondo in Rome from Rocca d'Orcia[13] a letter that Tommaseo calls at once *tractate* and ode and drama, lofty as the Paradise of Dante, but with more ardor, a criticism that lovers of Dante will scarcely accept.

Among her circle were learned men such as Caffarini, who directed her biblical studies, and Raimondo, who read the New Testament and parts of Aquinas to her. The learned editor of her letters, Tommaseo, explains the passage as meaning that she saw Raimondo with Saint John and Aquinas in a vision, but it is more natural to suppose that before Raimondo went on his important visit to Rome, he visited her at Rocca d'Orcia, and while there read passages of the Angelic Doctor to her. She could hardly have studied them for herself, for he admits that "she did not know letters." What is now understood by a Bible would then have been a massive manuscript, costly and cumbrous, and very unlikely to have been in her possession, but there were collections of texts and chapters largely used in the Middle Ages; Ochino at a later time had one that he calls the *Biblia Aurea*, which was finally put on the Index[14] on account of its many mistranslations. She would also know a certain amount of Scripture from the offices of the Church. Her letters show that she often had biblical words in mind as she wrote. The assertion that she could explain all Holy Writ must, however, be regarded

[13] Letter 262.
[14] Index of Prohibited Books.

as merely the fond exaggeration of some who admired and loved her. If it were seriously made, the contemptuous anger of those theologians and professors who came to question her is easy to understand.

Chapter 7

⚜

Catherine in Avignon

Catherine was not allowed to remain long in Siena; public affairs
claimed her afresh; all Upper Italy was rising in revolt against the
Holy See, stimulated by the lords of Milan and Bernabò, one of
the family whom Villani calls "those wild beasts, the Visconti."
"Wild beast" was a name that certainly suits Bernabò, who ob-
served no law, feared neither Heaven nor Hell, and mocked
excommunication. In a time when to judge or punish a cleric
was to call down heavy spiritual penalties, he quartered his dogs
on the monasteries in his domains, and for every dog that died,
a monk was hanged.

Like not a few Italian despots, his head was turned by power,
and, jaded by utter license, he sought sensation in devising tor-
tures, delighting in cruelty for cruelty's sake, and taking away
life as indifferently as if he were killing an insect. He was of the
race of Ezzelino and Alberic da Romano and Galeazzo Sforza.
Peace in Italy was the last thing he desired, and the one hope
for it was to crush him. There had been a moment when this
was possible, and Catherine never made a greater mistake than
when she induced the Pope to make terms with him. Her love of
peace and desire for a Crusade was too strong for her judgment,

as again when she wrote bidding the king of France to end the Hundred Years' War even at the price of abandoning his dominions to the English. Bernabò was too crafty not to seek to win her, but his real aims were soon revealed. His insinuations that the Pope was intending to make all Tuscany subject to his rule, or even to allow France to seize it, fell into Florence like a spark in dry fuel, and the conduct of the papal legates confirmed his suggestions. Catherine herself calls them "eaters and destroyers of souls, not converters but devourers," while a chronicler, quoted by Gregorovius, bitterly exclaims:

> For more than a thousand years these districts have been in the hands of priests, and all through the fault of these they have been dragged into most cruel wars, without even now the priests owning them in peace, without even hope that they ever will do so. Oh, verily it were better before God and the world that these shepherds should strip themselves utterly of temporal dominions, since, from the time of Silvester downward, the consequence of temporal possessions has been countless struggles and destruction of people and cities.... Certain it is that one cannot serve God and mammon, nor have one foot in Heaven and one on earth.

Most of the Italian Legates did not attempt to solve the difficult problem; they frankly served mammon. They were the more hated in Italy because almost all were foreigners, unable to speak the language of those whom they came to rule, and quite indifferent to their interests. Italy seemed of no account with the Popes; French influence was all powerful. In Gregory's first creation of cardinals there was only one Italian to seven Frenchmen, and three of these were kinsmen of his.

It was the conduct of a legate that finally drove Florence to League with the other cities of Northern and Central Italy against the Pope. Just at the time when there was a well-founded suspicion that Guillaume de Noellet, legate of Bologna, was plotting to get possession of Florence, fresh indignation was roused by his refusing, in flagrant defiance of Gregory's orders, to allow so much as a sack of corn to pass from his territory into Tuscany during the scarcity of 1376. Moreover, he dismissed Hawkwood, who had been in the papal service, with a significant message to the Florentines, that if the Free Lances should ravage their territory, it was no affair of his. Machiavelli's account of the matter runs thus:

Gregory XI being Pope, and living at Avignon, governed Italy like his predecessors by legates, who, being full of avarice and pride, had afflicted many cities. One of them, who was then at Bologna, thought to gain possession of Florence on account of the famine that prevailed there, and not only would give the Florentines no food but, to deprive them of the hope of coming crops, planned to assault them as soon as spring came with a great army, hoping, as they were unarmed and foodless, to conquer them easily. And it may be he would have succeeded, had the forces with which he attacked them not been faithless and venal.... Wars begin when one likes, but not when one likes do they end. This one, begun through the ambition of the legate, was followed by the wrath of the Florentines, and they made a League with all the cities hostile to the Church, and set eight citizens to govern the city, and this they did with such virtue and general satisfaction that they were called saints [surely Machiavelli was indulging

in a sardonic smile as he wrote this] though they heeded little this (papal) censure, and despoiled the Churches of their possessions, and forced the clergy to celebrate the divine offices [during the interdict].

The suspicions as to De Noellet's designs were strengthened by the discovery that the legate of Perugia was plotting with Cione dei Salimbeni against the liberties of Siena, which suggested a design to seize the Tuscan cities one after another. Florence thereupon took Hawkwood into her service, made a treaty with Bernabò Visconti, and elected the eight magistrates of whom Machiavelli speaks, who were known as the Eight of War, all of Ghibelline persuasion. Varano was made generalissimo of their forces, who later played the Florentines false, and took service with the Pope. The whole city was in an uproar; crowds paraded the streets, shouting, "Death to the priests!" and carrying a red banner with *Libertas* inscribed on it in silver letters, while the Pope was solemnly declared to be the enemy of the Republic.

Until thoroughly scared and angered, Gregory honestly tried to calm the excitement, ordering corn and flour to be sent to Tuscany, and assuring the Tuscan cities that he had no designs on them, nay, that he had refused to accept Lucca when offered to him by the emperor. Lucca believed him and remained faithful. Florence would not listen. She called on all the cities around to join an antipapal League and shake off the yoke of the legates; more than eighty towns and fortresses responded, and had Rome joined, the papal states might have been lost in the fourteenth instead of the nineteenth century.

But Rome held back. With her desolate Campagna, the absence of any strong middle class, her savage barons and her unruly population, she neither could nor would forward the purposes

of the League. Her importance depended on the return of the popes; the good or ill fortunes of the Tuscan cities were nothing to her. For a while, her indifference seemed of little consequence; the League became more and more formidable, and the news of one town after another rising against Gregory filled Catherine with pain and dismay. Her letters to Avignon show how great was her alarm and anxiety. Whether we have the first that she sent there is uncertain, but in all those of this date that exist, she writes — with one exception — in a tone of equal respect and frankness, declaring unhesitatingly that the legates were responsible for all the ill, "men whom you know to be incarnate demons," and beseeching the Pope to win back his rebellious children by kindness. She can see no other way of recovering his authority, but with kindness he can do what he will with them, especially the Sienese, "than whom no people were more susceptible to loving treatment." She was full of anxiety for Siena, which was in a very difficult position, whether siding for or against Florence. If she chose the former alternative, the Pope might, and did, lay her under an interdict; if the latter, the forces of the League might crush her, besides which she owed gratitude to Florence at this juncture for the help given when the legate of Perugia and Cione dei Salimbeni menaced her.

She took a middle course. Catherine had the mortification of obtaining no more from her native town, not siding openly with Florence, but keeping up friendly communications with her and lending help in a quiet way. But this seemed as heinous to the Pope as open rebellion, and not all Catherine's efforts could avert his anger from her beloved Siena. It had not fallen on the city when she wrote those early letters whose tone is almost caressing; Gregory is to her as a *Babbo* (Daddy), but he also is to her "Christ on earth," against whom rebellion is a fearful sin. "Uplift

the gonfalon of the holy Cross," she writes, still with the hope that a Crusade would gather and fuse all jarring elements, "if you would see the wolves turn into lambs. Peace, peace, peace, that war may not delay the Crusade."

The one letter[15] that is the exception to her usual tone at this time is written in a way that shows she was strongly moved. Internal evidence shows that it must have been sent soon after Gregory was elected, and it is so remarkable that it must be quoted at some length.

> In the name of Jesus Christ crucified and sweet Mary. Most holy and most sweet Father, your unworthy and wretched daughter Catherine, in Christ gentle Jesus, recommends herself to you in His precious blood, with the desire to see you manly, without any fear or carnal affection for yourself or any creature allied to you, for I consider and behold that in the sweet sight of God, nothing so hinders your own holy and good desire, the honor of God, and the exaltation and reformation of Holy Church as this. Therefore, my soul longs with boundless love that in His infinite mercy He may take from you every passion and lukewarmness of heart, and make you a new man, one on fire for reform and most ardent desire, for otherwise you cannot fulfill the will of God and the longing of His servants. Alas, alas, my most sweet Father, forgive my presumption in what I have said and say. I am constrained to do so by the sweet Primal Truth. His will, Father, is this, and this He asks of you, that you do justice on the abundance of many iniquities committed by those

[15] Letter 255.

who nourish themselves feeding in the Garden of Holy
Church, for He says that the animal should not nourish
itself on human flesh. Since He has given you authority,
and you have taken it, you ought to use your virtue and
strength; not using them, better were it to give up what
was taken. More honor for God and better for your soul
would it be.

The other thing that he wills is this, and this He de-
mands of you. He wills that you pacify all Tuscany, with
which you are at war.

This is plain speaking indeed, and she goes on to say that as
far as possible the Pope must avoid war altogether, except in the
Crusade. All this may seem impossible to him—she has already
discovered his faintheartedness where prompt and vigorous ac-
tion is required—but it is possible to God in His goodness.

In the same tone of severe admonition she bids him, if he val-
ues his life, not to be negligent. If he chooses to execute justice,
he can. He holds the keys of Heaven; he can open and shut—and
if he does not do it, were she in his place, she would fear lest the
divine judgment should fall on her. Let him do God's will, lest
the hard rebuke come, "Accursed be thou who hadst time and
strength entrusted to thee, and used them not." This letter ends
with a piteous cry:

I say no more. Pardon, pardon me; it is the great love
which I feel for your salvation, and the great grief when I
see it in danger, which makes me speak. Willingly would
I have spoken it to you, to fully discharge my conscience.
When it pleases your Holiness that I should go to you, I
shall willingly do so. Act so that I may not have to appeal
to Christ crucified against you, for I can appeal to none

other since there is no greater than yourself on earth. Humbly I ask your blessing.

The lofty tone she takes is almost startling from the dyer's daughter to the Pope, who was to her the representation of Christ on earth, and proves her conviction that she was given a mission direct from Heaven. There is a slight incoherence here and there, as if her feelings hurried her along. A minor point to observe is the overuse of the word *dolce*, whether we take it as "gentle" or "sweet." She had certain favorite words and metaphors that occur repeatedly in her letters, and sometimes jar on the modern reader, though they suited the taste of the Trecento.

This was not the only time that Catherine expressed her opinion of the worthlessness of temporal possessions to the papacy compared with that of souls. "Let us suppose," she wrote to Gregory, "that you are bound to recover lordship over the cities that the Church has lost, yet are you far more bound to win back so many lambs that are the treasure of the Church, the loss of which would indeed make her very poor. Better let go the gold of worldly things than of spiritual."

Besides urging peace on Gregory, Catherine put with equal fervor the need and duty of returning to Rome. Hers was by no means the only voice that from Dante's downward had bidden the popes return to the Eternal City. Petrarch had appealed to them with all the force of his rhetoric; so had Rienzi, and the royal Swede Brigitta, from her convent in Rome, related visions that bade them linger in Avignon at their peril. At the time this visionary princess was almost as famous as Catherine Benincasa, though with far less influence. Both she and her husband were tertiaries of Saint Francis of Assisi, and when widowed she came to Rome, both because the plain speaking in her so-called

revelations brought her into trouble among the Swedish clergy and because she believed that she had been ordered by a voice from Heaven to make it her home until a Pope and an emperor met there, which came to pass in the time of Urban V. She wrote an account of her visions in Swedish and caused them to be translated into Latin.

Like Catherine, she ardently desired to reform the Church and is said to have raised the extremely low standard of morals among the Roman clergy. Unlike Catherine, on the other hand, she entered a convent in Rome, at the door of which she used to sit, begging for the poor. There is a link between Saint Brigitta and England, for she founded the order of the Brigittines, a branch of the Augustinians, and it was a community of these nuns who occupied the famous Sion House.

Catherine had heard of her, for she alludes to her in a letter, and moreover was well acquainted with her Spanish confessor, Vadaterra, since it was he who carried a plenary indulgence to her from Gregory XI, with a request that she would pray for him and a command to say every Friday thirty-three Our Fathers, and ninety-five Hail Marys, thus furnishing a proof that as yet he did not understand the mystic and lofty nature of Catherine. She felt that she gained nothing by these repetitions, and begged to be released from the obligation. Later she knew Brigitta's beautiful daughter, who bore the same name as herself.

The wild and fantastic "revelations" of Brigitta had greatly impressed Gregory, and as early as 1375 he declared his intention of returning speedily to Rome, but meanwhile great additions were being made to the papal palace at Avignon, and it was noted that the name of New Rome was given to these buildings.

If Gregory "would and he would not," there was great excuse for his irresolution. The task before him was one requiring a

Hildebrand or an Innocent III to deal with it. But the papal chair was filled by a man sincerely anxious to do right, but timid and uncertain where right lay, his youth increasing his doubts as to his own judgment, and hampered by that fatal connection between the Church and the temporal power that Dante had anathematized, and which Catherine would have broken unhesitatingly if peace and reform could be thus obtained, but which Gregory and his successors maintained, as though the Church must stand or fall by it.

Deeply troubled by the immorality and sinning that corrupted his clergy, he yet dreaded the irritation that any effort to check them would cause among high and low, but at the same time he trembled at the fear that if he remained passive, things must go from bad to worse, and that to remain at Avignon would make the papacy a mere appanage of France and suggest to Italy that she could do very well without a Pope. "Throw off the yoke of the foreigner" had been the ominous cry in revolted Florence, and though there was much to be said in favor of a residence in Avignon, where the province as well as the towns had been bought by his predecessors, and the Rhône made a highway through France and toward Germany, the neighborhood of the French kings was not always an advantage.

Benedict VII would willingly have returned to Rome, but Philip le Bel would not allow it, and when the Pope insisted on relieving the emperor from the sentence pronounced against him by John XXII, the king seized the cardinals' revenues, after which they put such pressure on Benedict that against his conscience he was induced to yield. Again, though nominally a free agent, it had been with extreme difficulty that Urban V had succeeded in leaving Avignon, for, says a contemporary Franciscan, "the king resisted with all his might, having led

the last pontiffs as he would, the cardinals being of his family and friends."

The burning question of Avignon versus Rome was complicated by the failure of Urban V, who had gone back only to return disheartened three years later, and Urban not only was a much stronger man than Gregory XI, but in his time the States of the Church had been reduced to obedience under the heavy hand of Cardinal Albornoz, while now all was revolt and confusion. The French cardinals, who composed two-thirds of the Sacred College, naturally used every means to oppose and discourage any thought of leaving the pleasant places of Avignon for Rome, poverty-stricken, malarious, in ruins, never free from popular tumults and struggles between her lawless barons, and without any central authority, now ruled by one great family, now another. In their fortress erected within the Colosseum were entrenched the Colonna, whom even a Boniface VIII could not effectively crush, with rule over all the district between what is now the Piazza of San Marcello and the Church of the Santi Apostoli; the Orsini held Sant' Angelo, the Savelli the Capitol, one and all fighting each other for purely selfish motives, absolutely indifferent to liberty, conscience, or the good of Rome. Assassination was constant in the streets, and the surrounding country was swept by men at arms belonging to one baron or another; brigands came up to the very gates of the city, where Petrarch was crowned with laurel amid the acclamations of the Romans, always charmed by a show, only to be seized by robbers as soon as he was outside the walls.

All this and more was told to Gregory, besides which he was greatly and not unnaturally alarmed by a letter warning him that he was to be poisoned if he ventured into Rome. He knew that Pope John XXII had narrowly escaped death from

poison prepared by his chaplain, the bishop of Cahors, and others of his court. His less fortunate nephew died in agony at his feet. "What have I done to my cardinals!" this Pope exclaimed. "They have sworn my death. Watch over Thy servant, great God, for my enemies are very many!" Gregory put forward the letter which he had received as an excuse to Catherine for remaining at Avignon, and she comments at some length upon it. To have risked death in a righteous cause seemed to her altogether desirable, and she was scandalized by his timid alarm. She wrote in reply:

> So far as I have understood, that person [the writer] has treated your Holiness in this matter as the soul is treated by the devil, who ofttimes under pretext of virtue and pity injects poison into it, using that device especially with God's servants, knowing that he could not deceive them with open sin. Thus, it seems to me, does this incarnate devil, who writes to you under cover of compassion and in holy style, for the letter feigns to come from one holy and just, while it really comes from wicked men, councilors of the devil, who cripple the common good of the Christian congregation, and the reform of Holy Church, self-seekers, looking only to their own interest.

And then comes a pregnant hint to find out the real source of the letter: "I do not think the man a servant of God so far as I can see, and his language does not show him so—the letter appears to me forged. Nor," she adds with some irony, "does he who wrote it know his trade very well. He should put himself to school; it seems as if he knew less than a little child." Then, with a significant allusion to the Pope's well-known nepotism and dislike of all that was unpleasant, she continues:

Observe, most holy Father, he first appeals to what he knows to be the chief frailty in man, especially to such as are very tender and pitiful in natural affection, and toward their bodies, for such hold life dearer than others. But I hope that by the goodness of God you will regard His honor and the safety of your flock more than yourself, like a good shepherd, who ought to lay down his life for the sheep.

There is a ring of irrepressible scorn in the next paragraph.

Next, this "poisonous" man seems to approve of your returning to Rome, calling it a good and holy thing, yet he says that poison awaits you there, and seemingly counsels you to send good and trustworthy people before you, who apparently will find it in bottles on the tables, ready to be given by day or month or year. Now, I quite admit that poison may be found — as for that also on the tables of Avignon or other cities, as well as in Rome.

There seems a covert allusion here to the wine drunk in large quantities at the meals of ecclesiastics in Avignon and elsewhere, according to Tommaseo, but the earlier editor of Catherine's letters, Gigli, takes it as meaning genuine poison and gives a formidable list of great men who had been thus put out of the way. Continues Catherine:

It can be found everywhere. He thinks you should send them, and delay your return; he suggests your waiting until divine judgment shall fall by this means on those wicked ones who, according to him, seek your death. Were he wise, he would expect that judgment to fall on himself, since he is sowing the worst poison cast this long time

into Holy Church by seeking to stay you from following
the call of God, and doing your duty. Do you know how
that poison would be sowed? If you did not go, but sent
as the good man counsels, scandal and rebellion, spiritual
and temporal, would be roused up, men finding a lie in
you who occupy the seat of truth. For since you have
decided to go and have announced it, the scandal and
bewilderment and trouble in men's hearts would be too
great if they found that it did not come to pass.... Much
I marvel [adds Catherine, who herself courted martyrdom
as a great privilege] at the words of this man, who praises
an act as good and holy and religious, and then would
have it given up through bodily fear. It is not the habit
of God's servants ever to be ready to renounce a spiritual
act or work on account of bodily or temporal harm; had
they done so, none of them had ever reached the goal....
I beg of you for the sake of Christ crucified that you be
not a timid child, but virile.

She ends with a plain hint that the letter was forged by those
around the Pope to scare him. As usual, there is no date to hers;
it was probably written in Avignon, for though the allusion to
Gregory's having announced his intended departure may refer
to his early declaration that he meant to return to Rome, there
is a request for an audience before she departs, and "the time
is short." It has a great interest, both from what it reveals of
the Pope's character, as read by Catherine, and her own. The
sarcasm is stinging; she is almost out of patience with him, as
she was at times with her good Raimondo. What does anything
matter — life or bodily suffering or death itself compared with
the welfare of the Church and doing one's duty? She cannot

understand how Gregory can think twice about it, and her "Pardon, Father, my over presumptuous speech" comes in as an afterthought. Such a letter as this brings the real woman very near us. Whether, had she not gone to Avignon, Gregory would have ever left *la ville sonnante* may be doubted, but the course of events was soon to take her there.

Florence had much to be forgiven. The wholesale confiscation of ecclesiastical property, the massacre of several priests and monks, the death of a Carthusian prior who had exported corn during the famine, and who was now murdered under exceptionally horrible circumstances, made up a tale of offenses such as began to alarm the perpetrators and horrify all who had consciences in the city, so that obedience was rendered to the Pope's stern command to send delegates to answer for what had been done. Three were chosen, one of whom was the patriot Barbardori, who held the office of captain of the people. His two companions were also men of note in the Republic, Domenico di Silvestro and Alessandro dell' Antella.

They came to Avignon at the end of March 1376; the Pope received them in full consistory, justly displeased with Florence and awaiting their submissive excuses. But, carried away by his recollection of the sufferings of Tuscany, Barbardori broke into an enumeration of the wrongs committed by the legates, their pride, their avarice, their enormous cruelty such as thrilled the assembly, moving even those who understood him only through an interpreter. The Pope himself was so much impressed that he promised to consider and redress the grievances brought before him, in which he was supported by the few cardinals of Italian birth, but the overwhelming influence of the French ones turned the scale, and when the ambassadors were recalled, and entered the great hall full of hope and gratitude, to learn the Pope's final

decision, they were thunderstruck at hearing that an interdict was to be laid on Florence. The sentence carried with it the deprivation of all spiritual privileges and struck a deadly blow at the prosperity and the commerce of the merchant city, and was the more cruel that no reason had been given to expect it.

For a moment the three delegates stood aghast and incredulous; then Barbardori flung himself down before the great crucifix at the end of the hall and exclaimed:

Great God! we delegates of the Florentines appeal to Thee and to Thy justice from the unjust sentence of Thy Vicar. O Thou who canst never err, whose anger is ever tempered with mercy, Thou whose will is that the peoples of the earth shall be free and not slaves, Thou who dost abhor tyrants, be today the help and shield of the people of Florence, who in Thy name will strive for their right and liberties.[16]

Great confusion followed this passionate appeal to a higher court than that of the Pope; shouts of "Presumptuous fellow! Crazy rascal!" broke out, and the delegates were pushed violently out of the hall, but Barbardori was beyond feeling such poor insults, and, had he cared to listen, he might have heard some there mutter that here was a brave man, in whom a ray of antique virtue had shone out.

At first the effect of the interdict on Florence was to rouse immense indignation, and for a while the peace party ceased to exist. Excommunication had lost much of its terrors in Italy, and the Florentines did not at first realize what the effect would be in other countries. But too soon they learned what it meant to

[16] Saint Antoninus, *History of the Papacy.*

find themselves banned and proscribed, unable to buy or sell in the great fairs of Europe, their contracts annulled, their debtors released from all liabilities. Commercial rivals and enemies took instant advantage of the situation; trade fell dead, workshops were closed; no vessels came up the Arno; poverty stalked ghastly through the city.

Besides this, the consciences of pious men and women were grievously troubled at the cessation of religious rites; the populace, hungry and workless, began to murmur and threaten, and the Eight of War, alarmed by the rising tide of discontent, suggested calling in Catherine of Siena to mediate between Florence and the Pope. It was known that she had already written to him on behalf of the city, and he was said to have an extraordinary respect for her, and on more than one occasion to have asked her advice. She had also written to Niccolo Soderini, a patriotic citizen who had held the offices of Gonfaloniere della Giustizia and Prior of the Arts — in the merchant city arts stood for trades — and her letter had suggested peace and reconciliation. Niccolo Soderini was sent to Siena to beg her to come to Florence and use her influence with the Pope, and Catherine, though hardly risen from a sick bed, at once consented and went for the second time to Florence.

Hardly more than two years before, she had entered the city gates for the first time, slandered, in disgrace with her sister Mantellate, summoned to appear and disculpate herself if she could before a chapter of the order. In a contemporary manuscript, as we have seen, it is recorded that "there came there in May 1374 when there was a Chapter of the Friars Preachers, by command of the Master of the Order, one with the habit of a *pinzochera* (sister) of Saint Dominic, called Catherine of Jacopo of Siena." Now the *pinzochera* was implored to come as mediator between

the city and Avignon, the one person whose voice might prevail with an angered Pope!

Her ready good offices for the formidable rival of her own city is a fresh proof of her courage and large generosity at a time when "country" meant to an Italian merely his own native place, whose interests he was bound to prefer to everything else. So far was this carried that old commentators on the *Divina Commedia* explain Dante's unflattering surprise at finding "*Giudice Nin gentil*"[17] in no worse place than Purgatory by his having known that the unpatriotic judge had ruled his province in Sardinia for its own good rather than to the advantage of his native city of Pisa. The good fortune of each town was regarded as the calamity of its neighbor. There was no thought at all of a united Italy in the modern sense, any more than there was of what is now called liberty, though it may have crossed a few elect minds, already touched by the breath of the Renaissance, such as Petrarch's, and possibly Catherine's. In the case of Petrarch, absence, reverence for Italy's great past, admiration for her buildings and her scenery taught him to regard her as one whole. It is not his birthplace, Arezzo, which he exalts in writing to his friend Francesco Nelli, but his country. With Catherine, Christian charity broke down all barriers, and, like Rienzi, she longed for "a brotherhood of cities," though an Italy under one ruler was an inspiration unknown to her. The help lately afforded by Florence had created a temporary friendship between Sienese and Florentines; otherwise her fellow townsmen might have put obstacles in the way of her good offices for a city that had always been a danger to Siena. Even in the present day, ill feeling has not quite died out between the two towns. Florence is slightly contemptuous of

[17] *Purgatorio*, Canto VIII, lines 52–54.

Siena, and Siena flatters herself that the defeat of Monteaperto
still is grievous to her former rival. Yet she went at once when
called to help the Florentines, and their historian Ammirato
testifies that "although there was no lack of those who spoke ill
of and blamed her, she truly was by the greater number of men
and women reputed a most acceptable and dear servant of God."

A most difficult task lay before her. The multiplicity of of-
fices in the government of Florence, the short time they were
often held, the contrary interests of those who filled them, the
intertwined factions, the jealousies and suspicions of high and
low made a labyrinth where it was hardly possible to find a clue.
Soderini introduced her to the captains of the people, and she
saw and spoke with all the other leading men in the city, seeking
to understand the general feeling of the townsfolk and what the
real position of affairs was. There was now a party of moderates,
led by Soderini, who urged that she should be sent to Avignon
to plead with the Pope face-to-face, but this plan was unwelcome
to the Eight of War, to whom peace meant not only loss of posi-
tion and authority, but the prospect of being called to account
for their stewardship. They had made too many enemies not to
fear the day of reckoning. They did not venture to oppose the
peace party openly, but that Catherine did not feel sure of their
support is shown by her words, quoted by herself in a letter sent
from Avignon. "See, signori, if you truly mean to submit to the
Sovereign Pontiff, I will flinch from no toil or trouble in bringing
this matter to a happy end, but on no other condition will I go."

She sent Raimondo to Avignon, to prepare her way, and while
waiting for his report, refreshed herself amid the anxieties and
toils that crowded on her by visiting the churches in Florence,
spending much time in beautiful Santa Maria Novella, not yet
completed, but she would see the frescoes painted in what is now

called the Spanish Chapel, probably by her fellow townsman Simone Memmi, with their scenes from the life of Saint Dominic, where black and white dogs—*domini canes*—represent his monks, and bite and hunt heretics in the form of wolves. And opposite she would find a quaint version of the angels proclaiming that which was her heart's desire, peace on earth and goodwill to men, while the shepherds gaze startled at the angelic choir overhead, one holding back his dog which leaps furiously upward, barking at the angels, and overhead on a hilltop are sheep and lambs, and an angel bends downward and stretches out his hand to stroke them. She went to other places, too, in the surrounding country, where her name is still held in honor: in Val d' Elsa a chapel was built over a fountain at which she drank; in Pontormo lives a tradition that she came there just when the bell for the church was being founded, and cast her ring into the molten metal, in memory of which the bell received her name.

She was conscious of the difficulties in her way as to reconciling the Pope at Florence, but full of hope, earnestly repeating what she had already enforced by letters to Soderini and others, that the duty of the Florentines was to humble themselves before the justly offended Pope, "but worse things came upon them than ever their forefathers had known." On the other hand, she wrote to Gregory, sending her letter by Neri di Landoccio, whose rank and accomplishments would claim consideration at the papal court, putting before Gregory the wrongs of Florence and the intolerable tyranny of his legates. Raimondo da Capua was already negotiating there. But again Gregory would and would not, according to the influence that chanced to be uppermost. While ready to treat with the Florentines and constantly asking Catherine's advice, he was preparing for a war in Italy that was to disgrace his pontificate as one of the most savage of that

bloodstained century. The commander-in-chief was not even a layman, but one of the Sacred College, Cardinal Robert of Geneva, a daring soldier, one day to be antipope. He led a horde of mercenaries, Bretons, Germans, English, French, who laid Romagna waste and shocked profoundly an age not easily moved by crime or cruelty, by the sack of Cesena. When the cry of that miserable city went up to Heaven, did Gregory XI recollect his own solemn letter to the Black Prince, representing to him the horrors of war? When in 1377 this "enormous crime," as the archbishop of Prague most justly called it, was committed, Florence took instant advantage of it, appealing to all Italy and the rulers of Christendom against it, and not one voice was heard to excuse it; for the moment it greatly strengthened the League and rendered vain all efforts to obtain peace. This iniquity had not yet taken place when Catherine was at Florence, or she might never have been sent to Avignon, so great was the indignation against Gregory. As it was, she felt the discouragement of the conflicting parties in the city and the want of result of her letters to the Pope, in which she vainly urged pity for his flock, his little sheep, worth so much more to the Church than gold or lands.

He was by no means a cruel man, but a weak one, and a weak man irritated and frightened is capable of any cruelty. He asked her advice, but he listened only to the voices of his fears and of his French cardinals. Fearing that letters were of little use, Catherine prepared to go herself to Avignon, as the moderate party in Florence had wished, and she wrote once more to Gregory, announcing her arrival as ambassadress of the Florentines and to speak in the name of all Italy, which implored him "to linger no longer in Babylon"; it was high time to go to Rome.

It was indeed. There were seditious cries there that if the Pope did not return speedily, Rome would elect another, and

an antipope was not a thing unknown. When Louis of Bavaria came to Italy, Rome warned John XXII that if he did not come back, they would receive the emperor; and Sciarra Colonna, whose name alone was a threat to popes, was elected captain of the people. The Roman populace demanded a Roman Pope, and with no more consecration than the consent of Louis, Pietro di Corvara was proclaimed Pontiff and created cardinal. But the tide ebbed. Louis quitted Rome; Sciarra Colonna did the same. Nicholas V, as the schismatic Pope was called, fled to a castle in Pisan territory and thence was taken to Avignon and led into the hall where the consistory sat, with a halter around his neck. On the whole, he was generously treated. Pope John spared his life, and he was kept in a not-severe imprisonment, with books to pass the time, and so disappeared from the world.

But the fact that there had been antipopes who were received by Rome and many ecclesiastics, together with the discovery that numbers of the country priests had encouraged their flocks to drive out the legates, alarmed Gregory seriously, and his advisers assured him that concessions spelled weakness, and they advised severe measures. He still listened now to Catherine's counsels and his Italian cardinals, now to his French ones, uncertain of his own judgment, anxious to do right, afraid to do wrong whichever way he turned. He was one of those gentle, overconscientious, disastrous rulers who so often appear at critical times, and ruin themselves and others with every desire to act justly and wisely, drifting hither and thither, and always led by stronger and less scrupulous spirits, and Catherine's lot was to be among such as "Fought in vain / For those who knew not to resign or reign."

Chapter 8

⚜

Catherine as Ambassadress

It is unfortunate that neither Raimondo nor any of Catherine's followers give details of her journey to Avignon. That it was slow and dangerous is certain. She traveled through country disturbed by war and where at any moment the Free Lances might appear. Very few of her company were capable of bearing arms, and among them were helpless women, chosen from among the Mantellate, to share her perils and have the coveted honor of seeing the Pope and receiving his benediction, a privilege for almost seventy years almost unknown to Italians, besides which, although they must have been rather a hindrance on the way, she thus had witnesses to testify to all that she did to any of the sisters left behind who might murmur or criticize.

Whether Florence provided funds for the journey is not known, but difficulties and fatigue were minimized as far as possible by the Buonconti, Catherine's kind hosts when at Pisa, who accompanied her and made arrangements for rest and traveling. One of the very few notices that throw any light on the arrangement is a chance mention that at meals the men of the party were served first, eating alone, and then the women.

Saint Catherine of Siena and Her Times

They left Florence in May 1376, a party of about twenty, among whom, to his great joy, was Stefano Maconi. While still in Siena she had told him that his dearest wish would be accomplished, to which he answered, "My dearest Mother, I have no greater wish than that of always remaining near you."

"It shall be fulfilled," was her smiling reply.

Stefano could not but think of all the obstacles in the way — sex, rank, his parents' plans for him, and said nothing, but when chosen to accompany her to Avignon he left with joy (as he says in a letter preserved in the Library of the Grande Chartreuse as long as there were monks and a library there) father, mother, brothers, and sisters, so happy was he to serve her. He acted as one of her most trusted secretaries, and was loved by her "with the tenderness of a mother, and far more than he deserved," as he tells the friend in Venice to whom the letter is addressed, and "consequently several of her disciples conceived a strong feeling of jealousy."

Besides Maconi there were Neri dei Pagliaresi in her company, and Don Giovanni Tantucci, and Neri di Landoccio. Her journey was overland, since it is stated in the bull of her canonization by Pius II that "to reconcile the Florentines and the Church she did not hesitate to cross the Apennines and the Alps in order to reach Gregory." Her route was the same as Dante's; she too followed the Roman road along the Cornice, now coming down to the shore, now climbing high aloft; she too descended the steep cliffs of Noli and passed under the ruined Turbia and passed through the Esterels, and we may be certain that one so sensitive to the beauty of nature was charmed by that beautiful scenery. Saint Bernard might travel for a long day beside the Lake of Geneva, lost in meditation, and at the end of his journey say, "A lake? Where was it?" but Catherine was made in a different

mold. Stefano Maconi records her delight in the mountain flow-
ers and how she called the attention of her companions to them,
and we know how the sight of the sea impressed her. But she
could not linger; she longed to reach Avignon and plead that
Gregory would pardon Florence and return to Rome; besides
which the thought of finding herself in the presence of the Pope
was a spur that drove her on, ill and weak though she was. On
the eighteenth of June 1376, she reached Avignon.

Petrarch had found no words bad enough for *la ville sonnante*,
as it was called from the ever-ringing bells of its churches. To
him it was "avaricious Babylon, the smelliest of cities, horribly
windy, ill built, inconvenient, the inferno of the living, a sink
of vice, the opprobrium of man," and finally, "the stink of the
universe." Nevertheless, he spent a good deal of time there, and
his rhetoric must be taken with several grains of salt.

Other writers give a different aspect of the little city by the
Rhône, with its palace piled up on the rock overhead, a wicked
little city that had become more luxurious than any town in
Christendom since it could boast of being the seat of the pa-
pacy. "In the streets, where all kinds of goods are displayed,"
says Calisse,

> sheltered from the sun by awnings extended high above
> them, moves a restless and singular crowd, such as could
> hardly be found elsewhere. Here are splendid cavalcades
> of ladies, knights, and cardinals, all purple, silk, and
> glittering armor, hawk on fist, pages and jugglers around
> them. Troops of lighthearted students, bands of pilgrims
> with gourd and staff, friars of all kinds and colors, doc-
> tors in their robes, theologizing as they go, clerics come
> from every part to ask for dispensations and prebends,

astrologers, poets, insolent mercenaries, Italians and French, now brawling, oftener reveling together, without a thought of the morrow, and over all, most threatening of strongholds, is the seat of the Vicar of Christ.

Catherine had seen three of the chief cities of Italy: Siena on her three hills, Pisa and her mart, "Queen of the Western waves," Florence with her "architecture of civil war," but nothing that she could have beheld could have prepared her for such a scene as Avignon presented. With her lively interest in her fellow creatures, she must have been greatly struck by it, although all would have seemed unimportant compared with the palace overhead where she would find Gregory.

Raimondo met her and translated to her a Latin letter from the Pope, who had ordered a *livrée* to be prepared for her. This was the name given to the palaces of cardinals in Avignon; the one destined for Catherine and her companions had belonged to one who, according to some accounts, was dead, to others, absent at that time. It was built in the shape of a great tower and in a later century passed into the hands of the Jesuits.

In its beautiful chapel Catherine was kneeling the next morning when the Pope sent one of his dignitaries to greet her and ask for her prayers. This was Thomas Petra, the papal pronotary, who became one of her warmest adherents and was in Rome at the time of her death. Although the hot weather had hardly begun, Gregory had already retired to the country palace where the Popes were accustomed to spend the summer months, and two days elapsed before he returned to Avignon and received Catherine. She spent these in visiting the hospital founded by the nuns of Saint Prassede, detached from their convent, which was outside the town, and then the Dominican friars, in whose

monastery their founder had blessed a well for the use of the community when he was there to preside over a council that decided on war against the Albigenses. In this monastery sat the Inquisition, out of reach of the French Parlements, which steadily opposed its introduction into Gallic territory. Nothing remains of the fine buildings, which were all destroyed in the Revolution.

Everything connected with Saint Dominic had a strong interest for Catherine, and tradition tells that on her way to Avignon, she paused at Bologna, visiting the Dominican convent there, and that she stood looking long at the cemetery enclosed by cloisters where he is buried. "How sweet it is to sleep there!" she is reported to have said. Had not a book ascribed to Don Giovanni delle Celle, relating to Catherine, been lost, we might have had more details of this memorable journey. In the monastery at Avignon she asked and obtained the friars' advice as to what was her wisest course amid the pitfalls of the papal court, but they declared that they gained more wisdom from her than they could give. "It is always so when one comes to our Mother," said her followers triumphantly.

On June 28, with Raimondo to interpret her sweet Sienese dialect, she climbed the windy rock where the huge pile of the papal residence stood and entered the hall adorned with frescoes by great Tuscan painters, all unhappily now destroyed. Had she not been strong in the belief of a Heaven-given mission, she might well have trembled at the ordeal of appearing in that same hall where the delegates of Florence had fared so ill, where Barbardori had appealed from the injustice of a Pope to the judgment of God, and where now sat the same magnificent court, full of unfriendly faces, all the questioning eyes turned silently on the young ambassadress in the mantle so often patched by her own

hands.[18] Seated in the center of the semicircle, the Pope almost alone looked encouragingly at her and listened with marked interest as her Tuscan was interpreted by Raimondo into Latin for his benefit, for though he had studied for a short time in Perugia, all lectures were given in Latin, and, like a true Frenchman, he had never cared to acquire any modern language not his own.

Strongly moved by her pleading for Florence, he answered in words that startled his court and, in spite of the warning of Barbardori's bitter delusion, filled her with hope of peace and clemency: "That thou mayst clearly see, O woman, that my desire is for peace and concord, let all the matter remain in thy hands; only I recommend to thee the honor and welfare of Holy Church." He then left the hall, as did Catherine, while the French cardinals drew together to discuss this unwelcome turn of affairs, and the measures to be taken with regard to this Mantellata, who already had so strongly influenced the Pope, and who would assuredly use all her power to induce him to return to Italy.

For a happy moment Catherine could believe that one of the great objects of her journey was secured, and it is pathetic to read the joyful words that she wrote to one of her disciples in Siena, all unaware that she was building on sand. "By the grace of our sweet Savior we came to Vignone twenty-six days ago, and I have spoken with the Holy Father, and certain cardinals and secular lords, and the grace of our gentle Savior has been greatly shown in the matters for which we came here."

But the tragic fate of great plans begun in hope and ending in failure that marks the whole history of Siena followed Siena's daughter now and always. She had soon to write in a

[18] Some of Catherine's biographers assert her to have first seen the Pope privately, but this is doubtful.

very different strain to Florence, whence no ambassadors came to ratify the peace to which Gregory had consented. On the contrary, new causes of offense arose, and a report was spread, apparently by those who wished ill at Avignon to peace in Italy, that a heavy tax had been laid upon the clergy.

Even Catherine believed it at the time, and she found herself in a most painful position, ignored by the *Otto della Guerra*, and sneered at by the papal court, who questioned whether she had really been accredited to the Pope or had come on false pretenses. The gay ladies who formed a too prominent part of that court were at first disdainful of her, then jealous and alarmed by her influence with the Pope, who showed his esteem for her unmistakably. His leaving Avignon would destroy the brilliant circle where they shone. They set themselves to win her. Religion became the fashion; they learned at what hours she went to pray in the chapel attached to the palace where she was living, and they appeared there too, kneeling and apparently absorbed in prayer.

Raimondo was accustomed to being asked to allow Catherine to be seen when rapt in ecstasy. Often in Siena had such requests been made, and they neither surprised nor shocked him. He saw nothing incongruous in them, and much edified by these tokens of grace in the lively ladies of Avignon, and, as he ingenuously owned, a little impressed by their beauty and fine dresses, he called Catherine to account for showing them something like discourtesy. She turned on him with burning words, telling him that these lovely ladies were mere hypocrites, vile of life, full of the odor of sin. He must have changed his opinion of them when the Pope's own niece, Madame de Beaufort Turenne, played a cruel trick on Catherine, as it seems with the hope of proving that her unconsciousness of all earthly things while praying was

but feigned. Kneeling close beside her, she ran a slender dagger deep into her foot. Catherine felt nothing at the moment, but when she arose, she could hardly limp out of church.

The attempt already made by learned men in Siena and Pisa to put her to confusion was repeated at Avignon with the same result. A full account is given in a letter of Maconi to a friend who was a monk in Venice.

> Three eminent ecclesiastics came to Gregory and asked, "Most blessed Father, is this Catherine of Siena as holy as they say?" "We truly believe that she is a holy virgin," answered the Pope. And they: "If it please your Holiness, we will visit her." Answered the Pope, "We believe that you will be edified thereby." Then came they to our house directly after Nones in summertime, knocking at the door, and I ran toward them, who said, "Tell Catherine that we would speak with her." Hearing this the holy virgin came down, together with Maestro Giovanni, her confessor [this is the only time that Prior Giovanni is so named; he must have had this office because Raimondo had been absent] and some other religious, and in a convenient place they made her sit in the midst. Their exordium began with a great pride, seeking to irritate her with biting words, and among other things they said, "We are come from the Holy Father, our lord, and desire to know if Florence have sent thee, as is publicly said, and if it be true, have they no worthy man whom for so great a business they could send to such a lord? And if they have not sent thee, we marvel greatly that thou, being of mere base womankind, shouldst presume to speak of such high things with the Pope our lord."

But Catherine, like an immovable column, ever gave such humble yet most effective replies that they remained exceedingly astonished. And having fully satisfied themselves on this matter they put to her many questions, especially upon her abstractions and very strange way of life, and since the Apostle saith that Satan can transform himself into an angel of light, by what sign she knew that she was not deluded by the demon, and many other things they said, and indeed the discussion lasted until nightfall. Sometimes Maestro Giovanni wanted to answer for her, but although he was Master in theology, those others were so strong that in a few words they confounded him, and said, "You ought to blush to say such things in our presence; let her speak for herself; she satisfies us better than you." Among the three was an archbishop of the Minorites, who showed a pharisaic countenance, and at times seemed not to approve Catherine's words, and at last the two turned on him, saying, "What more do you seek from this virgin? Without doubt she has declared and answered fully these matters more than we have found in any Doctor, and many other signs, and those most true has she shown us," and thus there was schism among them. At last they departed, edified and comforted, and told the Pope that they had never known a soul so humble and so illuminated. But when he heard how they had proved Catherine, he was displeased and excused himself to her, adding, "If ever they come again, have the door shut in their faces."

The following day our Maestro Francesco da Siena, then the Pope's physician, said to me, "Dost know those prelates who went yesterday to thy house?" to which I said, "no." He then: "Learn that if the knowledge of

those men were put into one scale, and in the other the knowledge of all the Roman Curia, that of those three would weigh far heavier, and I can tell thee that if they had not seen this virgin to be firmly founded, she would never have taken a journey worse for her."

Such examinations in theology were indeed a dangerous matter, for a chance word or inexact statement would have given opportunity for the terrible accusation of heresy. Enemies had already suggested that Catherine held the doctrines of the Fraticelli, whose teaching was that priests should own no gold or silver or worldly goods, a view that brought them into extreme ill odor among the higher clergy, and when Don Giovanni was fain to reply in Catherine's place, he may have feared lest she should commit herself. It is noteworthy that while she showed some just displeasure at the snares laid in like manner for her at Siena and Pisa, she answered the self-styled papal messengers with perfect mildness and patience, supposing them to have come by Gregory's desire. She had so overcome a naturally very eager and impetuous temper that Maconi goes so far as to say he never knew her to speak with irritation. Yet she was rarely out of pain, often worn out, and always with countless anxieties and difficult questions to claim her attention. The very love poured out on her was at times exacting and a burden, and she was thwarted, misunderstood; her longing was for solitude and meditation, but she was called to live a life of incessant occupation among people often quite uncongenial. And yet Stefano Maconi, who saw more of her than anyone except Raimondo and Alessia dei Saraceni, never saw her out of temper!

Just at this time her private troubles were pressing on her. Whenever she was away from Siena the magistrates were

dissatisfied, and jealousies sprang up among her followers; there were querulous complaints that she cared more for strangers than for them. Matters went wrong for want of her advice and super-intendence; families, members of whom had left home to follow her, wrote recalling them; Stefano Maconi's mother could not reconcile herself to his long absence.

Monna Lapa, now an aged woman nearly eighty years of age, was another difficulty; she could not put up with Catherine's leaving her and heard all the gossip in Siena about her wandering from her cell; Catherine had to write again and again reminding her that she had not hesitated to let her sons leave her to earn money and surely ought not to grudge her daughter to far more important work. To Monna Giovanna di Corrado Maconi she also wrote, trying to soothe her impatience at the delay in her son's return, and pointing out that he was leading a better and higher life than he could possibly do among the gay young nobles of Siena. Monna Giovanna's impatience reached a climax at last, during a long unexpected delay at Genoa, and Catherine wrote:

> Comfort yourself gently and be patient, and not troubled because I have kept Stefano so long, for I have taken good care of him; through love and tenderness I have grown one with him, and so have treated what is yours as if it were my own. I think you have not taken this in bad part. I wish to do whatever I can for him and you, even unto death. You, his mother, bore him once, and I desire to bear him and you and all your family in tears and sweat by continual prayer and longing for your salvation.

Whether the mother was satisfied we do not know, but it may be conjectured that she was, as Stefano was allowed to go

to Florence as a deputy from Catherine not long after his return from Avignon.

All minor troubles were swallowed up by the great and increasing anxiety with regard to Florence, which had replaced Catherine's first glad hopes. Ten days after her arrival in Avignon, she found herself obliged to write severely to the Eight of War, warning them to act straightforwardly.

> I complain greatly of you if what they say here be true, namely, that you have taxed the clergy. If this be so, you have done a twofold wrong, first because you are offending God, for you cannot do it with a good conscience. But it seems to me that you are losing your conscience and everything good; it appears as if you care only for the passing things of the senses, which go by like the wind.... I tell you, such doings are ruin to your peace, for if the Holy Father knew it, he would feel yet greater indignation against you, and this is what some of the cardinals, who seek and desire peace, are saying. Now, hearing this report, they say, "It does not seem as if they really want peace, for then they would avoid every least act against the Holy Father and the usages of Holy Church." I believe that the sweet Christ on earth may say these or like words, and He has very good reason to do it.... You might bring shame and confusion upon me [she adds, as a very gentle reminder of the painful position in which she found herself], for nothing but shame and confusion could come of it if I told the Holy Father one thing, and you said another. I beg that it may be so no longer. Rather, seek by word and deed to show that you want peace, not war. I have spoken with the Holy Father, and by God's goodness and his own,

he heard me graciously, showing that he had a love for peace. When I had talked with him for a good long time, he ended by saying that if things were as I set before him, he was ready to receive you as sons, and do what seemed most pleasing to me.

I say no more here. It seems decidedly that no other rule can be given till the ambassadors come. I marvel that they are not already here. When they arrive, I will see them and then the Holy Father, and as I find things, so will I write to you. But you with your taxes and novelties spoil all that is sown. Do so no more, for the love of Christ crucified and for your own advantage.

The ambassadors came at last, but from the brief tenure of office in Florence a new set of men were now in power, and the Eight of War had been able to choose delegates averse to peace, and who perfectly understood that their business was to make it appear to the Florentines that through Catherine's ill management the Pope refused to negotiate with them. Such treachery could not cross her mind, and she was unable to understand the meaning of their conduct, but the Pope, shrewd and versed in the ways of men, perhaps too kept aware of the secret policy of the Eight by adherents in Florence, warned her what to expect. "They are deceiving you, Catherine," he said. The truth of this was forced upon her by the studied and insolent neglect of the three ambassadors, who, far from consulting, actually disowned her. It cost her bitter tears, and, writing to Buoncorso di Lapo, one of the "grandi" of Florence, she says:

Alas, alas! dearest brother, I grieve much over the fashion in which peace has been asked for from the Holy Father. Words have been more to the fore than deeds. This I say

because when I went to you and your Signori, they spoke as if they wished to humble themselves, asking mercy from the Holy Father, and I said to them, "Then, Signori, if you really mean to show all humility in word and deed, I will labor all you can desire, otherwise I do not go," and they answered that they were well pleased. Alas, alas! most dear brother, that was the way and the door by which you should have entered, and there was no other. Had you followed that way in deeds as in words, you would have found it the most glorious that ever man had. And this I say not without warrant, for I know what the mind of the Holy Father was, but since we began to leave that way, following the subtle fashions of the world, doing otherwise than words had implied, matter not for peace but for more disturbance has been given to the Holy Father. For your ambassadors coming here have not behaved in a manner to make them held servants of God. You have behaved after your own manner. And never have I been able to confer with them as you told me to do when I asked for the letter of credentials.

As if to show that he in no way held Catherine responsible for the conduct of the Florentines, Gregory treated her with constant favor. By his order she spoke several times to the cardinals and great ecclesiastics in the hall of the consistory, where their unaccustomed ears heard startling truths. Why, she asked on one occasion, standing before them, a slender figure in the black mantle and white serge dress of the Mantellate, did she find only the worst vices in a court where all virtues should dwell! She stood silent, waiting for a reply. The Pope, uneasy at the anger he saw around him, interposed by asking what she, only lately

come, could know of the matter. Catherine stood erect, with an air of authority that astonished everyone and, lifting one hand to Heaven, said, "I will dare to say that I was more aware when I lived in my own city of the infection of the sins committed in the Court of Rome every day than are they who commit them." The Pope had no reply to make, and Raimondo, although well used to her fearless speeches, listened with astonishment at her boldness not unmixed with alarm. "I shall never forget the dignity with which she did not fear to speak to so great a prelate," he writes.

It needed no superhuman powers to perceive the sins and follies of the court at Avignon, with its luxurious prelates and its gay ladies whose names fall on the ear like music — Miramonde and Elys and Énémonde, Briande and Éstephanette and all the rest — but Catherine could read hearts in a way that almost made those about her fear her powers. "Truly, dearest mother," said Stefano Maconi, between jest and earnest, "it is as dangerous to be with you as to cross the sea, for you see all that is in us." And Raimondo testifies, "She often told us the thoughts of our hearts as fully as if they were hers, not ours; I know it by myself, for she often blamed me for certain thoughts of mine that indeed I had, and I — I will not blush to own this, since it is for her fame — I would seek falsely to excuse myself, and she would reply, 'Why deny what I see plainly? More so than yourself.'"

It might not need much discernment to guess the thoughts of one so honest and simple, but Fra Bartolomeo goes a step further. Astounded by her knowledge of what he and another friar had spoken deep in the night, he exclaimed, "O mother, how do you know this?" She answered, "Know that since our sweet Savior was pleased to give me sons and daughters, nothing that concerns you is hidden from me; I watch and pray for you, and if you had good eyes, you would see that I am with you and behold all you

do." Catherine here claimed a power that undoubtedly exists in certain cases and is acknowledged in our own day in many who are not saints, but which science has yet to explain.

Baffled in her efforts to make peace between Gregory and Florence, obliged to put aside her hopes of a Crusade, Catherine set herself strenuously to induce the Pope to return to Rome. Not only was Rome his proper place, but if the luxurious and vicious Court of Avignon were broken up, a step of great importance would be taken toward the reformation of ecclesiastical morals. Urban V had thought the same and given it as one of his reasons for leaving Provence. Besides this, every Pope must have felt that not in a palace on a rock amid a small Provencal town, but where the blood of martyrs had consecrated the soil and where were glorious associations such as only Rome could boast was the rightful seat of the papacy. As early as 1375 Gregory had sent letters to different princes, declaring his firm intention of going back there, but he had done no more. The sense of an obvious duty unfulfilled troubled him; the adjurations of Petrarch and of Brigitta of Sweden rang in his ears; his legates assured him that unless he arrived quickly, the Popes might lose both their spiritual and temporal hold on Italy; Catherine of Siena told him the same. He answered that he was fully purposed to return, but he had neither energy nor courage to break through the obstacles raised up all around him by those whose interests it was to keep him in Avignon. "All the cardinals of this tongue [French] are opposed to his going, and so are his father and brothers, and I hear that the Duke of Anjou is coming to hinder it if he can," Cristofero di Piacenza wrote from Avignon that July of 1376, and Gregory XI did not share the view of Benedict XII, who said that a Pope should be like Melchisedek and have neither father or mother nor genealogy.

Cristofero di Piacenza had been correctly informed; the Duke of Anjou was really coming to Avignon, charged by his brother, Charles V, to dissuade the Pope from leaving Provence and to counteract the influence of the *pinzochera*, who had gained so great an ascendancy over him. He arrived prepared to look on her as an enemy; he became her friend. At his request she went to visit his wife, who disliked the court at Avignon and its fair, frail ladies, and was staying at the border fortress of Villeneuve, which belonged to the duke. The town beneath it can now be reached only by a wooden bridge, for of the stone one, built in 1188, only a few arches remain. Strong as it was, it could not resist the tremendous current of the "arrowy Rhône," and in 1669 the greater part fell. But Catherine crossed it in 1376 and no doubt was told the legend of its shepherd builder, Saint Benezet, whose body was placed in a little chapel on the bridge, which is there still, but his remains were carried to Saint Didier in Avignon, where they have remained ever since, undisturbed even in the revolution that swept away so much that was ancient and interesting in the city of the Popes.

The Duke of Anjou was not a particularly estimable man, but he had a good wife, and Catherine spent three days in his castle, during which she had much conversation with him and inspired him with a strong desire to head the Crusade, and her hopes rose again. Now she could tell Gregory that the leader had been found without whom he had declared nothing could be done.

He replied by objecting that until peace was made among Christian nations, it was useless to plan Crusades. Catherine was not of this opinion. Where he saw difficulties, she saw hopes. To proclaim a holy war would draw those now engaged in fighting for themselves into a nobler warfare, and occupy the mercenaries. "If these gained victories," she argued, "the Pope could deal with

the Christian princes; if vanquished, he would have at least saved their souls, besides which, many Saracens might be converted." Catherine was of an optimistic nature.

Either from genuine admiration, or mindful of his mission to detach the Pope from Catherine, Anjou urged her to go to Paris and negotiate a treaty of peace with England. It seemed, however, improbable that since the Pope's effort to mediate had been received with almost insulting indifference by England, hers would be successful, and she refused, but she wrote the long letter to Charles V already alluded to. His people flatteringly called him the Wise, a name she gracefully alludes to when she writes, "Therefore I beseech you, as wise, act as a good steward, holding your possessions as things lent." She pleads for peace at any price, and war with only infidels, and tells him that her brother *"missere il duca d'Angiò"* is, she thinks, desirous to take the cross. From the heading in a codex, the letter appears to have been written by the desire of the duke.[19] What Charles V thought of her letter does not appear, but he did not make peace, nor did Anjou head a crusade; instead he died ingloriously in Apulia, a supporter of the antipope and of Giovanna of Naples, and thus another great hope of Catherine's proved but delusion.

The question whether to go or stay tortured Gregory. His family and his cardinals put before him the unhealthiness of Rome, and the dangerous state of the country, the greater distance from France, Germany, and England, the long time it would take for messengers and dispatches to pass between him and the courts of Christendom if he went to Rome; the need of hastening negotiations for peace between Charles V and the English government. The Black Prince had died, and his son was a young boy. Now

[19] Tommaseo, Letter 235.

was the time for a durable peace. And Gregory was attached to England, as he did not fear to show, and Englishmen were always welcome at Avignon.

Frenchman though he was, he always dealt fairly toward England, though he held that he had reason to complain of her. The papal treasury was uncomfortably empty; the war with Bernabò Visconti ruinous. Gregory asked for subsidies from all the faithful, but in his letter to the archbishop and bishops in England, he complains that all countries have responded to his appeal, theirs excepted. He also begs King Edward III not to hinder money being collected for him, a request that met with a tacit refusal, since the King's justiciaries and also the bishop of Lincoln were summoned to Avignon for having impeded the collection. Another letter written to Edward three years later, in 1375, speaks of his feeling that it his bounden duty to visit Rome speedily. The time was come when this decision must be carried out, if he were to continue to rule in Italy. He longed for some sign that might guide him, and sent a message, bidding Catherine put up special prayers for him. The supplication uttered by her in ecstasy was heard and written down by his pronotary, Petra, and is found among others that have been preserved. One of the Buonconti was also present and relates that after making a second prayer she remained rigid and unconscious, with her arms crossed on her breast for about an hour, without visibly breathing. Alarmed at the length of her trance, those about her sprinkled her with holy water, and she came slowly back to life, murmuring, "Praise be to God, now and forever."

This state has been regarded by some who have written of Catherine as merely hysterical, but it differed from such an experience in being a time of vivid spiritual illumination, of which a distinct memory remained, though little could be put into

words. It also differed in that, though weak and feeble before it occurred, she constantly felt refreshed and full of energy after it ceased. Other mystics of various communions knew and know conditions of the same kind. It is this state that Saint Teresa calls "the orison of union," when

> the soul is fully awake as regards God, but wholly asleep as regards things of this world, and with regard to herself ... she is absolutely dead to the things of this world, and lives only in God.... I do not even know whether in this state she has enough life left to breathe.... When she returns to herself it is wholly impossible for her to doubt that she has been in God, and God in her.... If you ask how can a soul see and comprehend that she has been in God, since during the vision she has neither sight nor understanding, I reply that she does not see it then, but that she sees it clearly later, after she has returned to herself, not by any vision, but by an abiding certainty that only God can give her.

And in another place she writes, "Often feeble and wrought on by severe pains before the ecstasy, the soul comes forth from it filled with health and admirably ready for action ... as if God had willed that the body, obedient to the desires of the soul, should share in her happiness."

More or less, Catherine shared the same experiences as the Spanish saint.

Hoping to bring Gregory to a decision, she asked for an interview, and went with Raimondo to the palace, where she found Gregory standing at a window, looking with sad eyes on the wide view extended far below. She could not venture to address him until he should turn and speak, and she paused before a table

on which lay a beautifully illuminated missal, with silver clasps. Gregory was both a student and a book collector. At one time he desired a canon of Paris to have certain works of Cicero that he had heard of in the Sorbonne copied as soon as possible by capable scribes. At another he bade his legate de Noellet have all Petrarch's works sought out and copied, especially his Latin poem "Africa" and his letters, and he also invited the poet to Avignon in a letter written by his own hand. Clement VI had already employed Petrarch in the congenial task of collecting ancient manuscripts for the papal library, and he was nonetheless welcome at the court because he had said exceedingly hard things of it — things that his own life hardly gave him the right to say. Catherine must have heard of them and him, and though his love poetry would not interest her, she may have read his *canzone* to the Virgin and some of his religious sonnets, but there is no allusion to him in her letters.

Pleased by her admiration for the missal, Gregory came up to her and said, "Here my spirit finds repose in study and in contemplating the lovely things around me." But Catherine had no sympathy for this mood, and looking straight at him, as her manner was, she said, "To do our duty, most Holy Father, and act according to God's will, you shall abandon these beautiful things and take the road to Rome, where perils and malaria and discomfort await you, and where the delights of Avignon will be but a vain recollection."

There was something in Gregory's character, notwithstanding his nervous timidity, that responded to words like these, but several other interviews were needed before he could definitely make up his mind, and Catherine's whole energy was needed to support him. To the argument used by his cardinals that Clement IV, or Pope Chimente, as she calls him, never acted against the

advice of the Sacred College, and even if it seemed to him that his was the right view yet followed their advice, she answered,

> Alas, most holy Father, they bring forward Pope Clement IV, but say nought to you of Pope Urban V, who when in doubt asked their counsel, but for a thing clear and sure to him as is your departure to you, he heeded not their opinion, but acted on his own, and cared nothing though they were all against him. Use a holy deceit; appear to delay and then act at once, for the sooner you do so, the less harass and trouble you will have.... Let us go soon, *babbo mio dolce* [no translation can give the equivalent of the caressing Italian] without any fear.

Catherine understood the character that she was dealing with. Gregory had not courage for open resistance, but he seized on the idea of a *santo inganno*, and while allowing it to be supposed that the date of leaving Avignon was still uncertain, secretly hurried on his preparations. A galley had come to Marseilles to receive him before his cardinals realized what was about to happen. He appointed the Vicomte de Turenne to govern the city and province of Avignon, advised by such cardinals as would not go to Rome, and the Sicilian barons were bidden to meet him at Ostia in about a fortnight.

Opposition now only angered him, and when the day of departure came, he put aside his weeping mother and sisters and would listen to none of those who implored him yet to change his mind. It was a cruel moment, and pain made him cruel also. As he left his chamber, his father prostrated himself on the threshold, refusing to let him pass. "God hath said thou shalt walk upon the asp and the basilisk; thou shalt trample on the lion and the dragon," Gregory exclaimed, and with this singular quotation

passed on amid the lamentations of his household and of the Avignesi, who crowded around, beseeching him not to desert them.

A prolix account of his journey is given by Amelio da Aleta, bishop of Sinigaglia and his chief almoner, in extremely bad Latin verse, in which is recorded the misfortunes and incidents that attended it, not omitting the good cheer that seasickness does not seem to have prevented the travelers from enjoying. He describes the train of cardinals on white horses or in carriages, the chaplains and domestics, the armed knights to guard not only the Pope but wagons full of treasure—apparently money was after all not scarce; the reception at Aix, the toiling over barren hills, the increasing heat, the crowds that met them at Marseilles, where they embarked, escorted, as we learn from another source, by a galley sent from Florence, to show that although at war with him, she welcomed the Pope back to Italy.

From the time that the reluctant company, all in tears, including Gregory himself, took ship, ill fortune attended them. On leaving Marseilles they experienced all the horrors of the Golfe du Lyon; "furious winds made them believe death at hand; all crowded together dismayed and trembling. Even the sailors were pale, and the passengers moaned and called on Saint Cyriac." Not till they reached the port of Villafranca did they obtain a respite. There they landed and "fell like men starving on the good cheer provided," but hardly had they again put to sea when the storm again rose, and from Monaco they were forced to put back to Villafranca. With tattered sails and sinking hearts they made the harbor. "All was confusion, nothing audible but roaring waves, heart-breaking cries, and angry shouts. The next day the sea had grown calmer. 'O lily of pontiffs,' we said, 'behold how the sun shines out! All nature seems to greet thee, and we thy servants salute thee in the delicious city of Savona.'"

The relief of a calm sea and sunshine must have singularly beautified Savona in the poetical eyes of the bishop of Sinigaglia.

It was, however, many days later that the Pope arrived at Genoa, and he had had time to repent of having left Avignon and doubt whether he had done well to listen to Catherine. Had she not been there to steady his wavering resolution, even then he would have gone back to Provence.

Chapter 9

✣

Pope and Saint

Catherine had no share in the difficulties and luxuries and dis-
comforts of the Pope's voyage. Like Joan of Arc when her work
was done, she only desired to go home and resume her life as a
Mantellata. But Charles needed the Maid, and Gregory needed
Catherine too much to allow them to withdraw themselves, and
Catherine was bidden to await the Pope at Genoa. Whatever
her enemies might invent, no one ventured to say that she had
accepted gifts or asked favors from anyone. Gregory allowed her
only one hundred florins to pay the expenses of herself and her
company during the return journey, to which the duke of Anjou
added another hundred, and, even considering the greater value
of money in those days, this could not be called a large sum.

She sought to travel as quietly and unobserved as possible and
left Avignon unnoticed, but at Toulon it became known that she
was there, and a crowd of men and women pressed around the
hostelry where she had alighted, calling for her. How the fame
of her saintliness and healing powers had spread there is not ex-
plained. In Avignon—alone of any town where she stayed any
time—she worked no cures and made no converts among the

people, keeping much within doors and often preferring to write to the Pope rather than seek him, but Toulon must have heard great things of her. For some time, she refused to appear, until a woman's sobbing entreaties to cure her sick baby reached her ears, moving her so much that she came out, took the little one in her arms, and prayed over him. The child seemed at once to revive, and the joyful mother carried him away, blessing Catherine.

The little seaside town of Voragine, now Varazze, lay in her homeward way. It was the birthplace of Giacomo de Voragine, archbishop of Genoa and author of the *Golden Legend*, so popular in the Middle Ages and well known to Catherine, who alludes to it more than once. She found the place plague stricken but paused to pray in the Church. The inhabitants implored her to request that the plague might cease, and she bade them build another Church and dedicate it to the Holy Trinity, promising that the sickness should be removed. To this day her memory is dear to the people of Varazze, who boast that no epidemic has ever fallen on them since that time, and yearly a great procession in medieval costumes goes to her Church, giving an excellent idea of what such spectacles were in the Trecento.

Very early on the last day of April the little town is humming with excitement; at street doors a bevy of small angels are having their wings and haloes fastened on by mothers, while all the rest of the family superintend, or from within a monastery come sounds of voices, where a young priest is anxiously making the boys who are to take part in the procession practice their chanting for the last time. Trains and omnibuses pour out visitors from Savona and Genoa and the smaller places around; parties come in on foot. The inns are crowded; so is the street.

Then the procession forms: men, women and children, in dresses handed down no one can say how long. There are

pilgrims from the Holy Land with scrip and staff; standard-bearers waving heavy banners, saints — saints — all the calendar seems represented; sometimes a favorite one will have half a dozen people who have taken his name. Saint Dorothea is one of these; usually it is a child who stands for her, with a lap full of roses. Little Saint John the Baptists pass, in sheepskins, leading a lamb, or with a brown arm thrown around the neck of an infant Christ, and now it is the Virgin Mary, wearing all the ornaments that her family can muster, with a canopy over her head. The honor of representing her is so great that quite a handsome sum is paid to secure it. Among the Virgins — there are four or five — is the only anachronism in the whole thing: the Madonna of Lourdes.

For nearly a mile between the two churches the long procession walks between double and triple lines of deeply interested spectators, all absolutely decorous, and down to the youngest child all who have a part in it *are* that part, absorbed, reverent, unconscious (apparently or really) of all but what they are doing. There is no rehearsal beforehand; these people come from various places, but all have that instinctive dramatic gift and absence of self-consciousness that are Italian characteristics. There is blue sky above, blue sea beside them, and a background of shadowy olives — and so all pass on to the church dedicated, as Catherine desired, but always called by her name; and as many of the grown-up people as can crowd into it, but the children go down to the shore and play and eat hard-boiled eggs with a result that suggests a new reading to the hymn, "How many a spot is on the robe/That wraps an earthly saint."

The festival is probably connected with the dedication of the church, for Catherine passed through Varazze in October, not April.

Saint Catherine of Siena and Her Times

She and her company reached Genoa long before the Pope and were received in the house of a noble lady named Orietta Scotti, a branch of whose race lived in Siena, and was one of the noblest of her families. Gigli's account of the Scotti is that they came to Italy in the time of Charlemagne and were descended "from the famous Counts Duglas." The Genoese branch, however, ascribed their origin to a captain of the Free Lances, who having fought successfully for Genoa against Pisa, settled in the former town in the twelfth century. Orietta was a name long handed down among them and held in honor, because she not only harbored Saint Catherine but tenderly nursed several of her companions who fell seriously ill. Among them was Neri di Landoccio, to the deep distress of his friend Stefano Maconi, who threw himself on his knees before Catherine, imploring her to use her healing power and not let his friend die far from home. There were occasions when she could do nothing, and was aware that it was best so. At Pisa, where she cured many, the young friar Baronto was not one of these. There is a ring of regretful tenderness in her reply when he begged her to heal him of an illness incurable by doctors though not deadly: "My child, this trial is necessary for your salvation; it will accompany you to the grave, but it will not hinder you from serving God as a friar." He accepted the answer and was one of her most devoted followers.

Now she answered Stefano's passionate entreaties: "My son, why are you so troubled? If God wills so to crown your brother's labors you should rather rejoice than lament." But as he persisted, she told him that although she desired to see him resigned to God's will, she and he would pray that Neri should recover. "Remind me," she added, "before I receive Communion tomorrow"—though surely she could need no reminder, for Neri was nearly as dear to her as Stefano himself. He knelt beside her

next morning in church, and after remaining long in prayer, she looked at him, smiled, and said, "Your request is granted." And Neri recovered.

Genoa was unhealthy, and next Stefano fell ill, to the dismay of all the college, for all loved him, in spite of occasional jealousies. Catherine cured him by laying her hand on his forehead and commanding him to recover. The sickness of others seems to have been even to death, for she said to Stefano, "I will not have you follow their example." All this kept the travelers at Genoa, and Stefano's family grew angry, and Lapa Benincasa wrote that she was old and lonely and should die if her daughter would not come back, but even had the illness of so many of her companions not tied her, Catherine dared not go before Gregory arrived. His ships must put into the harbor to buy provisions and water, and, probably, considering the wild weather, for repairs. They were long due, and Catherine awaited their coming in great anxiety, certain that those around him were seeking even now to persuade him to go back. Meanwhile Madonna Orietta's care and kindness were unbounded. An affectionate letter written by Catherine after leaving her was preserved in the family as a precious heirloom, though it was unfortunately lost about the time when the family changed name and arms for those of the Centurioni, by which they are later known in Italian history.

Catherine's sojourn among them was one of the memories most proudly cherished by the Genoese. The streets she used to go through, the apartment she occupied, the neighboring places where she had paused on her journey were remembered and pointed out with pride down to the sixteenth century by rich and poor. The lonely monastery of San Fruttuoso, which sheltered her both as she went and came boasted of the honor; Varazze, as we have seen, celebrates her passage through its humble street

to this day; the room she chose in the house of Madonna Orietta was looked on as a consecrated place. Florence, for which she did so much, has no such tender recollections of Catherine Benincasa.

At length the papal galleys appeared, escorted by the fleet of the Knights of Rhodes under the command of their grand master, and Catherine's apprehensions were justified by finding Gregory depressed, troubled, and so near yielding to the urgency of his companions that as soon as they had recovered the fatigues of their voyage, the cardinals induced him to call a consistory, and confirm the vote to return to Avignon. The news he was met by was not calculated to cheer him. Florence had sent emissaries to Rome, who persuaded the populace that with the arrival of a Pope, they would find themselves enslaved, and tumults had broken out, while the Florentines, furious at the ravages of the Breton troops, refused to treat with Gregory. The temptation to return to safety and popularity was great.

Gregory listened to his cardinals by day, but under cover of night he stole with one or two trusted friends to the house of Orietta Scotti, to find strength in Catherine's firm conviction that the right road was the one to Rome. Among the prayers of Catherine that have been preserved is one with a significant note appended to it, saying that it was made at Genoa "to dissuade the Pope from returning to Avignon, things contrary to the journey to Rome having been deliberated in the consistory." It is the prayer of a fervent believer, yet startlingly unlike one so assured as was Catherine that her God was a God of love. It runs as follows:

O eternal God, let not Thy Vicar yield to the counsels of the flesh, nor judge according to the senses and self-love,

nor let him permit himself to be terrified by any opposition, and immortal Lord, if Thou art offended by his hesitations and delays, punish them on my body, which I offer to Thee to be tormented and destroyed according to Thy will and pleasure.

She prevailed, and on September 29 his vessels again put out to sea, but it seemed as if even the elements combined to keep him back. So bad was the weather that the bishop of Sinigaglia declares it incredible and only to be explained as a supernatural sign of the wickedness of the Romans. Much valuable property was washed overboard. The bishop of Luni was drowned; a cardinal died. Among their misfortunes Amelio does not fail to record that at Porto Venere they had a most miserable dinner, and who could tell, he adds, in the lowest of spirits, but that they might all fall victims to the cruel Italians, who breathed nothing but hatred and fury. Even the arrival of an ambassador from Pisa and Lucca hardly cheered him, though he admits that they brought "splendid gifts" of veal and lamb, comfits, bread and Greek wine, but how could one trust the citizens of towns that, like Siena, though not fighting against the Pope, yet kept up friendship with the "guilty city," i.e., Florence?

Some consolation was found in an excellent dinner at Porto d'Ercole, but again storms rose and drove them on the isle of Elba, fortunately on the less precipitous side of the mountain island. They landed with great difficulty; one of the cardinals had even to submit to being carried on shore pickaback by "a rustic clown." The force of the wind prevented tents being set up, and even the bishop of Carpentras, to whom all turned in an emergency, had nothing to suggest. There is a pretty touch for once in Amelio's prolix narrative when he mentions that

Gregory found himself an oratory under the shade of the thick olive woods of Elba, but discomfort is generally in his thoughts, and it certainly suggests that accommodation was indifferent, since they found it necessary to take tents to put up when landing for the night. The length of this voyage seems almost incredible; it was not until the sixth of December that the Pope landed at Corneto, which was in papal territory. The *popolana* of Siena had undone the work of Philip le Bel.

The Pope, who had been greatly mortified by the lack of enthusiasm at his arrival in Italy, contrasting so strongly as it did with the reception given to Urban V, was much gratified by the welcome given him in this, the first town on papal territory that he had entered. Bearing olive branches, the citizens hurried out of towers and streets as the Pope's vessels came in sight, passing by the promontory of Argentaro, where the beacon light shone, as Bishop Amelio writes, brighter than the sun; it shines there still. Here he wrote the first part of his poem, if it can be dignified by that name, and though he says the time passed "very mournfully" during the five weeks spent there, he still was so thankful to be on land, and freed from the painful necessity of dining on "obscure frogs," that the little town is actually described as having wide and handsome streets. He notes, too, the high towers, some of which remain.

Christmas was passed at Corneto, where the Pope transacted much business, and received ambassadors, after which "the lily of the papacy" continued his voyage, now over calm and moonlit seas, thus bringing to nought the predictions of the Avignonese astrologers, who had declared that the journey would end in disaster. It had tried Gregory severely; worry probably had done so still more, and his pallor and feebleness suggested that, after all, the prophecies of the astrologers might be fulfilled. Although

little over forty years old, a mortal disease was exhausting him and making effort of mind or body painful and reluctant.

At Ostia, on whose desolate shore Dante pictures the souls awaiting their angel pilot whose bark will bear them far over the ocean to Purgatory, Gregory paused for a night, but did not sleep on land. Troops of Romans came down to welcome him, and show their satisfaction at his coming by torchlight dances and songs. It must be owned that the performers were neither young nor beautiful: "chorizabunt cum tubis et faculis calvi decrepiti cum sonore," he says in lines that may serve as a specimen of the whole chronicle.

Ostia was left behind, and the galleys sailed up the Tiber, then navigable, and the Pope landed close to San Giovanni Laterano, where again he spent the night onboard ship, for the palace was too ruinous to be inhabited, and the church was still in process of rebuilding after the disastrous fire in 1308, which had consumed both the basilica and its priceless contents. The Pope's journey had lasted five months.

It was nightfall when he arrived, and the Romans lined the banks of the river, carrying torches, to watch his vessels sailing up against the strong current, and he was welcomed with the same ephemeral enthusiasm that had greeted Urban V. In the dawn of the next day, variously given as the sixteenth and eighteenth of January, he disembarked and proceeded to Saint Peter's, passing through the city gate of San Paolo, through which Totila and his Goths had entered. A great crowd escorted him; knights in armor rode backward and forward on either side of the procession; hundreds of *histriones*[20]—we would hope less infirm than those of Ostia—dressed in white, danced and clapped their hands. Great

[20] Buffoons.

nobles too were there, representatives of the Orsini, the Conte di Fondi who by and by played a leading part in the schism, one of the Gaetani from whom sprang Boniface VIII, and many other barons. There too appeared the magistrates, councilors, and bannerets of Rome, all robed in silk, remarks the bishop of Sinigaglia. The windows were crowded with spectators of the higher class, showering down comfits and such flowers as the season afforded. Even the roofs were covered with people eager to see the Pope; shouts of "*Viva Gregorio*" mingled with the chanting of the priests; the senators brought him a loyal address.

"Verily I did not think to see such glory with mine own eyes," writes the bishop, who had modified his first ideas as to the savagery of Italians. Under the gate of San Paolo the keys of the city were presented to the Pontiff, and then the train moved slowly on past the Aventine, where rose the stronghold of the Savelli, passing the capitol and the Campo di Marte, a desolate road bordered by ruins and grim medieval fortresses, often built of the stones of noble classic buildings. Not till evening could the procession make its tedious way to Saint Peter's, all "very hungry," as well they might be. There the exhausted Pope prostrated himself in prayer, and the first act of his return was safely accomplished. It is commemorated in the bas-reliefs on his tomb in Santa Francesca Romana, but they were executed only in the sixteenth century.

Even on this first day a discordant note was struck. Petrarch had written,

There is no need that the Roman Pontiff should go to Rome with the armed hand; his authority will ensure his safety better than the sword, sanctity better than armor. The arms of the priesthood are prayers and tears, fasting,

virtue, good conduct and abstinence and charity. What need of military show has the Father of all? The Cross of Christ is enough; that and that only do devils fear and men reverence. What need to sound the trumpet? Alleluia suffices.

Catherine of Siena too had repeated this advice, strongly advising absence of warlike demonstrations, as both unbefitting the return of an apostle of peace and as implying distrust. Nevertheless, Gregory was accompanied by two thousand soldiers under Raymond de Turenne.

He could not and did not pretend to feel safe in Rome, and his spirits fell with each day that he lived in the ruinous city surrounded by a desolate Campagna, and full of neglected churches. Grass grew in the cracked pavements up to the very altar of Saint Peter. The memories of martyrs in the Colosseum had not prevented one of his legates from ordering its marble to be burned to make lime; priceless statues had shared the same fate, and the classic temples yet remaining were filled with rubbish and filth. There was no order, no law, no virtue anywhere, says an old Roman chronicle, least of all among the clergy, the younger of whom are accused of going about the city by night, visiting disreputable houses, and, sword in hand, committing theft and murder and all manner of enormities. Petrarch hardly exaggerated when he asserted Rome to be a sink of iniquity with *"Beelzebub nel mezzo,"* and the *Dialogue* of Catherine supports these accusations. Gregory had a herculean task before him in reforming the Church, and Catherine constantly urged him to set about it, but his timid nature made him flinch from the danger and opposition he foresaw, and putting off attacking abuses among his clergy to a more convenient day, which never came, he devoted himself to

subduing temporal enemies. His policy was on the whole a wise one: when resisted, he struck severely; when he could, he conciliated; and he succeeded in regaining an indefinite overlordship of Bologna, the "pearl of the Romagna," though after the sack of Cesena, the Bolognese had vowed nevermore to have anything to do with Pope or cardinals, since massacres and religion had nothing in common. He struck, too, a new blow at Florence, by inducing both Bologna and Venice to cease trading with her, as they had hitherto persisted in doing.

Florence was undaunted, but she made the mistake of demanding impossible concessions short of which she would not ask for peace. Other cities also held aloof, and it was said that some of the cardinals joined the Florentines in stirring up trouble in Rome, with the hope of driving Gregory back to Avignon. There were always those beside him who pointed out how useless it had been to come to this ungrateful city, which had called so loudly and lamentably for a Pope, and now that he had come, was disobedient and insolent.

And Catherine was not at hand for him to lean on. Although both in San Domenico at Siena and in the Sala Regia of the Vatican she is painted entering the city with Gregory, she was not really there, yet if historically incorrect, it is right that her figure should appear in a return to Rome, which but for her would hardly have taken place.

She left Genoa later than did Gregory, but experienced the same tempestuous weather, since there are allusions in her biography to peril by shipwreck, which can be referred only to this voyage, though no date is given.

At Leghorn she was met by her old mother and sent the reluctant Stefano Maconi home, with letters and directions as to various matters he was to arrange, while she again went to

Pisa, perhaps to treat with Gambacorta both on papal affairs and the question of Talemone, a coast town, where there is now a dreary little station, then a strong and important post on the Sienese frontier. It had been seized by "the Prior of Pisa," a Knight of Saint John, to whom she had written energetically when hoping that a Crusade would be organized, bidding him and his companions to be true knights, not arming themselves merely with earthly, but with spiritual mail—the allegory is carried out in a way that appealed to the taste of that day, but now seems grotesque rather than forcible. This Prior had done no small harm to Siena with little or no excuse, under pretext of fighting for the Church, and among other misdeeds had seized Talemone. Gambacorta supported him, and at that time Catherine failed in recovering the fortress, especially as the Pope did not assist her.

After an absence of eight months she returned to Siena, whence she wrote to encourage Gregory and deprecate his displeasure with the city, which then and for some time longer was a sharer in the interdict, a grievous matter, though it does not seem to have been as ruinous to Sienese commerce as it was to Florentine:

> Be pleased to take back your rebellious children. Their malice and pride will be vanquished by your goodness. It is no shame to stoop to raise a repentant child, but rather glorious before God and man. No more war, then, Holy Father, but give us peace, and turn the war against the unbeliever.... As far as I can tell, the general disposition is to accept you as a father, especially in this poor little city, which has ever been the beloved daughter of your Holiness, though circumstances drove her to things that

have ill pleased you. You can draw them easily by the bait of love.

She repeated this argument at a later date, but Gregory paid little attention to it, perhaps displeased that she had again declined to go to Rome, finding herself sorely wanted where she was. She found Siena, as usual, in the state described by one of her earliest poets, Bindo Bonichi, "the shoemaker turning his son into a barber, and the barber turning his into a shoemaker, the notary making his into a draper, and the merchant making his a notary, one and all dissastified with their trade." Added to this, feuds had broken out among the higher class both of nobles and merchants, such as required all Catherine's authority and influence to deal with. She found some relief from anxieties and troubles—among which the unholy love and then the dangerous hatred of one of her own followers must be counted, though of this there are given only hints—in turning Ser Nanni's castle of Belcaro into a convent. Money does not seem to have been wanting for repairs and alterations, so that friends must have come to her assistance, and thus enabled her to found a community under strict rule where girls who elected to take the veil might be safely placed. She had often discussed the matter with the abbot of Saint Antimo, the faithful friend who brought her the *viaticum* on her deathbed, and his advice was always valued by her.

This was a breathing time in her life, but her sky was never long unclouded. An unexpected trouble arose in Gregory's altered bearing toward her. The urgent advice she sent him in one letter after another, suggesting measures he had not the resolution to carry out, yet knew to be right and necessary, depressed and irritated him. He felt too that he was incapable of dealing

with his inconstant Romans, who one day acclaimed him and the next threatened him with death, and he began to resent having been placed in this position by Catherine, who now refused to come and help him in his need. And he could not have forgotten that stinging declaration of hers that a "great refusal" might be the right course for a Pope who could not fulfill the duties of his position.

His cold displeasure tried her sorely, as is plain from a letter she sent to Raimondo, then in Rome, which ends by a direct appeal to Gregory. Raimondo had been summoned to the papal court and had been the bearer of letters from Catherine containing suggestions that, as he observes with unconscious satire, would no doubt have been very useful had they ever been carried out. While in Rome he was elected prior of the Dominican Convent of Saint Maria sopra Minerva, and thus could not return to Siena, which was a deep disappointment to Catherine. Though called to Rome by Gregory, he too was in disfavor, and much distressed by it, as may be gathered from her letter — one full of pain and unusually depressed. "If you chance to find yourself in the presence of his Holiness, commend me humbly to him and ask his pardon for the many faults I have committed through my ignorance and negligence. I fear," she continues with that inclination to take the offenses of others on herself that Raimondo considers to be a proof of utter humility, supporting his view by the words of Gregory the Great,

> it is the property of the good to see sin where none is, and where it is light to hold it as heavy. I fear that it is my sins that are the cause of the persecution that he suffers, and all the woes of the Church may justly be laid at my door. He has therefore good reason to complain and punish me

for my faults, but tell him that I will do all I can to correct myself and serve him better.

Further on she repeats her painful conviction that the troubles that beset both the Pontiff and the Church arose from her lack of virtue and many faults of disobedience. Raimondo may well say, "*Ingeniose imponebat sibi offensos.*" But with passionate appeal she exclaims, turning from Raimondo to address Gregory himself:

To whom can I turn if you abandon me? Who will help me; to whom can I flee if you send me away? My persecutors pursue me, and I take refuge with you; if you desert me and are angry with me, I can but hide myself in the wounds of Christ crucified, whose Vicar you are, and I know that He will receive me, for He wills not the death of a sinner. And when he has received me, surely you will not reject me, and we shall remain at our post, fighting for the sweet Bride of Christ. It is so that I wish to end my life, in tears and sighs, giving my blood for her if need be, and the very marrow of my bones. If all the world repel me, I will not torment myself, but rest weeping and satisfied on the breast of that sweet Bride. Most holy Father, forgive my ignorances and many offenses against God and your holiness. It is the Eternal Truth that excuses and gives me courage while I humbly ask your blessing.

The letter is thoroughly characteristic in its vehemence, its humility, its conscious dignity, and we must add with some perplexity, its mingled contrition and the extraordinary sense of her own value conveyed in the self-accusations. It is difficult to suppose that the words mean exactly what they imply, but what

then do they mean? Had the haunting fear of the effect of her shortcomings that appears in earlier letters increased with failing strength and disappointments and become altogether morbid? Who can say? And who can venture to judge one so exceptional as was Catherine Benincasa?

No doubt it was a comfort to find that even if no longer friendly, Gregory still trusted her and depended on her as she presently did, though it does not appear that Raimondo ventured to lay her appeal before him. Florence was to him what Italians would call a long thorn in the foot. Her ambassadors had indeed come, but with "as little intention of making peace as those sent to Avignon," and they were not graciously received. A letter the Pope sent in July 1377, and still to be seen in the archives of Florence, is at once pathetic and querulous, the composition of a weak and aggrieved man. He complains that he had left a fair and fruitful native land, a grateful people devoted to him together with very much else, and had resisted the entreaties of kings, princes, and cardinals, going to Italy with the firm determination that for love of peace he would make good all wherein his legates had failed. To his profound grief his hopes were all vain.

Although the Eight of War were as strongly opposed to submission as before, the peace party had gained strength, and members of the proletariat joined it, who cared nothing for the honor of the city, and hardly understood what the cause was for which Florence was being ruined, but who keenly felt the privations entailed by the taxes and the interdict. Almost as soon as Catherine returned to Siena, Soderini had come to implore her to go back with him to Florence, and once more mediate between the city and Gregory. She refused. Her experience of Florentine politics did not encourage the hope that she could be of real use, and she had much to do at Siena.

Raimondo tells how he and Soderini spoke much together of the tortuous policy of the Eight, and the condition of the "divided city," and his journey to Rome promised an opportunity of laying what he had heard before the Pope. But for several months after his arrival, he was engaged in preaching and in the duties of his office of prior, to which he had once before been elected. Although he makes no mention of being allowed an audience by Gregory, it may be supposed that he saw him, since the Pope himself had summoned him, and his discomfort at the coldness he experienced implies that he had been in his presence. In one way or another, he certainly put before him what Soderini had said, but with no result.

It seems to have been a surprise to him when one Sunday he heard from a papal messenger that he was invited to dinner that day. Gregory was then living in the Vatican, as the Lateran was uninhabitable. Nothing appears to have been said of any interest during the meal, but when it was over, the Pope remarked, "I am told that if Catherine of Siena went to Florence, peace would be made." Raimondo answered, "Not only Catherine, but we all, Holy Father, are ready to serve you and endure martyrdom if need be." Gregory replied that he did not wish to send him, as he might meet with rough usage, but that Catherine could safely go, being a woman so much venerated, though at the same time he said that he would not have any of the Mantellate accompany her, a precaution that suggests that he was not so sure of her safety as he declared himself to be. Raimondo, at all events, knew there was great risk, for although she had refused to accompany Soderini, she had sent Maconi to see what he could do, believing that his high rank and charm of manner would gain him a hearing, but he had barely escaped with his life from the tumult raised by a report that Catherine of Siena had sent

him to induce the Signoria to deliver the city over to the Pope. This was an unhappy prelude to a visit from Catherine, and it must have been with a heavy heart that Raimondo prepared the necessary papers for the Pope's signature, and sent them to Siena. Catherine, of course, obeyed at once, and set out accompanied by a few of her college, and her mother, who may have used the pretext of visiting the sons and grandchildren living in Florence, since the Mantellate were forbidden to go, and Lapa was now one of the order, as also was a sister of Catherine's with the same name as her mother.

Weary of the tumult and dissatisfaction of Rome, the Pope retired to Anagni, in spite of its unpleasing associations with the mistakes and humiliations of a greater Pontiff than he. Thence he launched several bulls of excommunication against Wickliffe, and sought to detach the Tuscan cities from the League, not without some success. The bishop of Sinigaglia completes his itinerary of the papal journeys by a description of the removal to Anagni, written in equally bad Latin, as was the earlier part of his poem, but in a much more contented frame of mind. He does indeed mention traveling through valleys dark with clouds, but Anagni found favor in his sight, and he speaks with complaisance of its fountains, its streets, and its inhabitants. Of the Pope's stay there, there is no word — but all around him saw that death was approaching to set a most unhappy man free from a task for which he knew himself to be incompetent. He had made mistake upon mistake, always delaying until the time was past for action. His policy had gone little beyond continuing the ruinous war with Lombardy that he had inherited from his predecessors and which had made him unpopular in other countries called on to contribute to expenses in which they had no interest. To reduce the luxury of Avignon or make the cardinals share in

papal liabilities had not even crossed his mind. Petrarch's had been a voice crying in the wilderness when he denounced the

> successors of a troop of poor fishermen who had forgotten their origin, walking in gold and purple, dwelling in splendid palaces instead of little boats on the lake of Gennesereth, with parchments whence hung leaden seals to catch the poor dupes whom they put on a gridiron and a scale to satisfy their greed, and instead of going barefoot, behold them — satraps mounted on horses covered with gold, champing golden bits and soon to be shod with gold, unless Heaven should repress their insolent luxury. One would take them for Kings of Persia or Parthia whom one must adore and not approach empty-handed.

Gregory was well acquainted with Petrarch's writings, but he had not been impelled by them to reform the court or the Sacred College, though the state of the Church weighed increasingly on his mind. He could not be unaware of the excitement, the hopes and fears, the plots and intrigues that were already gathering around his last days, and he remembered the words of the duke of Anjou sent to dissuade him from leaving France, "If you die yonder, which it seems you will, according to what your physicians tell me, the Romans, who are marvelous treacherous, will be masters and lords of all the cardinals, and will make a Pope at their will."

Who the next Pope would be Gregory could not even surmise, but one thing was certain, the all-important question whether he should be French or Italian, remain in Italy or go back to Avignon, would have to be decided. All that he could do was to promulgate a bull that whoever had a majority of votes, with or without a conclave, in or out of Rome, should be held to be legally

elected as Pope, and that the votes and desires of the minority should be held of no account. But here he reckoned without the Romans, who foresaw the probability of the cardinals attempting to hold a conclave when the time should come, elsewhere than in the papal city, and prepared to hinder any such attempt.

Chapter 10

✢

Catherine in Florence

"Before I left Tuscany," writes Raimondo, relating the conversation with Soderini already alluded to,

> I had an interview with Niccolò Soderini, a man most faithful to God and the Church, and greatly attached to Catherine. He talked of the affairs of the Republic, especially of the malice of those who feigned to desire reconciliation with the Church, yet did all they might to hinder peace. I complained of this line of conduct, and that excellent man replied thus: "Be you sure that the people and every honest man in the city want peace; it is only a few obstinate men who rule us that put difficulties in the way." I said, "Could not a remedy be found for this evil?" He answered, "Yes, if some honorable citizen took the cause of God to heart and had an understanding with the Guelfs so as to take away power from those intermeddlers, enemies of the public good. It would be enough to remove four or five."

This conversation was repeated to Catherine, with unfortunate result. Gregory too must have had some such declaration

made him, though not apparently by Raimondo, who writes as if unprepared for his sending Catherine to Florence. The upshot was that she went, this time as the ambassadress of the Pope.

Before she left Siena, she dispatched "a true and good servant of God" in the shape of a Franciscan friar with a letter to Soderini, to advise him as to his own affairs and those of the city. Her choice of a messenger suggests that he was to instill good counsel into the populace as well as Soderini. They had all but lynched Stefano Maconi when he came with the same intention, but the Franciscans were popular, often of the lower class, and well acquainted with its grievances and aims. Catherine also wrote to the Signoria, as the priors of the arts were collectively called, and then, having prepared the way as far as she could, she obeyed the Pope's order and arrived in Florence early in 1378 or the end of 1377—as usual, no date is given. Gregory's desire that she should take no women with her was unheeded; besides her mother, she took Giovanna di Capo (a favored sister, for she accompanied her later to Rome), who shared her danger when the mob threatened her life. Stefano Maconi came too, though his presence did not make for safety, as it would recall the rumors of Catherine's desire to have Florence handed over to the Pope, and no people are more ready to believe a rumor, however wild, than the lower class of Italians. Moreover, one so useful to the war party would not be suffered to die, since their existence depended on bringing her mission to nought, whether they were of those who prolonged the struggle out of ambition and fear of the day of reckoning, or were more patriotic citizens, proud that their city should head the League for independence, and reluctant to endure the humiliation of submitting without gaining any of the advantages for which they had made such sacrifices.

On her previous visit, Catherine had been entertained in the palace of Soderini, but now she and her companions were lodged in a little house at the foot of the hill called San Giorgio, which he and some other friends had built expressly for her use. She found the conditions of Florence much worse than in her last visit. Although the citizens, in spite of hard times and war expenses, were bravely continuing to build the Loggia dei Priori[21] and the Duomo, poverty and gloom pervaded the city. Italian towns had not seldom been little the worse for papal censures, and at the beginning of the century Florence herself had defied an interdict successfully, refusing with scorn the good offices of the cardinal of Bologna, while princes such as Ezzelino and Bernabò Visconti treated them with contempt. She could do so no longer, now that her widespread trade, chiefly foreign, had raised a host of commercial rivals, eager to push her out of the field. It was not deference to the Church that caused their shops and warehouses to be destroyed and the owners driven away as soon as the interdict was pronounced. The great banking business of the Florentines came to an end; no orders were now received for fine dressed cloth, or any of the other goods for which Florence was celebrated: the workshops were closed, and the *braccianti*, a name equivalent to "hands," were starving and sullen, only half understanding what the war was about.

Added to this, the consciences of the religious were greatly perturbed at finding themselves ranged against him whom they looked on as Christ's Vicar on earth and by the suspension of holy rites when no church bells called to prayer or to those festivals that made welcome breaks in the monotonous toil and sordidness of daily life even for the poorest. So strong became

[21] Now Loggia dei Lanzi.

this feeling that the magistrates made great efforts to oblige the clergy to open their churches, where they celebrated Mass behind closed doors, and when the bishop — Florence had as yet no archbishop — left the city, a penalty of ten thousand florins was threatened if he would not return. He was one of the historical family of Ricasoli; as a "grande," he could hold neither the See of Fiesole nor Florence and, in order to become eligible, had renounced his *consorteria* and changed his coat of arms to those of a miter and two gold and silver angels. But to the people he was as much of a grande as ever; they mocked at and suspected him, and though he gained his end, they finally got rid of him, and he was translated to Faenza. There is a letter from Catherine encouraging him to hold out against the magistrates, but neither this nor others that she wrote to him imply a high opinion of her correspondent. In one she says twice over, "I most gently beg you to awake from the sleep of negligence," while her letter written at the time of his flight from Florence suggests that she thought his chief motive for going away was care for his own safety. She wants to see him "manly and not timid," "serving the sweet Bride of Christ with manliness," not returning to his See. She is glad of his constancy but once more bids him arise from the sleep of negligence.

Another letter sent from Florence soon after her arrival shows how painful an impression the state of things there had made on her. It is to the cardinal of Luna, whom she and Raimondo had known at Avignon, and in whom she was to find herself woefully deceived. With all her singular power of reading thoughts and characters, she was not seldom mistaken. Gregory, experienced in men and accustomed to the intrigues and ambitions of the ecclesiastical world from boyhood — his uncle, Clement VI, had created him cardinal deacon before he was eighteen

years old—doubted him from the first, and on making him a
cardinal had said, "Beware lest thy moon be eclipsed." After-
events caused this play of words to be taken as a sign that the
Pope had foreseen the unscrupulous ambition that led him to
accept the doubtful dignity of the antipope. By the father's side
a Spaniard, on the mother's he claimed descent from Saracen
kings, an origin in which Burlamacchi sees the explanation of
his stubborn schismatic conduct. When Catherine called him
a column of the Church, he had not yet had an opportunity of
showing himself in his true colors, and she looked to him for
help and sympathy.

There is a tone almost despairing in her letter. Things are
going very ill in Florence, especially among the clergy, to say
nothing of laymen, among whom there are many bad and few
good; the monks and secular priests, and above all the friars,
whose work it is to announce the truth, all forget it, preaching
that the interdict may be violated, and that those who attend the
offices and communicate may do so without sin—indeed, ought
to do so, thus leading people into a schism dreadful to think of,
let alone to see. And it is the base fear of man or of human desires
to receive offerings that make them act and see thus. The last
words suggest how much poverty there would be among those
priests whose small income greatly depended on the payment for
Masses and other offerings of their flocks, as well as among the
laity suffering from the cessation of commerce. "Ah me, ah me!"
Catherine exclaims bitterly, "I die, yet cannot die at thus seeing
those deprived of the truth who ought to give their lives for it."

Her view of papal authority demanded passive obedience, yet
surely even those who felt as she did and were equally ortho-
dox must have asked themselves whether anyone, be he even
the head of Christendom, had a right to ruin the public and

private life of a whole city, full of innocent people, among a few who were guilty: and yet more, where was the excuse for inflicting a like penalty on towns such as Pisa and Genoa and Siena, which had committed no offense beyond refusing to drive out the Florentines and allowing them to attend Mass. "Such teaching is horrible in our day, and should have been to them," says Muratori.

This suspension of spiritual rites favored another condition of things that exceedingly troubled Catherine: the increase of heresy. For a century or more Florence had been the headquarters of the Paterini and Fraticelli, notwithstanding the vigorous efforts of the Dominicans to destroy them; the former were so numerous that the chief inquisitor was known among the people as the *inquisitore dei Paterini*.

The *Cani Domini* had literally hunted them down, seizing them in their houses and as they fled through the streets, but for one who was put to death, half a dozen started up, and the sympathy of the people was with them, for during the outbreak of fury against the clergy early in the struggles with Gregory, the populace had wrecked the buildings where the Inquisition sat adjoining Saint Maria Novella.

What the tenets of the Paterini or the Fraticelli or those of the other numerous sects that then existed really were is impossible to ascertain. Their writings, when they wrote, were usually seized and destroyed, though it is said that they might be found in a part of the Vatican not open to readers; they are known only through the reports of their enemies, and few creeds or characters could stand such a test. That there was no clear knowledge of them outside themselves is shown by the way in which Dante classes Farinata degli Uberti as an "Epicurean," and therefore believing that the soul perishes with the body, which certainly was

not the view of the Paterini, yet the lately discovered archives of the Inquisition in Florence charge Farinata with all his family as being of that sect. The accusation was evidently a calumny, invented after his death as an excuse for that continuous perse-cution of the Uberti of which his descendant, Fazio, complains in his very dull work, the *Dittamondo*, for Farinata was buried in holy ground, beside the old Church of Saint Reparata, and to lie in holy ground was, of course, denied to a heretic. Indeed, if a priest were undiscerning enough to take one as orthodox and give him burial accordingly, should the mistake be found out, he had to dig up the body with his own hands, and the spot was considered as desecrated.

To Catherine heresy was dreadful, being schism, a rending of the seamless coat, and she abhorred it accordingly. There is no mention of her having anything to do with the Paterini, but she had anxious consultations with Don Giovanni delle Celle both as to the war, and the interdict, and the teaching of the Fraticelli, against whom she makes several discourses in public, holding them the more dangerous that they were an exaggera-tion of the early Franciscans, teaching the entire renunciation of property in every shape, and when reminded that our Lord and His apostles had a purse, replying, "Yes — entrusted to Ju-das. Had it been for our example, it would have been in the hands of Peter." Every sect that preached poverty was sure of persecution, but the Fraticelli claimed to have prophets among them and to speak with authority against the corruptions of the Church, which made them doubly obnoxious. Like most of the heretical sects, they were charged with leading immoral lives, and it has been suggested, though on slender grounds, that Catherine had the Fraticelli in her mind when she wrote to her young niece Eugenia in the convent at Montepulciano,

threatening her with such an application of the discipline, i.e., scourge, as she would remember all her life should any word reach her that the girl had been found talking with a friar. Unhappily morality had sunk low enough in the mendicant orders for such a warning to be needed even concerning those who were not Fraticelli.

If Catherine's discourses against the errors of these had been preserved, we might know more about what their tenets really were. Her letters were carefully copied by her secretaries and friends, but no account of any speech or discourse made in public survives. She was always listened to with eager interest, even if no lasting effect ensued, except on an individual here and there. When Catherine spoke at this time, she was listened to with an interest the more eager that she had come on an errand not fully understood by the people, and was regarded with some doubt and suspicion, fomented by the war party, which burst into flame a little later. She had a most difficult task in dealing with a government so complicated and with officers constantly changing, so that hardly had she won them when new ones were appointed, possibly with other views and aims. But here, as in Siena, she had the great advantage of being connected with no party in the Republic, and of having no personal ends to gain. One thing she effected amid much that disappointed her; she induced the city to observe the interdict. Immediately on her arrival in Florence, as is related by Stefano Maconi, she went to the Palazzo Vecchio, where sat the priors of the arts, and made three speeches, and "by the grace of God, so great was her success that though, until then, they had broken the interdict and manifested much contempt for the Holy See, after hearing the exhortations of that holy virgin, they obeyed and observed it." Glad at heart she wrote to Alessia dei Saracini,

The dawn is come, since the darkness that prevailed here on account of many mortal sins committed by saying and hearing the offices publicly is taken away in spite of those who have hindered this, and the interdict is observed. Thanks, thanks be to our sweet Savior who despises not humble prayers. Pray to the Divine Goodness that peace may be soon made in order that God may be glorified and all this ill be done away, and we find ourselves together to tell the admirable things of God.... Cause special prayers to be put up in the monasteries, and tell our prioress to bid all her daughters implore peace, and that He will show us mercy, for I do not return until it is made.

It was further off than her hopeful spirit foresaw. "Our prioress" was, of course, the one who presided over the Mantellate, Nera di Gano, the one to whom Catherine sent a letter[22] from the castle of Agnolo Salimbeni, which more than hints at difficulties among those over whom she ruled, since it bids her pay no heed to their murmurings and ingratitude, but go on her way without hesitation. The young Sister who a very few years earlier had stood before her, blamed and slandered almost to the point of expulsion, now gives counsel and encourages her, and men and women her elders and superiors in rank and position seek her advice, and proudly call her "Mother."

While urging obedience to the cruel mandate of Gregory, well aware that he would listen to no overtures from Florence while it was defied, Catherine knew that if orthodoxy were dumb, heresy would speak the louder, and she encouraged the meetings where pious men and women came together for private prayer,

[22] Letter 125.

or to read some holy book, as she had done among her own fol-
lowers in Siena, independent of any interdict. Processions went
through the streets singing devotional verses in Italian, known
as *laudi*, many of which were composed at this time by Sacchetti,
a friend of Soderini and a devout believer in Catherine. It must
be owned that some read not unlike a love song.

There were also *laudi* much older than those of Sacchetti.
From the time when those "great and manifest miracles" were
shown forth by a painting of the Virgin in the grain market of San
Michele in Orto on July 3, 1292, which "the preaching friars and
the friars minor likewise through envy or some other cause would
put no faith in," as Villani records, there had been a company of
laymen who came before her picture to sing *laudi* in her honor,
and the unbelieving friars "fell into much infamy." It is to this
Madonna that Dante's beloved friend, Guido Cavalcanti, alludes
as having the features of his lovely lady, Primavera, in a sonnet
where he repeats the accusation against the friars who say that
the worship addressed to the painting "is idolatry, for envy that
she is not their neighbor," but he is not very much in earnest. The
devotees who came to sing hymns in honor of the Virgin formed
themselves into a company called the Laudesi and were celebrated
for charitable works, and they paid for the shrine and internal
decorations of San Michele when it was rebuilt in 1339, after the
earlier edifice was burned in the great faction fight between the
Cavalcanti, of whom Guido was the most brilliant member, and
their enemies, the Neri and Donati, while the podestà looked
on and did nothing, and all that quarter of the city was ablaze.

The respect now shown toward the interdict made it possible
that Gregory would listen if reasonable overtures were made by
Florence, and Catherine used all her authority and influence
to induce both Ghibellines and Guelfs to be at one and make

terms with him, now meeting the heads of one party, now the
other, and often producing such an effect, at least for a time, as
recalled the involuntary exclamation of the Italian cardinals at
Avignon: "It is not a woman who speaks, but the Holy Spirit!"

Still the Eight of War held out, though not openly, putting
every obstacle in the way, not always selfishly, for there was a
reasonable desire to check the papal power so as to defend Flor-
ence from a repetition of such ruin as the interdict and the war
had brought upon her. Only after stubborn opposition would
they agree to refer the cause between Florence and the Pope
to a congress that should be held at Sarzana, where every town
that had taken arms against the Pope would send representa-
tives. Gregory was to send the bishop of Narbonne and Car-
dinal Robert of Geneva of evil fame; Naples was to have two
ambassadors, appearing, it would seem, in right of being his ally,
since she had taken no share in the struggle against him. Genoa,
Venice, and Florence had four deputies each. Though Venice too
had held aloof, her trade and that of Florence were sufficiently
connected to make the matter important to her. The arbitrator
in the congress was the wily Bernabò Visconti. That Robert of
Geneva, on whom all Christendom had so lately cried shame,
should have been sent by the Pope though his hands were still
red with the blood of Cesena and Faenza, and accepted by Italy as
the papal representative, argues that even such enormities as he
sanctioned made no lasting impression in that age of atrocities.
And the general acceptance of Bernabò Visconti as arbitrator is
even more startling, for all knew his life of insane cruelty and his
falseness. None of the legates who drove their cities into furious
rebellion governed half as abominably as he. But the Italians
could endure much more from one of their own race than from
foreigners, and his time was not yet come.

Why this man who had stirred up strife so carefully now appeared in the character of peacemaker was not at once known; later it was found that to win over his dangerous enemy, Gregory had promised him a large share of the fine that he demanded from the cities that had rebelled and driven out their legates. It was to be the business of Bernabò to make them pay. The sum was calculated less in proportion to their offense than to the emptiness of the papal treasury and, even if divided among all the delinquents, was so huge that the money could hardly have been raised. Some progress was made; Gregory ratified whatever Catherine had done, and sent the cardinal of Amiens as his legate to treat with Florence, and the Congress had begun its sittings when all was thrown into confusion by the news that the Pope had died in Rome on the night of March 27, 1378. He had occupied the papal throne seven years, and would have left little mark in history had he not been the last of the French Popes.

Before his death, Gregory is reported to have alluded bitterly to Brigitta of Sweden and Catherine, warning those around him not to listen to visionary women: he himself had suffered from having done so. One would hope that these words were not carried to the ears of Catherine.

While the Pope was thinking hard things of his ambassadress, she was working for him at the imminent risk of life. Finding that the chief obstacle among the Eight of War was one Giovanni di Dino, a man of great weight and importance, Catherine bethought herself in an evil moment of the power that Soderini had alluded to in his conversation with Raimondo and suggested that it should be used. The Eight had indeed all but unlimited power as to their measures and spending money, but the captains of the people had theirs also, more ancient and more fully recognized. Among them was that of "admonishing" anyone of Ghibelline

politics. Should his conduct not satisfy them after he was warned, he could be exiled and his property confiscated. Had Soderini still been in office, this power might possibly have been justly used, but Catherine must have known how often it had served to gratify private enmities, and to propose that it should be exercised to remove Dino and others of his party was strangely rash. If she thought that she could trust to the patriotism and honesty of the Guelf party, she was soon undeceived by finding that as their confidence grew, they instituted a veritable proscription against all their personal foes, using her name both as sword and shield and asserting that all they did was by her advice and was approved of by her. The Florentine historian Ammirato tells the state of the case thus:

> There lived at that time a young virgin born in Siena, so self-restrained in her life, so set on all good works, that down to this writer, who may be seen not to be one of her followers, all call her *"Beata"* (blessed). But the heads of the Guelf party used her name not only to blame the war against the Church but to justify their constant admonitions, perhaps thinking to deceive the good and holy virgin, proclaiming in the piazza and churches and all public places that not so much by their advice, but by the urgency of the blessed Catherine was all this done.

The names of Soderini, Bindo Altoviti, and Pietro Canigiani are especially mentioned as "exalting admonition as a most excellent medium to cast down the evil mind of those who were enemies to the Church," but as two of these were close friends of Catherine's, and in her letters to them after the tide turned against them she makes no mention at all of their having deserved their misfortunes, it may be merely a calumny.

Saint Catherine of Siena and Her Times

Becoming aware of the use made of her name, Catherine vehemently protested and made her followers protest publicly that she neither advised nor approved of the measures taken by the Guelf party, which had succeeded in wresting the power from its adversaries, and admonishing no fewer than ninety of the chief citizens, under pretext that they were Ghibellines. In a Latin manuscript left by Maconi, he declares, "I, Stefano Maconi, an unworthy Carthusian, was in Florence at that time with Saint Catherine, who ordered both myself and others to set forth the scandal that would be caused by the admonitions, unless they were forthwith stopped, but I labored in vain." Raimondo confirms this statement: "The holy virgin neither did these things nor caused them to be done," he writes in emphatic denial, "and grieved exceedingly over them, and commanded and caused to be said to many that they did most ill in laying hands on so many, and of such great estate."

The treatment meted out to many who were innocent of any offense except that they were not Guelfs began to exasperate all Florence, and a new name came to the front in political intrigues that henceforth played a great part in the history of Florence, that of Salvestro dei Medici, whom Sacchetti in one of his sonnets is pleased to call the savior of his country in a play of words quite good enough for his subject: *Non già Salvestro ma Salvator mundi.* Amid the commercial ruin of the Florentine merchants he had contrived to remain rich and was at this time *Gonfaloniere di Giustizia.*

Notwithstanding his many opportunities of studying the democracy, he had yet to learn how easy it is to excite a mob, and how impossible to restrain it at will, and, jealous of the fast-rising power of the captains of the people, he called on the people themselves to guard their rights, betrayed as he declared by their own

side. The *popolo minuto*, answering roughly to what is now called the proletariat, though with a mixture of a better class, and the minor *arti*, were ripe for mischief, especially the weavers and wool carders, whose wages were very low, while the rules of their guilds were framed by and for their masters. Their wrongs were real, but they had no votes, and their complaints were unheeded. Besides this, work at that time was difficult or impossible to obtain, and the unemployed were desperate. These were the people whom Salvestro dei Medici thought to use. He found how true is the warning given by Machiavelli in his history of Florence, "There is no man bold enough to arouse a revolutionary movement in a city who can, when he will, curb it when he would stay it, or guide it toward that at which he aims."

The whole of Florence was in an uproar, now partially calmed, then breaking out with new fury. Salvestro lay low, threatening to resign his post unless he was assigned the rents of the shops on the Ponte Vecchio, and having obtained this concession, kept out of sight and left his fellow authorities as best they could to get out of the troubles he had aroused. Fire and bloodshed filled the streets. Some of the most violent in the crowd were such as "went a burning more for fear than liking," not daring to seem lukewarm in the popular cause, and burning other people's houses in the hope of protecting their own. One ill deed brought another. "We have done such ill to these lords that nevermore can we trust them" was the explanation of much that was done. There were some of higher rank who directed the movements of the crowd; many are said to have been Fraticelli; and there were those who would fain have been rid of Catherine.

Soon a shout was raised, none could say by whom, but one after another took it up, "Down with the false traitor and hypocrite Soderini, who thinks of nothing but building a house for his

blessed Catherine! Down with the Canigiani!" The conjunction of two names of those known to be Catherine's especial friends was ominous. Led by a certain Mannelli, who, as he believed, had been admonished at the instance of Ristoro Canigiani, one of the sons, the mob poured into the narrow Via dei Bardi, where Dante's Beatrice spent her short married life, and where Petrarch's mother, Electra Canigiana, was probably born. They set fire to all the houses belonging to that family and, leaving the rest to burn or not, turned their fury on the palace of Soderini by the Arno, which they leveled to the ground.

Next the cry was heard, "Where is Catherine? Where is that wicked woman? Let us take and burn Catherine, who is the ruin of Florence!" And there was a rush through the city in search of her. The Eight of War did nothing to protect her, and her own friends were in danger of their lives. At this moment, she was sheltered by some whose name is forgotten, which is well for them if, as is told, they sent her away in cowardly fear for themselves. Her own few followers would not leave her, and they went from place to place, escaping their pursuers by almost a miracle, but finding none to protect them or give them a refuge.

At last they entered a deserted garden; where it was is unknown, and there Catherine was found kneeling in prayer when a band of wool combers discovered her. They burst in carrying axes and pikes and shouting her name; one who led them had a naked sword. "Where is Catherine?" he shouted. She answered, "I am Catherine: in God's name do to me whatever He allows, but let these go." The spell of her sweet voice and gracious presence was never stronger; his answer was, "Fly, I say, fly!"

"I am very well where I am," she said. "Where would you have me go? I am ready and willing to suffer for God and the Church,

and I wish for no better. If you are charged to kill me, do so, but let these go in safety."

The man made no reply, but led his troop away, and Catherine stood unharmed amid her companions, who tremblingly rejoiced over her wonderful escape. But she only wept at having been found unworthy to pluck the red rose of martyrdom, words that recall the sculpture on an ancient Christian sarcophagus in the Lateran where a Roman soldier is about to place on the Savior's head a crown not of thorns but of roses.

After this she was sheltered and hidden for three days by friends who are believed to have been Francesco Pipino and his wife, Agnese, to whom many of her letters are addressed, but her position was so unsafe that she was persuaded to leave the city. Soderini sent her into some secure refuge, and then went back and lived in the little house he had built for her, and which, strangely enough, had escaped the popular fury. She is generally supposed to have gone to Vallombrosa, where lived Don Giovanni delle Celle and many other holy men, but Vallombrosa was then and long afterward very inaccessible, and at a considerable distance from Florence. She makes no mention of where she went in her letter to Raimondo, and she dwells much more on her sorrow that she was not allowed to meet martyrdom than on her danger. There are, however, many ways of being a martyr, and Catherine's endurance of pain and toil and disappointment entitles her to count as one of that noble army. Her friends tried to persuade her not to venture back to Florence, but she replied, "I have been commissioned by God to stay here, and I will not leave Florentine ground until there is peace between the Holy Father and His children."

After a while the outbreak quieted down and she returned to the city, where she was received with shame and respect. The

storm had passed over for a time, and the people were astonished at their own ill doings. Proscriptions had, however, begun against the Guelfs; it was their turn for exile and confiscation. Although none denied that when Soderini was in power he had ruled justly and well, not only had his fine *palazzo* been destroyed and sacked, but he was sent into exile. The Canigiani fared worse; already nearly ruined by the burning of their houses, they were heavily fined, and although Ristoro had been enrolled as a *popolano*, he was now declared to be not merely a grande, but a super-grande and, as such, for his whole life ineligible for any office in his tumultuous republic. Another son, Barduccio, went to Siena with Catherine, a disciple of Don Giovanni delle Celle, who thenceforward lived with her and was one of her secretaries. He was a very young and saintly man and had been acquainted with Catherine before she came to Florence, and introduced her to his father, Pietro Canigiani. Raimondo says that Catherine had a special affection for him. "I think," he writes, "that it arose from his angelic purity, nor is it wonderful that a virgin soul should be dear to a virgin." After Catherine's death, he became a secular priest. Catherine had put him under Raimondo's especial care, and by him, "fearing that the air of Rome was hurtful to him," he was sent to Siena, where he died with a smile on his face a little more than a year after her release, glad to lay down the burden of life.

At the time when she was in such danger, Catherine did not know how soon Gregory's life would end, and she was haunted by the fear that he would return to Avignon. She therefore minimized the risk she had run in writing to Raimondo, lest the news of the tumult in Florence might increase both his anger against the city and his fears for his own safety. That every excuse for quitting Italy would be laid before him by his court she knew too

well, and in her letter to Rome, she bade Raimondo implore him not to allow what had happened to delay the peace, but rather to hurry it on while the city was tranquil.

Almost as she wrote came the news that Gregory was dead, and again her hopes were brought to nought, but Catherine was of too noble and sanguine a nature to be downcast, often and bitterly though she had been disappointed. There was a time of great anxiety until it was known that an Italian Pope had been elected and that there was no danger of a return to Avignon. But all the while she continued her efforts to reconcile Florence and the Holy See, happily unaware of what was in the near future, writing as soon as a new Pontiff had been elected in terms even more urgent than those in which she had addressed the late Pope to beseech him to begin his reign by pardoning the cities that had joined the League, and assuring him that one and all were inclined to submit. She could say so even of Florence, dispirited by the falling away of Bologna, and the treacherous defection of her captain of the forces, Varano.

To us, reading her letters in a different age, they may seem at times monotonous, as we find the same thought and arguments repeated. In this case, for instance, she says that justice without mercy is injustice, and that it is the Pope's proper work as a true shepherd to eradicate vice and plant virtue. Catherine could not always stay to notice whether her metaphors are mixed or not, nor do they always please modern taste. If need be, he must be ready to lay down life for the truth. If it appears to us that she has said this often before, we must recollect that the letters were intended for various correspondents, and not to be read one after another by indifferent eyes. She ends with a passage of characteristic good sense, warning the new Pope that it is useless to ask for too much; one must accept from a sick man what he

has to give, and take pity on the numerous souls who are perishing and begging for the oil of mercy. And this should be done even if they do not ask in exactly the courteous way that would become them, nor feel as heartily regretful for their misdoings as they ought to be.

The death of Gregory not only changed the aspect of political affairs but was accompanied by tumults and intrigues recalling those of the Conclave at Carpentras, after the death of Clement V, when the populace surrounded the palace where the Sacred College had met, burned the neighboring houses and pounded at the barred doors within which the cardinals were deliberating with shouts of "We will have a French Pope! Italian Cardinals, name a French Pope!" The conclave broke up in terror and, pulling down part of a wall at the back of the palace, escaped in all directions. The cry now was "French Cardinals! Name an Italian!"

Florence, like all Italy, was deeply interested in the matter, the more that, with a new Pope, negotiations might be made on a better footing, but internal matters were even more pressing. Discontent was still rife among the lower classes, while the perennial struggle with the grandi always threatened law and order. Roughly speaking there were always five parties in Florence, trying each to get the upper hand. With such a solvent as is suspicion always at work, such a complication of offices and change of officers, such elements of disquiet as existed in Florence, it is wonderful how a city could exist, much more rise to such a glorious eminence as did the city of the lily.

All these difficulties had to be taken into account by Catherine, and that she dealt successfully with them is a decisive proof of her powers. In July 1378 she saw her task accomplished; Florence and the new Pontiff were reconciled, the interdict was

raised, and she had also the promise that Talemone should be restored. She could write to Siena with rapture that "in spite of those who sought to hinder," peace was made; messengers had arrived bearing olive branches, and she sent a twig of one to Siena. Readers of Dante will recollect an allusion to some such scene that he too had joyfully beheld:

> Come a messegger che porta olivo
> Tragge la gente per udir novelle,
> E di calcar nessun si mostra schivo.[23]

Catherine's work was done, and with deep thankfulness and relief she could say, "Now, therefore, let us go back to Siena."

Returned there she took up her former life of combined meditation and active good works, passing from one to the other without any jar, a Martha and Mary in one, now lost in superconscious ecstasy, now giving her mind to politics and the reform of the Church, seeking to make her fellow citizens observe the interdict from which they were not yet relieved, making foes into friends and visiting the Spedale. Catherine's life was a continual prayer, but no one ever insisted more strongly that prayer should not supersede good works. When she saw danger of spiritual selfishness, she did not fear to write, "Better good works than many psalms," "Be not satisfied with saying many *paternosters*," and again, "Good and holy works are that continual prayer that every creature endowed with reason should make."

It was at this time that she wrote and dictated her famous *Dialogue*, or, as it was at first called, *The Book of Divine Teaching*, a more appropriate name since in it the soul is supposed to be listening to divine teaching and hardly speaks at all. Her disciples

[23] *Purgatorio*, Canto II, lines 70–74.

had begged her to put down the thoughts and meditations they heard from her lips; wherefore, says Di Gano, "this servant of Christ made a noteworthy thing in the form of a missal.... She composed it all in ecstasy, abstracted from the use of all her senses except her tongue."

This agrees with Raimondo's report, but he was then in Rome, and Stefano Maconi, who took down part from Catherine's dictation, told Caffarini that she wrote much of it herself, and that he had collected some of her manuscripts and put them for safety in the Carthusian monastery of Pontignano, a little way from Siena. She is also spoken of as walking about while she dictated, and part was composed in the quiet hermitage of Fra Santi.

How and where the work was written is of small importance. Its value consists in its own merits and in its having breathed new life into arid scholasticism, as is declared by no less an authority than Cardinal Capocelatro in his fine life of the saint of Siena. Much is an amplification of what has been touched on in letters, such as the beautiful passages on prayer. The work was originally in short chapters, but Gigli divided it into *tractates* that treat of prayer, discretion, obedience, and perfection. It is a wonderful study of the soul's relation to God, and we can well believe Catherine's declaration that no man, not even her friend and confessor Raimondo, although he was "of subtle genius and a great searcher into the mysteries of the Divinity and of Holy Scripture," but only God Himself had guided her in composing it.

It belongs to the class of writings that come from the Convent of Hilfta in Germany, and the Abbey of Saint Victor in France, but the breath of practicality pervades it that characterizes Italian mysticism, distinguishing it sharply from the works of the French and German school. Di Gano put it into Latin, because, as he says, those who had any learning did not care to read what

was written in the vernacular. Therefore, he translated it for his own satisfaction and that of his friends, spending several years over his version and, when he had completed it, sending the manuscript to Maconi to correct, since he had heard most of the original as it fell from Catherine's lips. After this it was entrusted to a good copyist, a man according to Petrarch far from easy to find. De Gano had not long got it safely back when a French Dominican bishop who had known Catherine at Avignon came with Raimondo, then risen to be general of his order, to Siena and begged it, saying that he found some things in it better put than by any of the Doctors of the Church, and that he would preach from it in his diocese and gain much fruit of souls, and De Gano had to let it go.

Chapter 11

⚜

Gathering Storms

Affairs at Rome soon began to preoccupy Catherine. Never had there been more excitement, more hope and fear, nor such consciousness that a great crisis was at hand than around the dying bed of Gregory XI. Even before he expired, the chief authorities of Rome, together with many clergy and laymen, went to Santo Spirito, where had gathered the cardinals who were then in the city to demand an audience and press the election of a Roman as Pontiff. The cardinals spoke them fair but declared that they could only act as directed by the Holy Spirit and, having dismissed them ill satisfied, hastened to convey all their most valuable possessions into the castle of Sant' Angelo, which was held by a strong garrison under Pierre de Rostaing. As soon as the death of Gregory was known, every gate and bridge in Rome was guarded and watched by order of the civic authorities, lest the conclave should be held elsewhere, and such barons as were likely to interfere with the election of the new Pope, such as the Orsini, were ordered to leave Rome. Deputations were again sent to put before the members of the Sacred College how much Italy and especially Rome had suffered from the absence of the pontiffs and warn them to make a speedy choice of one who should be

Roman or at least Italian, for the temper of the people would endure nothing else. At the same time, to assure them of protection and overawe the turbulent populace, a block of marble and an axe were placed in the piazza before Saint Peter's, and thrice a day proclamation was made that anyone who harmed them or any of their retinue would be beheaded on the spot.

Of the sixteen cardinals in Rome only four were Italian, while eleven were French. The remaining one was a Spaniard. Of the Italians, Orsini was too young for a Pope, and Tebaldeschi was too old; only two possible ones remained, and they were not Romans.

Although the Senator of Rome and the thirteen *Banderesi* (Bannerets) who commanded the civic guard from the *rioni* or wards of the city had promised safety and freedom of debate, and though axe and block stood in the middle of the piazza, it did not seem as if their precautions were of much avail, for shouts filled the air of "Roman or Italian we will have. Give us a Roman Pope who will stay with us, French cardinals, or we will make your heads redder than your hats!" And the electors passed through the crowd before Saint Peter's on their way to the Vatican, where no conclave had been held for fifty-six years, followed by a number of armed rioters, who, in the confusion caused by a tempest, during which the Romans gloomily noted that the palace had been struck by lightning, pressed in after the cardinals, and even after the greater part had been expelled and the doors were supposed to be closed for the night, between thirty and forty were found to have remained. The bishop of Marseilles got rid of them by inviting them to an excellent supper, after which they departed in good humor.

In the belfry of Saint Peter's, the bells were clanging wildly all night, and below, a dense mass of people, townsfolk and peasants

who had flocked in from the Campagna, ate and drank and shouted till even through the barred doors and thick walls of the Vatican the noise reached the cardinals as they sat in hot debate before formally opening the conclave. Nor was this all; against all precedent the Banderesi insisted on entering, and again warned them to choose a Roman Pope. They then withdrew, and again the threatening voices outside penetrated to the cardinals' ears.

There is little darkness in an April night in Rome, and a lesser matter suffices to keep the people all night in the streets. "Scarce a cardinal slept." It would have been wonderful had they done so, even had they had less uncomfortable "cells" than those occupied by them, little spaces curtained off in the hall of conclave, where the next day they met and again could hear the roar of impatient voices outside, and the pounding and battering on the doors, and a report was brought that the rabble were collecting fuel to burn them down. The need of a speedy election was evident, but there were many opposing interests. Six of the cardinals were from the Limousin and wished for a Pope from their own province; but four others, though also French, formed what was known as the Gallic party, headed by Robert of Geneva, and would not hear of this; Urban V, they said, and Gregory XI were Limousins and had brought only misfortune. Rather than have another Pope from that province, they would join the Italian party, which consisted of the old Cardinal Tebaldeschi and Orsini, Romans, Corsini, a Florentine, and Simone da Borsano, a Milanese.

The debate might have lasted long had they not been spurred on by personal fears. The bishop of Florence proposed Tebaldeschi as Pope, but this suggestion was strongly opposed by the cardinal of Limoges. "The cardinal of Saint Peter's"—Tebaldeschi—"is ineligible," he said, "because as he is a Roman, it will seem as if the Sacred College had yielded to the clamor of the

Romans; moreover, he is aged and infirm. The bishop of Florence is ineligible because he comes from a city that is in revolt against the Church. Cardinal Orsini is a Roman, and far too young.... I propose the archbishop of Bari."

All agreed to this compromise and voted for Bartolomeo Prignano, archbishop of Bari, except the bishop of Florence, and Orsini, sullen and disappointed that the choice had not fallen on himself. At the time, the choice seemed politic. Prignano was of high character, a good businessman, and popular with the Romans, and there was a secret hope among the cardinals that one who had lived at Avignon, and could compare its luxurious safety with the squalor and chronic anarchy of Rome, must desire to return.

Of course, he was not present in the conclave, and the news of his election was sent to him. It took him altogether by surprise. Hastily bidding his servants hide and remove all his books and most valuable possessions before the mob could use their singular privilege of pillaging the house of a newly chosen Pontiff, he obeyed the summons to the Vatican.

In the mysterious way in which news leaks out when a conclave is sitting, the crowd discovered that a Pope had been elected but mistook the name for that of Tebaldeschi, and while one part of the throng rushed off to sack his house, another burst the doors and pressed in to do homage to him, with exultant cries of "We have a Roman Pope!" The magistrates sent out couriers to announce the news, and the cardinals, who were "eating a most miserable dinner"—probably their unwelcome guests of the night before had consumed their provisions—terrified at what would ensue when the mistake was discovered, fled wherever they could, and the poor old cardinal of Saint Peter's, too gouty to move, was left alone, nearly suffocated by the crowd pressing on him to kiss

his gouty hands and feet, and feebly tried to explain the mistake, while Prignano concealed himself in one of the most distant parts of the Vatican.

The uproar and jubilation was redoubled when the cellars of the Vatican were discovered, stored with excellent Malvoisie, Greek and diverse other good wines. There was such confusion during these two days that accounts of what occurred differ very widely, but all agree that when the mistake as to the new Pope was discovered, the popular fury equaled the first rejoicing and was intensified by a confusion between the archbishop of Bari and a certain Giovanni who had this name, a man who held some office in the papal household and was greatly hated. "Not a Roman? Death to the traitors," was the cry, justifying the cardinals' fears. Some were seized and forcibly brought back to the Vatican to choose a new Pope, but they found courage to declare Prignano duly elected and, in the confusion that followed, were able to disappear.

In the Vatican there remained only Cardinal Tebaldeschi, too infirm to run away, and the Pope, who kept out of sight until the next day, when the tumult quieted down, the Romans being pacified at finding that, if not one of themselves, the new Pontiff was at least an Italian, and beginning to be eager to see the coronation. Prignano himself—and the incident is noteworthy in the light of what followed—refused to be treated as Pope, saying that he felt uncertain as to the validity of his election, until assured on this point, but five cardinals who had escaped to their palaces came back and solemnly declared it to be regular, and those who had fled to Sant' Angelo wrote to the same effect. A little later, reassured by the Banderesi, they ventured out and found Rome in the best of tempers, delighted with the prospect of the impending ceremonies, which only the oldest had ever seen. On

Easter Sunday, April 18, 1378, all the legates except those who had refused to leave Avignon, and the cardinal of Amiens, whom Gregory XI had dispatched to Tuscany, assembled to crown the Pope as the custom then was, seated in a chair where all could see him, before Saint Peter's, after which he went in procession to the Lateran, now made habitable. Thenceforward he was known as Urban VI.

A greater contrast to his predecessor, the pallid, vacillating, refined Gregory XI could not have been found. Born of a Neapolitan father and a Tuscan mother, Urban VI was short, stoutly made, and swarthy, with fiery black eyes, unprepossessing and brusque. But the well-known purity and austerity of his life made him in Avignon "among the faithless only the faithful found," and his patronage of learned men, close study of canon law and of the Bible, which he caused to be read to him every night, suggested to Catherine, who had known him at Avignon, a great hope that he would put a new spirit into the papal court and reform the Church.

In all its corruption, the fact that faithful souls were still found in it was amply proved by the great missions to India, China, and Africa, for which there always were eager volunteers. Gregory and his predecessors had greatly encouraged these missionary labors, which should never be left out of account in estimating their merits. There were also devout and earnest men, free from any touch of that surface piety that Catherine scorned, all eager to cooperate in reform.

Urban had a golden opportunity, but he threw it away. The intentions with which he began to rule were excellent. He desired to free the papacy from foreign influence, especially that of France; to do justice between that country and England, and reform the manners and morals of the higher ecclesiastics. It was

a great program, but Bartolomeo Prignano was not the man to carry it out. No Brutus ever surprised those around him more by unexpected developments of character. When Lodovia Gonzaga of Mantua heard of his election he had said, "I am sure that he will rule the Holy House of God well, and I venture to say that for a hundred years the Church has not had a shepherd like him, for he has no relations, is good friends with the queen of Naples, and is experienced in worldly matters, and sagacious and prudent."

But there are many who do well in subordinate positions yet cannot bear the test of ruling others. Urban VI was emphatically one of these. Very soon the prior of Gorgona wrote ruefully to Catherine that he had seen Gambacorta and had heard from him that the new Pope was a terrible man and greatly frightened those who had to do with him. If Catherine had had to rouse Gregory out of *accidié*, she now found herself obliged to implore Urban to restrain his savage temper. "For the love of Jesus," she wrote, "restrain those over-quick impulses that nature suggests to you." From first to last, her letters to Urban have a touch of uneasiness; they are cautiously respectful though frank; the almost caressing tone of those to his predecessor, the last excepted, is quite absent.

But Urban, though he took her admonitions without offense, paid no heed to them. The very day after his coronation, he broke into reproaches as he sat in the consistory against the indecent luxury of the higher clergy, not without cause, if, as is told, many had a hundred horses in their stables and a retinue to match, while the extravagance of delicate dishes and wine at their banquets was notorious, and had called forth scathing notice from Petrarch. However, it was a considerable stretch of authority to bid them observe the rule of Urban's own order and have but a single dish at their meals. Besides this, the bishops were desired

to live in their dioceses and cease to be the pensioners of princes and cities. It is said that Urban had never visited his own diocese of Bari, but had that been the case, they would surely have met his rebuke as a French bishop did the inquiry of Gregory XI as to why he was absent from his see: "Holy Father, why are you not in yours?" "Perjured traitors" was Urban's name for them.

The anger of all present was unconcealed; the lame Robert of Geneva rose and limped up to the papal throne, and exclaimed, "Today you have not shown the cardinals that respect which they received from your predecessor. I tell you that if you belittle our dignity, we will belittle yours." That one who so lately had been merely a monk should thus treat the princes of the Church was intolerable, and the threat was no empty one, but Urban would not be warned. Repeatedly he offended his cardinals, bidding one hold his tongue and not talk nonsense, telling another that he was a fool. He actually sprang up to strike a third and was prevented from doing so only by Robert of Geneva, who seized and pulled him back, exclaiming, "Holy Father! Holy Father! what are you doing?"

"In Urban," wrote a contemporary, "was verified the proverb, None is so insolent as a low man suddenly raised to power." Never did a man do right in so wrong a way, and the consciousness of good intentions blinded him to his mistaken methods, while his view of himself as spiritual head of all Christendom made oppo-sition appear to him as sacrilege. His very virtues turned against him. That sense of justice that made him declare he would do right by England was supposed to mean that he would favor the latter country at the expense of France, and this belief was con-firmed by his harsh reproaches to the cardinal of Amiens when he came from Tuscany to do him homage—reproaches well deserved, according to Walsingham—for having stimulated the discords

between England and France, and diverted great sums of money to his own use. Urban's accusations were the more stinging from being deserved, and the haughty Frenchman retorted, "Thou liest, Barese," thus contriving to insult the man while avoiding direct insult to him as Pope, and, so saying, he walked out of the hall.

An even more dangerous enemy was created in the Conte di Fondi, governor of Campania, who had lent a large sum of money to Gregory XI. Urban not only repudiated the debt but deprived him of his office and bestowed it on a personal enemy of the count's.

Even more fatal was the result of his behavior to Otho of Brunswick, the fourth husband of Giovanna I of Naples. This queen had been well pleased that a subject of hers should be elected Pope and sent both ambassadors and Otho to Rome to congratulate him, but the austere Pontiff could only look with high disfavor on such a woman as Giovanna, feeling nothing of the fascination that had bewitched so many, and marked his opinion of her by an impolitic discourtesy to her ambassadors and her husband. When Otho knelt at a banquet to offer him a cup of wine, he feigned not to see him, and left him kneeling, until a cardinal, distressed by his rudeness, said aloud, "Holy Father, it is time to drink." To the ambassadors, he said that he was well aware of the evil condition of the court of Naples and was determined to amend it. Giovanna was infuriated at the offense she had received in the persons of those who represented her, and the friendship and support of Naples was lost to Urban.

Even if he took good advice, he turned it to ill. When Catherine repeated the counsel that she had vainly given to Gregory, that he should create "a troop of good cardinals," it suggested to him to threaten the Sacred College with swamping the French party with Italians, a declaration satisfactory to the Banderesi,

who had begged for a creation of new ones, but which made Robert of Geneva, pale with anger, leave the consistory. Secret interviews were at once held by him with his colleagues, and the schism that rent the Church for forty years began to come into sight.

Difficulties thickened around Urban. Unless the castle of Sant' Angelo were held by a garrison faithful to the Pope, he had no mastery over the city, and the French castellan refused to deliver it up until he had permission to do so from the cardinals in Avignon. When they loyally desired him to obey, the French ones in Rome secretly forbade him to do so, and Sant' Angelo remained a menace to Urban, and a warning of coming danger.

The heat and unhealthiness of Rome gave the cardinals sufficient excuse for leaving Rome and going to their houses at Anagni, as they had been accustomed to do in the time of Gregory XI. There it was easy to communicate with Naples and the Conte di Fondi, and there too went the archbishop of Arles, taking with him the papal tiara and other treasures. Urban ordered him to be arrested and summoned the cardinals to join him at Tivoli, and they tried to induce him to go to Anagni, where he would have been in their power. He refused to join them, and they refused to appear at Tivoli.

On this he carried out his threat of creating an overwhelming number of Italian cardinals by nominating twenty-four of that nation. The Anagni party thereupon declared him unlawfully elected, and an apostate and antichrist, and proceeded to choose another Pope, who took the name of Clement VII and was none other than Robert of Geneva. The choice of such a name by one stained with the blood of Cesena roused the mocking spirit of the Italians. Three Italian cardinals who had been sent to negotiate stood neutral, waiting to see what would happen.

Gathering Storms

It had needed no gift of prophecy when Catherine foretold the coming schism at Pisa; all who could read the signs of the times could foresee it, but it might have been delayed had Urban been less unwise. He himself believed that it was no fault of his. The pronotary of the Apostolic See, Tomaso Petra, ventured to ask him how the mistake between himself and his cardinals had arisen, and the Pope answered with unexpected mildness, "Truly, my son, it is no fault of mine" and explained it by his refusal to return to Avignon or to seize on the possessions of the Knights of Saint John as a means of filling the papal treasury, a proposal he had rejected with disgust, declaring that he would rather die a thousand deaths than destroy the right arm of Christendom. Urban, whatever his faults, was no Clement V. There was a third reason for the breach between this Pope and his high dignitaries, which is given by Theodore Niem, his secretary: the alarm created by his determination to extirpate simony, and also, no doubt, his rough attempts to reform their ways. "It is not what he does, but the way he does it" was the explanation of an ambassador when asked how Urban came to make so many enemies.

During this time, Raimondo of Capua was in Rome, and in high favor with Urban, who declared that he was hands and feet to him, though it appears that he was offended with two friends of Raimondo's and Catherine's, one of whom was Tantucci. Raimondo kept Catherine informed of what was passing, and a passage in a letter written to Urban only two days before the antipope was elected suggests that the intentions of the cardinals were already known. Her distress was unspeakable. The thing that she had above all dreaded had come to pass; the unity of the Church was shattered. There had indeed been earlier antipopes, but only to disappear speedily, disavowed by even the few who

had supported them. Now, not a Louis of Bavaria, not Florence, not a Tuscan League was defying the Pope, but his own cardinals and half Christendom. Henceforward the consciences of men would be distracted by the doubt of who was truly head of Christendom, who really held the awful powers that they conceived to be vested in the Vicar of Christ. And the blindness of the cardinals was willful, since at the time of Urban's election, the members of the Sacred College wrote with one accord to those at Avignon, declaring that "freely and by common consent they had elected the archbishop of Bari, a man eminent for his great merits" and had eleven days later sent letters to the kings of France and England and the emperor of Germany to the same effect.

Urban's own doubts at the time furnished another proof that all had held his election valid, since they called forth a positive assurance from all who had voted that there was no question on the subject. They had shown him homage as their head, had attended his consistories, and had asked many papal favors, as he remarked with a touch of humor. Now they wrote to all the courts declaring that the election had taken place under pressure of fear—that they had expected the archbishop of Bari to decline an honor for which he should have known himself unfit, and they warned all Christian peoples to withhold allegiance "to that wicked man" and in no way to obey the mandates, monitions, acts, or words "of him who must abdicate unless he was prepared to incur the wrath of Heaven, Peter, Paul and all other saints."

Christendom was split into two camps, more through politics than religion. Spain, Savoy, Cyprus, and a few German princes sided with the antipope; France wavered and tried for a time to take neither side; Scotland naturally took the one that England did not, and England would have none of Clement;

the schismatic cardinals wrote to Archbishop Sudbury in vain. Neither clergy nor laity could forget that Robert of Geneva was "a man of blood," and his military genius and gracious manners did not appeal to them. The ministers of the boy king Richard II drew up a list of reasons why they held their allegiance due only to Urban, and among them is mention of a revelation made to a holy hermit, in whom may be recognized William Flete of Lecceto, showing him that Urban and no other was the true Pope. And when the other "nations" of the University of Paris accepted Clement, the English students stubbornly refused to do so. One voice was uplifted among the cardinals who had voted for Urban, to affirm the validity of his election; from his dying bed the aged Tebaldeschi declared Urban to be the true Pope, but his declaration had no effect, and of the Italian cardinals created in haste by Urban, several went over to the antipope.

Catherine, heartbroken and aghast, gathered up all her remaining strength to fight for the unity of the Church. She wrote fiery appeals to renegades, to the indifferent, to princes, priests, kings, cities, a very storm of letters recalling them to their duty, and reminding them that the arm of the Church might be weakened but would not break, and would emerge out of weakness strengthened together with all who clung to it.

With all the passionate eloquence at her command she addressed the Cardinal di Luna, who had been sent to negotiate at Anagni and as yet had not abandoned Urban's cause, but who one day would himself be an antipope — Benedict XIII. "Ah, wretched soul of mine!" she exclaimed, "all other things, war, dishonor, and other tribulations would seem less than a straw or a shadow compared with this," and she goes on to implore him to make peace and put away this great scandal. Both the Pope

and Catherine hoped much from his mediation, and the blow was a heavy one when it appeared that he had played false and had even induced the three cardinals who had hitherto stood neutral to go over to Clement.

Forty years of schism lay before the Church, forty years of mutual excommunications, fighting, utter disorder. At one time there were three popes. Often two bishops disputed a diocese, two priests claimed the same parish, and this not only in Italy but in Germany, France and Spain. And the main cause of all this horrible confusion and sacrilege was not even religious, but venal. "The origin of the schism," declares Chamange in his work *The Destruction of the Church*, "and the root of all confusion is money."

Catherine found some comfort in the very extremity of the situation, though convinced that it must become still worse before there was improvement. "I saw how the Bride of Christ can give life," she wrote, "having in herself such vital force that no one can stay her; I saw that she shed forth strength and light, and that none can deprive her of it, and I saw that her fruit never diminishes, but ever increases." Her noble faith upheld her, though the hopes that had filled her life lay dead around her. The few remaining years of her troubled existence were spent in a desperate struggle to support Urban, made more desperate by her consciousness of his unwisdom.

Among the many striking letters written at this time is an especially memorable one to the three Italian cardinals who had followed the lead of Luna. Righteous indignation thrills in every sentence. "What shows me that you are ungrateful, base, and mercenary?" she asks. "The persecution that you and the others are inflicting on that Bride [the Church] at a time when you should be shields to ward off the blows of heresy," a word that in her letters often stands for schism.

Yet you know clearly that Urban is truly Pope, the su-
preme Pontiff, chosen by due election, not through fear,
but truly by divine inspiration rather than your human ac-
tion. And so did you announce this, which was the truth.
Now you have turned your backs like base and wretched
knights; you have been afraid of your own shadow.... You
ought to have been angels on earth, set to free us from the
fiends of hell, and fulfilling the office of angels by bringing
back the sheep into the obedience of Holy Church, and
you have taken the office of devils. With that evil that
you have in yourselves, you seek to infect us, withdraw-
ing us from obedience to Christ on earth, and leading us
into obedience to antichrist, a member of the devil, as
are you also so long as you remain in this schism. This is
not the blessedness springing from ignorance.... No, for
you know what the truth is; you told it to us, not we to
you. Oh, how mad you are, for you told us the truth and
want yourselves to accept a lie! Now you would corrupt
that truth and make us believe the contrary, saying that
you elected Pope Urban out of fear, which is not so, and
anyone who says so (I speak without reverence, for you
have deprived yourselves of reverence), lies shamelessly.
Anyone who chooses can see whom through fear you
made show of having elected, namely Signor di San Pi-
etro.... That the solemnity was carried out in good faith
is shown by the reverence you gave and the favors asked,
which you have used in all kinds of ways. You cannot deny
this except by lies.

The allusion to "Signor di San Pietro," i.e., Cardinal Tebalde-
schi, shows that Catherine believed the report that the cardinals,

in their dread of the turbulent Romans, caused it to be believed that he was the new Pope, even persuading him to put on papal vestments.[24] Another story was that, in answer to the clamoring voices demanding who had been chosen, Cardinal Orsini called from a window, "Go to Saint Peter's and you will hear," and that the words were misinterpreted to mean that Tebaldeschi had been elected, but as the crowd was already in the piazza of Saint Peter's, this seems an unlikely story.

One wonders how the princes of the Church took Catherine's very plain speaking, especially when she went on to say that one reason for their defection had been that being used to soft and pleasant dealings from those around them, they could not endure Urban's asperity.

> Not only an actual correction, but even a harsh word of rebuke made you lift up rebellious heads. This is why you changed, and it clearly reveals the truth to us, for before Christ on earth began to sting, you owned and did him reverence, as the Vicar of Christ which he is. But this last fruit you bear which brings forth death and shows what manner of trees ye be, and that your tree is planted in the earth of pride, which springs from the self-love which robs you of the light of reason.... Speaking entirely in the natural sense ... Christ on earth being an Italian, and you Italians, I see no cause but self-love why affection for your country could not move you as it did the Ultra-montanes.... Let it not seem hard if I pierce you with the words that love of your salvation has made me write; rather would I pierce you with my living voice, did God

[24] See also Letter 317, to Giovanna of Naples.

allow. His will be done. And yet ye rather deserve deeds than words. I come to an end and say no more. Did I do as I would, I should not yet pause, so full is my soul of grief and sorrow to find such blindness in those set as a light, not lambs who feed on the honor of God and salvation of souls and the reform of Holy Church, but thieves who steal the honor due to God, and take it themselves, and as wolves they devour the sheep, wherefore I have great bitterness. I beg of you for love of that precious blood that was shed with such fiery love for you, refresh my soul, which seeks your salvation.

The bait held out to these three cardinals apostrophized in Catherine's letter[25] was no less than the papacy, secretly promised to each. Angered by the election of Clement VII, they deserted his side but, from either shame or fear, did not return to Urban, whose savage treatment of those whom he suspected might well make them keep out of reach. Catherine's letter had no effect on their conduct, and she wrote no more to them.

Some of the most persuasive letters sent by her at this time were to the queen of Naples. The antipope had been proclaimed in her kingdom; she had welcomed his election with costly gifts and congratulations, as she had done so short a time before for Urban's. When he went to Naples, a splendid reception awaited him; the queen and her husband met him and kissed his feet, and her chancellor, Spinelli, as Catherine implies in writing to her,[26] was at her ear, full of rancor because Urban had refused him a post that he coveted and had insulted him publicly. Catherine

[25] Letter 310.
[26] Ibid.

not only uses affectionate persuasion but menaces the queen, that unless she changes her mode of life, she will be set as a sign such as shall make any tremble who ventures to lift up his head against the Church. "Do not await this rod," she writes, "for hard will you find it to kick against the pricks of Divine justice. You will have to die, and you know not when.[27] Not riches, not state be it ever so stately, nor worldly dignity, nor the barons and people, your subjects in the body will be able to defend you before the Supreme Judge, nor protect you from Divine justice. But," she adds with curious approach to what was to happen,

> sometimes God uses them as executioners, to do justice on His enemy. You have invited and invite all your people to be rather against than for you, they having found in you little truth, not the state of a man with a manly heart, but of a woman with no sort of firmness or stability, a woman thing light as a leaf in the wind. Well do they recollect that when Urban VI, true Pope, was made with a great and true election and crowned with great solemnity, you caused a great and mighty feast to be held as the son should do when the father is exalted, and the mother for the son. For he was son and father to you; father through the dignity to which he came, son because he was your subject, that is, belonging to your kingdom. And therein you did well. Then you ordered all to obey his Holiness, as a high priest. Now I see you turned, as a woman without stability, and you will have men do the opposite....

[27] Neither Catherine nor Giovanna could have foreseen that in three years the wretched queen would be strangled in one of her own castles.

Do this no more, for the love of Christ crucified. In all you are calling down divine justice. It grieves me. If you be not aware of the ruin coming on you, you cannot come out of God's hands. For justice or for mercy, you are in His hands.... Constrained by the Divine Goodness which loves you unspeakably I have written to you with great sorrow. At another time I wrote to you of like matters. Have patience if I weary you overmuch with words, and if I speak boldly and irreverently. The love I have for you makes me speak without doubt. The ill thing you have done causes me to depart from due respect and to speak irreverently. Much rather would I speak with my voice and tell you the truth thus for your welfare and chiefly for the honor of God than by writing, and much sooner would I act than speak to any guilty, but guilt and occasion for it is in you yourself, since no one, demon or created being, can force you to commit the least sin against your will.[28]

After the murder of Giovanna, a packet of Catherine's letters to her were found, carefully preserved, and worn as if much read, but at the time they produced little or no practical effect. Her pride had been too deeply offended by the Pope, and she was further irritated by hearing, rightly or wrongly, that the reason of his putting difficulties in the way of her nephew's marriage to the heiress of Sicily was because he meant her to be given to his own dissolute nephew, Francesco Prignano. There was also a report that he had refused to crown Otho of Brunswick king in right of his being her husband, because if Charles of Durazzo came to the throne, he had promised to give this Francesco

[28] Letter 317.

four important Neapolitan cities. Giovanna did not pause to weigh probabilities or give Urban the benefit of his really lofty character, and allowed herself to be guided by Spinelli, brimful of rancor against Urban, and soon she had to be counted on as a very dangerous enemy.

Catherine's efforts to influence her through some of her ladies were equally vain, nor could she bring back the deeply offended Conte di Fondi, who was not only alienated from Urban for personal reasons but was allied by marriage to Otho of Brunswick and had lent his palace at Fondi to the cardinals, who assembling there held the conclave in which Clement VII was elected. To this day the people call it *Il Palazzo del Papa*.

The schism had passed beyond human power to remedy, and Catherine spoke to deaf ears, all the more that the doubt and confusion as to where right lay was so great that we find men such as San Vincenzo Ferreri siding not with Urban, but with Clement, and as enthusiastic on his behalf as was Catherine on Urban's. Something might possibly have been done had Urban's proposal to call a general council been listened to The question of his succession might have been decided, and had it gone against him, whatever his faults, there is every reason to believe that he would have submitted, but the schismatic cardinals refused to call one, and the king of France believed that in Robert of Geneva, of a house allied by interest and friendship to himself, lay the hope that Avignon would again become the seat of the papacy. The colossal egotism of all chiefly concerned, with the exception of Catherine and of Urban himself, determined that the schism should continue.

Chapter 12

᳹

A Last Journey

The position of Urban was hourly growing more alarming. His one thoroughly loyal supporter among the cardinals, the aged Tebaldeschi, was dead, and his dying protestation that Urban had been legally elected fell on deaf ears. The trustworthiness of those whom he had himself created was doubtful, even where they had not gone over openly to Clement. So grievous did the state of things seem to Urban that his secretary, à Niem, describes his bursting into tears as he listened to the reports brought him, and adds that "he was left alone like a sparrow on the housetop."

In this perplexity and distress, his thoughts turned to Catherine of Siena, and he sent to Raimondo da Capua, bidding him call her to Rome. When she received the message, she was ill in bed and quite unfit for a journey. Other reasons weighed more with her. There had been great murmuring among the Mantellate—naturally, those who did not go with her—on account of her frequent absences, to a degree that could not be ignored, and there were many outside the Sisterhood also who genuinely disapproved. "Why does this Catherine go a-roving?" they said. "She is a woman; if she would serve God, why cannot she keep quiet?"

Saint Catherine of Siena and Her Times

The uncertain position of "recluses," in the world yet not of it, unsheltered by a cloister, yet vowed to lead absolutely retired and inconspicuous lives, made it needful to walk warily, the more that not a few brought discredit on their profession. And Catherine never wantonly offended the conscience or opinions of others and, in ordinary cases, would have entirely endorsed the usual view of a Mantellata's life. She was well aware that the strong must submit to barriers for the sake of the weak who cannot dispense with them. Perhaps, too, failing health and strength made her reluctant to enter on such a struggle as would await her in Rome. She answered Raimondo's letter with as near a refusal as she could venture to make.

> My Father, many in Siena and some Mantellate think I travel too much; they are scandalized and say that a religious should not always be gadding about. I do not think that these reproaches ought to trouble me, since I never undertook any journey save at the command of God and His Vicar and for the salvation of souls, but to avoid any cause of scandal, I did not mean to leave home again. However, if the Vicar of Christ wishes it, it must be done, only in that case kindly send me his orders in writing, that those who complain may see and understand that I am not taking this journey at my own desire.

Urban sent her a written command to come, and she obeyed. It is said that after leaving Siena, she turned and looked long at its circling walls and towers, as if in silent farewell. She never saw her native city again.

Which road she took after passing through Porta Romana and traversing the valley of the Orcia is uncertain. She may have paused at Orvieto, though it is somewhat out of the way, for there

lived Sister Daniella, to whom she wrote many letters, in the last of which there is a hint that she might take that road. With the usual provoking absence of details, all that is recorded of her journey is that she was accompanied by numerous followers, of whom Stefano Maconi was not one, for he and others of her most trusted disciples had been sent to steady the wavering allegiance to Urban of various Italian cities. But he was soon back in Siena, consoling himself for not being allowed by his parents to join her in Rome by looking after her business in the city, and writing delightful letters, now gay, now grave, to his friends in her company. Her secretaries, Bardoccio di Canigiani and Neri di Landoccio, went with her; the old hermit, Fra Santi, who loved her so dearly, had left his quiet cell to accompany her; and Prior Giovanni III had left his monastery for the same purpose.

Among the women were her sister-in-law, Lisa, from whom Raimondo derived his information as to the facts in Catherine's life after he left Rome on a mission to France, in less than a fortnight after her arrival, Alessia dei Saracini, and Giovanna di Capo, who seems to have been of a forgetful disposition, since on one occasion, when it was her turn to provide for the meal of the company, often suddenly increased by pilgrims and visitors to Catherine, she totally forgot to do so, so that—as we are told—there would have been no food at all, had not Catherine worked a miracle! Lapa Benincasa was there, or came later; there appears to be some confusion between the mother and a daughter of the same name. When Catherine wrote to Stefano Maconi from Rome, "Tell the Prior to do as he thinks best about Sister Lapa; if she should go to Siena, I commend her to you," she may allude to a different Lapa from either. Lapa was a common name at that time in Siena, though now no longer used there, and may have been a feminine made from the family name of

Lapo. That Catherine meant to commend her old mother to Stefano is not likely. He could have needed no such request; everyone and everything connected with his beloved "Mother" was precious to him.

The travelers reached Rome safely in November 1373, more fortunate than the ambassadors sent there by Siena, two of whom were captured by the Clementine party and released only on payment of a great ransom. They took up their abode at first in a house in the rione di Colonna, not far from the Pantheon, but soon moved to one in Via di Papa, where now is a chapel of the Nunziatella. It stands between the Campo di Fiori and the Dominican Church of Saint Maria sopra Minerva, where a year and four months later Catherine was to find her last resting place. From the Pope she would accept nothing but this shelter, and all the party lived on alms, as a protest against the luxury of the time, alms which were freely given, fortunately for Alessia, who superintended the temporal concerns of the "college," and who often found her resources severely strained, especially when, at the bidding of the Pope and Catherine, numerous hermits and ecclesiastics came to Rome and sought the house in Via di Papa for maintenance, never refused or grudged. Raimondo had left Rome at this date; therefore, it must be on her authority that he reports that

> the Holy Father at Catherine's suggestion summoned to Rome very many of the servants of God, all of whom she received because of her great hospitality. For although she owned no lands nor gold nor silver, and lived with all her family on daily alms, yet was she as ready to receive and entertain a hundred pilgrims as though they had been only one, trusting heartily in God, and not questioning

but that His liberality would provide. The lowest number that lived in her house was sixteen men and eight women; at times there were even thirty or forty. She had established such good order in the household that each sister, week by week, took it in turns to provide and dole out to the others, so that they might give themselves to God and to pilgrimages, and other matters that had brought them there.

Whether Catherine was received in Rome with any of the enthusiasm shown in Pisa and Geneva and Toulon does not appear; probably not, since Raimondo omits it, and he is slow to ignore any circumstance redounding to her honor, but there is one little mention of her which forms a pendant to the notice of her first visit to Florence already alluded to as existing in the Strozzi archives. Ungaro, a Sienese sent by the authorities of the city to Rome, to complete the tardy arrangements for the restoration of Talemone, wrote home, "Catherine of Monna Lapa has come here, and our Lord the Pope has seen and spoken with her. I do not know what he said, but only that he was much pleased to see her."

Though it was their first meeting since he had become Pope, Urban had known her in Avignon and was aware of the effect she had produced by her addresses to the Sacred College there. Remembering this, he bade her a few days after her arrival to come and speak to such as were with him in Rome. She needed no interpreter, for most if not all of them were Italians. Accordingly she went to Santa Maria in Trastevere, where he was living, the Vatican being dangerously near Sant' Angelo and its French garrison. She had gone through a far more formidable ordeal at Avignon, but with better hope than now. No fear of the future,

however, was allowed to appear in her brave words, and Urban was much cheered and impressed, though unfortunately he did not take to heart her exhortation to "fight only with the weapons of repentance, prayer, virtue, and love." Summing up what she had said, he exclaimed, "How greatly unworthy are we before God when we yield to hesitation and fear! This *donnicciula*" — the shade of meaning in the half-contemptuous, half-caressing word is untranslatable —

> this poor woman-creature confounds us. I call her a poor woman-creature not in disdain, but to express the natural weakness of her sex, which would make her timid even if we ourselves were confident, yet she it is who shows herself calm and fearless while we are fearful. Does she not shame us all?

And, inspirited by what she had said, he added,

> What should Christ's Vicar fear though the whole world were against him? Christ omnipotent is stronger than the world. He can never forsake the Church.

One of Urban's most pressing anxieties was the support that Giovanna of Naples was lending to Clement. It seemed to him that if she could hear the eloquent voice that had put new courage into him, she would be won back to his cause, and he proposed sending Catherine to her court. The plan had already crossed Catherine's mind, for in writing to the queen she had said how thankful she should be if she could go to her, and lay down her life if only she could save her body and soul. Lest offence should be given by sending one who was only sprung from the people as an ambassadress to Naples, Urban suggested her being accompanied by her saintly namesake, the still very beautiful daughter of

A Last Journey

Brigitta of Sweden, who had come back to Rome after removing her mother's body to her native country.

The two met, and the description of their interview provokes a smile, so wide is the gulf between Catherine of Siena with her high ideals and wide outlook, and the highborn beauty who tells her of the ardent lovers who had sought to carry her off by force; of her journey to Assisi, her hospital work, and of the long journey back to Sweden, which, after all, was not unlike a triumphal procession, so great was the honor shown to her. She traveled under a safe conduct from all the authorities of Rome, who requested all cities and magistrates to permit the goods and chattels and the horses belonging to this royal lady of very great holiness and self-denial to pass free of toll or duty. She was now in Rome on business connected with the canonization of her mother, which, in spite of that schism that so long delayed Catherine of Siena's receiving a similar honor, took place in 1391. She spoke also, shudderingly, of a visit to Naples that had made such an impression on her that never could or would she return there. It was not surprising that she should feel thus.

Her brother, Prince Charles, had also been at Giovanna's court, and the queen's light fancy was caught by him, so that she used all her fascination to make him divorce his wife and marry her. His mother looked on aghast, praying that he might die rather than consent, and when he sickened of a fever that proved fatal, her feeling was one of thankfulness rather than of sorrow. His sister considered Giovanna as the cause of his death and declared that to go to her court would be tempting Providence. Nothing should make her go there.

While she spoke, Catherine of Siena had sat on the ground, listening silently. Raimondo, watching her, saw tears fall as the Swedish princess uttered the last words, but still she said

nothing. She had heard enough to understand that although her namesake was a good and holy woman, she was not of the stuff out of which martyrs are made. Nor was Raimondo, who seized with much relief on the chance of keeping her out of the way of probable insult, perhaps death. She had so lately escaped being murdered in Florence; how would it be in far more lawless Naples, where Giovanna was queen? Himself a Neapolitan, he knew much better to what she might be exposed than she herself could know. We may be sure that it was not with Catherine's leave that he reported to the Pope what had passed, and urged the greatness of the risk, the uncertainty of any good result if Catherine went, not even safeguarded by having the Swedish princess as her companion.

Gregory had bidden her venture into danger; Urban was more considerate. Disconcerted he was, but he showed none of the savage anger that he usually displayed if thwarted, and after sitting for some time in reflection, with his head leaning on his hands, he said, "It is more prudent for them not to go," and Raimondo went back at once to tell Catherine of his decision.

She was lying face downward on her bed, worn out by the excitement and disappointment of her interview with the princess, but rose as he spoke with that noble anger flashing in her eyes which her disciples knew and feared: "If Agnes and Margaret and many other holy women had reasoned thus, they had never worn the crown of martyrdom. Do you not know that we have a Bridegroom stronger than men, who can save us from the hands of the wicked and preserve our honor amid a crowd of licentious men? All the objections of which you speak are vain, springing from a wretched lack of faith, not true prudence."

Raimondo stood listening, humbled and full of admiration for her courage, but inwardly glad that the thing was settled. Unable

to give up hope of influencing Giovanna, Catherine advised that
Neri di Landoccio should be sent to Naples and wrote herself to
several of the great ladies there. The queen was as deaf to his ar-
guments as she would probably have been to those of Catherine,
but he succeeded in gaining over many Neapolitans to the side
of Urban, whom they were naturally disposed to support as their
countryman, a feeling with which Giovanna soon had to reckon.
Raimondo too was sent from Rome, reluctantly enough, on a
mission to the king of France, with credentials from the Pope,
and a letter in which Catherine said all that she could think of
to induce him to withdraw his support from Clement, and use
his influence with the queen of Naples to the same end.

Raimondo's departure, so soon after her arrival, was a severe
blow to Catherine. Before he left Rome, they had long and ear-
nest conversations together, as those who had much to say to
one another, and should meet no more. On the day of his leaving
Rome, she went with him to Ostia, where he embarked, and as
he stood on the deck of his ship he saw her kneeling on the shore
in tears. Then he could perceive that she had stretched out her
hands, and was making the sign of the Cross over the waters. "I
felt that in this world she would never bless me again," he writes,
with a heartache that still is felt in the simple words.

As he had foreseen, they met no more, but Raimondo did
not reach the court of France. Alarmed by warnings that the
Clementine party were determined he should not reach the king,
and aware of the horrible fate of priests of Urban's party who
had fallen into their hands,[29] he lost heart before he had gotten
farther than Ventimiglia. "Here," he says,

[29] Fleury, *Ecclesiastical History*.

a monk of my order, a native of that place, sent me a letter in which he said, "Beware of passing Ventimiglia, for treachery is prepared, and if you fall into the trap, no human help can avail you." On this, after advising with the companion given me by the Sovereign Pontiff, I went back to Genoa.

He fully believed that the difficulties and dangers in his way justified this abandonment of his mission, a view shared by Urban, who greatly valued the simple, honest man, and far from showing displeasure, gave him other work to do at Genoa.

Catherine saw it quite otherwise. She was almost incredulous that he could have been so fainthearted and sent him a letter that filled him with compunction, telling him that his conduct showed him to be a babe, not a man, and that if he dared not travel as a messenger from the Pope, he might have walked as a barefoot friar over the mountains and begged his way.

Her attitude both to Popes and confessors is very curious; while profoundly reverencing their spiritual authority, she never hesitates to rebuke them as men. Raimondo, though he may be treated as her "dear Son and negligent Father," when he speaks as her priest receives instant and entire obedience. Sometimes he would exercise his authority in what seems a childish way, considering with whom he was dealing, ordering her to sit down again when she was about to go, or in some such manner, and she instantly submitted, fully believing that it was her duty to do so. But though in matters of discipline he might sometimes reassure himself by taking a high tone, when he knew her displeased with him, he was sorely distressed, and after receiving her letter of reproof, he made a second attempt to reach France, again unsuccessfully, and she had to accept his failure, though to

flinch from the chance of martyrdom seemed to her even more cowardly now that she was in Rome than it had done elsewhere.

Dante, when he visited Rome nearly a century earlier, had felt that the very stones in her walls and the ground on which the city stood were to be venerated, for to him she had not only Christian associations, but also imperial. Like Dante, Petrarch had reverenced her as the center of empire and world rule. It is true that he writes about martyrs in quite the proper way, but that was when he was urging the return of the Popes and thought it the right thing to say. Her classic and imperial associations were what really appealed to him.

To Catherine, Rome was sacred solely and simply because it was the city of Saint Peter and Saint Paul, where countless Christians had laid down their lives for their faith. If to her it seemed "a piece not of earth, but of Heaven," she took it from an altogether different point of view from the Greek visitor who called it so; its pagan and historical associations said nothing to her. The places she visited were convents and churches; we hear of her seeking the convent of the *Clarisse*, or Poor Clares, near San Lorenzo in Panisperma on the Viminal, where she would find Catherine of Sweden, and the Church of Santa Croce, and the basilica of Santa Sabina, so closely connected with Dominic and the convent of nuns whom he insisted on making into an enclosed order, with small consent on their part. Whether she visited the neighboring Church of San Sisto is uncertain, but there is a memorial of her in a strange old painting on a wall behind the choir in which the Savior is represented as drawing from His wounded side a garment that He gives her as she kneels at His feet dressed as a Mantellata. There is also a small figure, supposed to represent the prioress of San Sisto. It must be a very early picture, for though around the head of Catherine are rays,

as in many of that date, she does not yet wear the aureole that marks her as a canonized saint in all paintings executed after 1460.

She certainly went to the Lateran, "Mother and Head of all Churches in the City and in the World," and here she would find the work of no fewer than three fellow citizens: Giovanni di Stefano of Siena was directing the rebuilding of the basilica; the silver figures of Saints Peter and Paul had been ordered by Urban, and from a goldsmith called Bartolo, also a Sienese; and the panel pictures adorning the upper part were painted by Berno da Siena. Catherine sought out almost all the basilicas, praying at the Stations of the Cross on their appointed days, fearless of the malaria that haunted the almost deserted hills, where here and there a convent stood among heaps of ruins and rubbish. Saint Peter's was a constant place of pilgrimage, reached from Via di Papa by crossing the bridges from the island in the Tiber into Trastevere, for the one below Sant' Angelo had been broken down, and the garrison made sudden sorties and "did most vehemently assault and bombard" all the district around, reducing the houses to heaps of bricks and fragments of wood. "They are battering all day long," wrote the Sienese who mentions Catherine's coming to Rome, and no one could pass near the castle.

Rome was indeed beset with enemies within and without. Almost at her gates were the soldiers of Giovanni and Rinaldo Orsini, and those of the Conte di Fondi, who was fighting in support of Clement against his own brother whose hill town of Sermoneta he had seized, together with Norma and Ninfa, which belonged to one of his cousins. The walls of the city were but a poor defense, "a frail patchwork of bits of marble and stones," and there were thirteen gates to defend. Ravaging the Campagna

were the savage Breton troops, whom Gregory XI had launched upon the unhappy Romagna, ever wasted by wars, civil and foreign, and who were now making war against his successor. Another enemy was that very duke of Anjou who, Catherine had hoped, would head a Crusade. Now, in that irony of fortune that pursued her, he was fighting indeed, but against the head of Christendom, and with a Crusade proclaimed against him by Urban. Clement counted upon entering Rome and being admitted into Sant' Angelo by the French commander. The circles of besiegers came closer to the city, and a hurried sortie made by the Romans resulted only in defeat. Many of the citizens were left dead on the banks of the Anio, slaughtered by the Bretons like sheep in the shambles, says à Niem, close to that bridge that was destroyed in 1869 by the order of Pius IX, lest Garibaldi and his band should cross it.

Provisions rose to famine price, and Rome saw herself threatened with the fate of Cesena. What she might expect was plainly shown by what occurred when the Bretons forced their way through one of the gates, and rushed up to the capitol, where at that moment most of the Banderesi and many others of the chief citizens happened to be gathered unarmed. They were slaughtered in cold blood, after which the invaders retired, leaving behind a scene of massacre that exasperated the Romans into blind fury, and with true mob logic they fell upon all the foreigners whom they could find, even the English priests who to a man were loyal to Urban, and murdered them. So intense was the hatred kindled by the wanton brutality of the Bretons and the distress and ruin caused by the bombardment from Sant' Angelo that à Niem says he saw Roman women spit in the faces of the few Frenchmen who still belonged to the papal court, and no foreigner's life was safe.

Saint Catherine of Siena and Her Times

Urban could see no hope except in opposing mercenaries by mercenaries, and with all her hatred of war Catherine was of the same opinion, and a band of Free Lances was gathered under Alberic di Barbiano that took the name of the *Compagnia di San Giorgio*. It was destined to become famous in the next century as a school of military discipline and great generals. At first they were but a handful; soon, however, they amounted to four hundred men, Italians one and all. They encountered and routed the Bretons, and Urban knighted their leader, and gave him a banner inscribed with the words, "Italy freed from the barbarians."

This victory was a national event and was realized as such. For the first time, Italian troops, fighting for an Italian prince, had met and defeated a renowned band of foreigners. At the news Italy thrilled with pride, and consciousness awoke, never again quite to be lost, that her many provinces made up one country. "Not English, not Germans, but Italians have vanquished the Bretons" was the triumphant record placed in the archives of Florence. In Rome, the victory was attributed to the prayers of Catherine of Siena, and her popularity was boundless.

Sant' Angelo still resisted, and it was absolutely necessary to gain possession of it. In a fresco by Cimabue at Assisi may be seen how massive and impregnable it then was; the walls were covered with marble, the lower structure was square with a round tower erected upon it, and above this again was a square one. Underneath it were great underground ways whose use is unknown. There was no hope of taking it by assault, and to starve the garrison required more time than Urban could afford. The commander might have held out but was discouraged by the news that the papal troops had gained another victory at Marino, thirteen miles from Rome, and consented to negotiate and finally

to evacuate the castle. Hardly was the last Frenchman out of it
when the Romans, as regardless of venerable associations then
as now, threw themselves furiously upon the fortress whence
they had been so long harassed, with intent utterly to destroy
it. They succeeded in tearing off its marbles and in pulling down
part of it, but its outer walls defied their rage, though for many
years vast heaps of stones and rubbish lay around it where weeds
and bushes grew and goats clambered and browsed — a quarry
for building materials and pavements.

That the garrison consented without more delay to yield up
such a stronghold as this was greatly due to the skillful negotia-
tions of the chancellor of the city, Giovanni Cenci, a friend of
de Rostaing, who commanded the French in Sant' Angelo, but
above all a patriot. It may be that the Romans could not forgive
him this friendship, for after the French had given up the castle
he met with such scanty gratitude that Catherine in a letter to
the Banderesi and the "Four Good Men, supporters of the Re-
public of Rome," found herself obliged to write:

> It seems to me that some ingratitude is being shown
> to Giovanni Cenci, who with so much solicitude, and
> faithfulness and simpleheartedness, solely to please God
> and for our good — and this I know to be the truth — left
> everything else to relieve you from the scourges which
> Castel Sant' Angelo inflicted on you, and showed such
> prudence, and now not only no thanks are given him,
> let alone any sign of gratitude, but the vice of envy and
> ungratefulness spits forth poison of evil sayings and much
> murmuring. I would not that thus he or any other should
> be treated who may serve you, for it would be an offense
> to God and for your harm, since the whole community

needs wise, mature, and discreet and conscientious men. Let this thing be no more, for the love of Christ crucified. Use what remedy may seem best to your Lordships, that the foolishness of the ignorant hinder not that which is right. This I say for your advantage, not from any (personal) feeling, for you know I am but one passing by, and speak for your good, for you all and he too are as my soul. I know that as wise and discreet men you will look on the affection and purity of heart with which I write, and thus you will pardon my presumption in venturing to write. I say no more. Remain in the holy and sweet love of God. Be grateful and conscious of what you owe to Him.[30]

Catherine had herself known what it was to have her patriotism suspected at the moment when she least deserved it, and she felt strongly for Cenci. That he recognized her efforts both on his behalf and on that of the republic he was able to show unmistakably at a later time. There is nothing to show that the Banderesi and the Four Good Men testified any more appreciation of his services after receiving Catherine's letter than they had done before, except that when Urban named him as senator of Rome, the authorities concurred in bestowing this honor upon him; otherwise he could not have received it, since the holder of this dignity was named by them and merely approved by the Pope. It was a recently created office, dating only from 1359, and the original idea, no doubt, was as at first with the captain of the people in Siena, that it should be held by an outsider who would be impartial, for the first senator was not a Roman but a Sienese. The four *Buon' uomini* were probably supposed to be checks on

[30] Letter 349.

the Banderesi, as the *gentil uomini* were intended to be in one of the many varieties in the government of Siena.

One other point should be noticed in Catherine's long letter to the authorities of Rome, namely, her anxiety that they should treat the company of San Giorgio properly and care for the wounded. It looks very much as if Rome had as little gratitude to spare for them as for Cenci since it was necessary for Catherine to write:

Also I want you to be grateful to the company, who have been Christ's instruments, providing that which they need, especially the poor dear wounded. Behave charitably and peaceably toward them, that you may keep their assistance, and take away those things that they have against you. You ought to do this, most sweet brethren, both as due to them and also because of the great need. I am sure that if you have the virtue of gratitude in you, you will study to do this and the other things aforesaid; if not, no.

To Catherine, if to no one else, the Romans were lastingly grateful. She had not only prayed for them and won the deliverance of the city, as they believed, by her supplications when hope was lowest, but she had had no small part in the negotiations for the surrender of Sant' Angelo. Tradition says that she even went to the castle herself and had an interview with Rostaing. By her advice, Urban announced that there would be a solemn thanksgiving for the success of his troops and the safety of the city, and all the population, high and low, poured out when he went in procession to Saint Peter's, barefoot, as were the clergy who accompanied him, and attended by all the barons and civic authorities. Notwithstanding all the squalor and barbarism into

which Rome fell after the Popes had deserted her, she had from time to time had splendid processions, when the senator and Banderesi and magistrates appeared in purple and silk and gold embroidery, and the delighted Romans crowded to see them pass. But the simplicity and gravity of the ceremonial with which the deliverance of the city was celebrated, if it did not dazzle the eye, touched all hearts. Such a ceremony had not been seen in Rome since Pope Stephen IV had gone in procession in 769 from San Giovanni Laterano to Saint Peter's, and it was recognized that the absolute simplicity of all that was done, the absence of pomp and the touch of humiliation were more fitting than splendor, since to gain the victory Christian blood had been shed. Catherine wrote on this occasion to Urban, "I feel cordial gladness, most holy Father, that mine eyes have seen the will of God fulfilled by you, namely, in that humble act, very long disused, of the holy procession,"[31] and a later passage shows that thanks to the recovery of Sant' Angelo, the Pope had returned to "his own place," in other words, to the Vatican.

A letter of Catherine's "written in abstraction," and addressed to the leaders of the Company of Saint Giorgio, is included in Tommaseo's collection, but its authenticity is doubtful.[32] Maimbourg, the historian of the Schism, notes how unlike is its tone to that of her other letters, and remarks that she would hardly, when in ecstasy, have dictated passages "full of abuse." This is a little too strong, but again, Catherine, who knew well what the plundering of Free Lances meant, could hardly have suggested booty as a reward to be looked forward to. Nor is the style of diction quite hers, and in spite of the great authority of Tommaseo we

[31] Letter 351.
[32] Letter 347.

may venture, and gladly, to exclude this letter from the number of those certainly written by Catherine.

The victory of the papal troops at Marino had not only the effect of relieving Rome from fear of the Bretons but caused Clement to escape in haste to Gaeta, pursued by the Company of Saint Giorgio. Thence he fled to Naples, whose queen welcomed him to the beautiful castle that Froissart declares to have been raised by magic in a single night. Giovanna had received him with open arms, but not so the Neapolitans, who shouted "Long live Pope Urban!" and raised such a tumult that he hurried onboard ship and sailed for Avignon, where he could feel safe. The Avignese did not trouble themselves as to the validity of his claims, and he tried to recover his shaken prestige in the eyes of the world by riding into the town in state, wearing the tiara that the archbishop of Arles had carried off from Rome. On hearing of his arrival, the cardinals in Avignon at once recognized him as Pope, and the king of France rejoiced greatly. "Now I am Pope!" he is said to have exclaimed triumphantly on hearing that Clement had touched Provençal ground.

There was no longer any hope of inducing Charles V to support Urban. Catherine had done her best,

writing very pressing letters to bring him back to that Pope. But that illustrious Catherine, carried away, no doubt, by her somewhat violent zeal, treated Clement and his cardinals as incarnate demons, and gave them other names almost equally strong, so that it made no impression on the mind of the king, for he did not care to prefer above the opinion of the most learned men in the kingdom the advice of a nun, who, though many may believe that she was a saint, even before her canonization,

yet wrote in a somewhat embittered style to persuade so moderate a prince. Once for all, every action of a saint is not a consequence nor a mark of saintliness. Certainly Saint Vincent Ferrière and other great and holy personages did far otherwise.

This is the view of Maimbourg, who takes the side of the antipope, but though blaming Catherine for overvehemence in her letters, he always speaks of her with great esteem, writing of her elsewhere as "this admirable maiden, who joined to eminent holiness a rare mind, and a courage much above that which is usual in her sex," and altogether shows an appreciation of her not generally found among French or German historians who support the schismatic popes.

"The learned men" of whose opinion Charles V thought so much were those who composed the University of Paris. Although such a body could have no right to assume the authority belonging only to a general council, he had turned to them for a decision as to whether Urban or Clement were lawful Pope. They hesitated, waiting on events, then replied, excusing themselves for the delay by observing that Mary Magdalen had done less for the good of the Church, by believing at once in the Resurrection, than had Thomas by long doubting, since through this doubt that great truth had been more clearly shown. Finally they announced that the university adhered and would adhere to Clement VII as the true Sovereign Pontiff and Shepherd of the Universal Church, thus "marvelously strengthening" the Clementines.

Chapter 13

ᴥ

Last Days in Rome

Clement's audacious scheme of making what he intended to call the Adriatic Kingdom out of the Romagna and Umbria, together with the towns of Ferrara, Spoleto and Perugia, had failed, greatly through the influence that Catherine had exerted. For the moment, Urban had the upper hand, and though his treasury was scantily filled, he had more to give and to spend than his rival, too often obtained by means that, when first elected, he would have been the first to condemn. Now he practically argued that necessity has no law. Some of those who had gone over to Clement now came back, finding that he could not maintain them, and hoping to regain property confiscated by Urban when they deserted him. Others contrived to have a foot in either camp and got offices and benefices from both Pope and antipope, and many bought them to keep or sell again. Although this was rank simony, both Clement, who was indifferent to the sin, and Urban, who had begun by prohibiting every kind under pain of excommunication, making such fierce war on it as was one of the chief causes of the cardinals turning against him, alike profited by it, and all the Church became a scene of monstrous scandals and disorders.

With what pain Catherine looked on can be only faintly imagined. The Popes had returned to Rome, and this was the outcome! The prince who should have led a holy war was in arms to support a schismatic Pontiff! The papal court was a scene of buying and selling holy things! In this crisis she suggested to Urban that he should call a number of holy men to Rome, not, of course, supposing that their advice could be of much use, but, as her letters show, with the hope of inspiring a more unworldly and religious spirit into the papal court. The proposal seemed good to Urban, who sent forth a brief to that effect. The choice of those bidden to come was evidently left more or less to Catherine, for most of the names are those of men whom she knew and trusted, such as the prior of Gorgona, Don Giovanni delle Celle, William Flete, and that Brother Antonio of Nice with whom, as an early letter of Catherine's betrays, he did not always find it easy to live in harmony.

She enforced the brief by letter to these and many others. Some came and some refused, and among the latter were the two hermits of Lecceto. Equally surprised and disappointed, she wrote to them again, bidding them leave their solitude and hasten to the battlefield. If they wanted woods, they would find plenty, she observed with that touch of irony that lends individuality to her letters. As the one addressed to them both did not produce the desired effect, she sent another especially intended for Fra Antonio, reminding him that the saint whose name he bore had assuredly loved solitude as much as he could do, yet left it in order to strengthen those who were weak in faith.

Catherine had every right to speak thus; her own ardent desire had been for a secluded life of contemplation. She had sacrificed this longing at the call of duty. "She begged of our Lord to grant her solitude," says Flete, "and He replied, 'Many live in a cell who

abide outside it, but I will that thy cell shall be the knowledge of thyself and thy sins' and from this cell she never departed." She disposes summarily of Fra William's defense that a couple of godly men had received a revelation to the effect that the plan of calling hermits to Rome was only a human counsel and not ways from Heaven — nay, that the Pope and his advisers had been deceived by the evil one, who desired to withdraw such pious men from a holy and retired life and sought to hinder prayer and meditation. "Lightly anchored indeed must be the soul," Catherine retorts,

which by change of place loses its hold upon heavenly things. Truly it would seem that God accepts places, and is found only in the forest and not elsewhere in time of need! What then shall we say if, on the one hand, we want the Church of God reformed, and thorns taken away, and the sweet flowers of the servants of God set therein, and on the other, we say that to send for them and withdraw them from quiet and peace of mind in order that they may come and help to steer this vessel is a deceit from the devil?... Not thus have done Frate Andrea da Lucca, nor Frate Paolino, such great servants of God, old and infirm, who have lived so long in peace, yet at once, for all their weariness and discomfort, they set out and came and have accomplished their obedience, and although torn with longing to go back to their cells, they nevertheless will not shake off the yoke, but say, "That which I have said, let it be as not said," stifling their will and their own consolations. Whoever comes not to gain advancements, but for the dignity of much toil, with tears, watching, and continual prayers should do thus. Now let us burden you with no more words. May

God in His mercy make all clear, and guide us in the way
of truth, and give us true and perfect light that we may
never walk in darkness. I beg you and the Bacceliere and
the other servants of God to pray to the meek Lamb to
make us go in His way.

She often alludes to Flete as the *Bacceliere*, a title found among
religious orders as a degree lower than that of doctor. In a manu-
script kept in the Spedale of Siena he is called "a man of great
penitence," and elsewhere he is described as spending his days in
the wood with a book, returning at night to his monastery, and
Catherine had occasion to reprove him for this habit of absenting
himself and paying little attention to the wishes of his prior, who
wanted him to say Mass in the church of his monastery, instead
of in some one of the caves turned into chapels, as he loved to
do. He had a passion for solitude and did not love the society of
Fra Antonio at all.

One must listen to other people's troubles and have
compassion on those who are bound to us by the bonds
of charity; it is a great fault if you do not do this. For ex-
ample, I would have you show compassion for those of Fra
Antonio and for his difficulties, and not refuse to listen
to him [Catherine admonishes him]. I beg you to do this
for Christ's sake and mine.

And she adds a wholesome warning against over-austerities and
hard judgment of those whose rule of life was different from his.
Flete had studied at Cambridge and had seen the world. It is to
be feared that he found his harmless fellow hermit insufferably te-
dious. But in one thing both were heartily in sympathy — namely,
in deep reverence and affection for Catherine.

His refusal to go to Rome was no small vexation to her. Too much annoyed to write directly to him, she sent a letter to Fra Antonio. "It appears from the letter that Fra William has sent me that neither he nor you mean to come. To which letter I do not mean to reply, but much am I grieved at his simpleness, since the outcome is small honor to God, or edification to one's neighbor."

Toward the end of this epistle it seems as if her heart smote her for her severity, and she names Flete among those whose prayers she expressly desires, and that she altogether forgave him is shown by her having sent him a message from her deathbed, showing entire trust in him, though her call to Rome had only made him hide himself deeper in his forests, declining altogether to follow the example held up to him of Andrea and Paolino.

Fra Antonio was less stubborn; he could not resist Catherine's appeal and rebukes, and he not only went to Rome, but remained there until his death in 1392, "having suffered much for the Church, and obtaining the title of *Beato*." If Don Giovanni delle Celle came, it was but for a short time; he was in Vallombrosa at the time of Catherine's death.

When those who responded to Catherine's summons arrived, many of them old and feeble, having gone through the difficulties and dangers of a journey through districts where civil war had just been raging, and all astray in a city, they naturally gravitated to the house in Via di Papa, and Catherine as naturally undertook to support them. The duties of Alessia dei Saracini as head of such a household could not have been easy in those days, especially if she had helpers as inefficient as Giovanna di Capo. Whether their presence in Rome had the desired effect cannot be discovered.

Public affairs again came to the front, and a serious danger appeared in the shape of Francesco di Vico, who held a high post

in the government of Rome but was living in Viterbo, whence he raided all the country round. Viterbo had been a papal stronghold, and Urban was determined to recover it, the more that di Vico had been a thorn in the side of Gregory XI, who had vainly tried to gain his friendship by mildness. Urban resolved to use stronger measures, as usual without much consideration as to whether the moment were propitious. The letter that Catherine wrote to him on the subject has some historical importance, as showing that Rome was a self-governing republic, and independent in political matters of her popes, who only much later claimed a right to interfere with the government of the city. The Romans had sent ambassadors to Viterbo on their own account, probably to remonstrate with Vico on the manner in which his men-at-arms were ravaging the surrounding country, and he had given a reply "wrathful and irreverent." This Urban knew, but it was only through Catherine that he learned the intention of the magistracy to call a council to deal with the affair, after which the Banderesi and the "Good Men" were to seek him and inform him of what had been decided, he being embroiled with di Vico on his own account. Catherine strongly advises him to continue his habit of often meeting the authorities of the city, and implores him to receive them mildly, whatever they may say, and to explain whatever he considered necessary. An anxious and propitiatory sentence follows this counsel:

> Pardon me, for perhaps affection makes me say what maybe should not be said, but I know you ought to be aware of the temper of your Romans, and that they can be drawn and bound much more by love than by any other means, or than by sharpness of words, and you know too the great need both for yourself and the Church to

keep this people obedient and reverent, since here is the beginning and end of our faith. And I humbly beg of you to be prudent in only promising that which you can fully perform.

Urban had need of the warning, for he is reported to have been "a great promiser,"

> that there may not come shame and confusion. And pardon me, most gentle and holy Father that I say these words. I trust that your humility and benignity will be content that they be said, not disgusted and contemptuous because they come from the mouth of a most lowly woman (*vilissima femina*).[33]

The difference of tone between this uneasy fear of how her words may be taken, and the frankness with which she said much harder things to Gregory XI, high in favor though she was with Urban, tells its own tale. Yet she still could consider him, with all his mistakes, and violent Neapolitan temper, as "a just and virtuous and god-fearing man, with such holy and honest intentions as for a long time the Church has not had," and this conviction, which was, of course, independent of her reverence for him as Pope, strengthened her to do battle for him to the last and to stay away from Siena, though its affairs at this time were heavy on her heart. She knew that even her own followers felt the ill effect of her absence; some were growing lukewarm; there were troubles relating to Signor Matteo and the Spedale, and difficulties had risen between the city and the Pope, as appears from a letter of hers to Urban.

[33] Letter 370.

Who the "Leone" of whom she speaks may have been is unknown; Tommaseo takes him to be one of the two knights captured by the Clementines when sent from Siena to the Pope, who later succeeded in coming to Rome. "I pray you," she writes,

that you will see to remedy that whereof Leone spoke to you, for the scandal grows daily, not only on account of that which was done to the Sienese Ambassador, but for other things constantly seen, which are such as to provoke to wrath the weak hearts of men. This (line of conduct) you do not need now; you want someone who will be an instrument of peace, not war.

The want of names makes the next sentence obscure:

Even supposing that he acts thus out of honest zeal for justice, there are many who do it with such disorder and hot anger that they pass the bounds of rule and reason, and therefore I urgently pray your Holiness to condescend to the infirmities of men and find a physician who may better cure sickness. Do not wait until death comes; if some remedy be not found for the ill, it will increase. Also, recollect the ruin that came on all Italy from not seeing to the civil governors who ruled her so that by their means the Church of God was despoiled. This I know that you are aware of. Let your Holiness see what should be done. Take compassion, take sweet compassion, for God does not despise your desire, nor the prayers of His servants.

The clue of this letter is lost, but it is too characteristic of Catherine's attitude toward Urban VI to be passed over. Those who are alluded to as instruments of war are believed to mean a certain Santa Severina and the Conte di Nola, men of war who

had the Pope's ear. Another letter written about this time was addressed to Louis, King of Hungary. Since the king of France could not be counted on, Urban had, if possible, to find some prince whose weight and loyalty might counterbalance this for-midable defection. The only one in the least able to do so was Louis, brother of Queen Giovanna's first husband, whom she had caused to be murdered and who therefore was her bitter enemy. He had distinguished himself in fighting against the infidels and was known as "the Standard-Bearer of the Faith." At this mo-ment, he was at war with Venice, and Catherine uses all her arguments to induce him to make peace with her, and come to Urban's assistance, and be deaf to those who assured him that Clement was the true Pope. Will he allow antichrist and a woman (Giovanna) to bring ruin and great darkness on the Faith? Much good would come of his arrival in Italy. Perhaps it might even be the saving of Giovanna, *"questa poverella di Reina,"* as Catherine calls her, with lingering tenderness, by making her see the con-sequences of persisting in her obstinacy. So far, Urban has not excommunicated her, hoping that she might repent.[34] The hope did more credit to Catherine's heart than to her head.

Domestic troubles were soon to occupy her painfully. "The old serpent, finding that he could not succeed in one way, tried another yet more dangerous," writes Raimondo:

> What he could not bring about through the schismatics, he thought to cause through such as had so far been loyal to the Holy See, sowing divisions between the Romans and the Sovereign Pontiff, and things rose to such a height that they openly threatened to put him to death.

[34] Letter 357.

Saint Catherine of Siena and Her Times

There was no need to call in the old serpent as a factor in the dissatisfaction that showed itself in Rome; the schismatic cardinals and those Roman barons who were more or less openly favorers of Clement had abundant means of stirring up disloyalty. The novelty of having a Pope in Rome soon wore off. The return from Avignon had brought instead of the expected wealth and splendor, war and ruin; a great part of the city had been destroyed and many lives lost. Urban had little money to spare for Rome, and his character was not one to win popularity. When in adversity he was humble and eager to gain the hearts of those about him, but with the first gleam of prosperity, the old overbearing, violent temper reappeared.

When he least expected it, a furious tumult broke out in the city. Catherine, kneeling in an agony of prayer, could hear the tramp of the armed mob marching by and shouting, "To the Vatican!" just as they had at an earlier time called, "Give us a Roman Pope!"

Forcing the great doors of the Vatican open, they rushed in, brandishing pikes and swords and seeking for Urban. Want of courage was never a fault of this Pope. They found him seated on his throne, wearing his pontifical robes and miter. "Whom seek ye?" he asked, facing them as fearlessly as Boniface VIII had faced the Colonna at Anagni, and with a better result. The Roman populace had neither wrongs to avenge like those of the Colonna, nor hereditary courage; they paused, alarmed and abashed by the awful indignation in Urban's countenance, and slunk away.

Catherine is said to have hurried to the piazza of Saint Peter's to remonstrate with the crowd; everyone there knew at least by sight that frail figure now so emaciated that "they who saw her would have taken her for a phantom rather than a living being."

Last Days in Rome

They had watched her going daily to Mass at Saint Peter's. That pale face was a familiar sight in the prisons and had bent over many sickbeds; she had prayed for them and won victory by her prayers. All listened to her voice, and by her means, peace was made between the incensed Pontiff and his rebellious Romans.

It was her last great public act; the schism and the hopeless effort to check Urban's violence and want of judgment were killing her, and it was with literal truth that she said to Fra Bartolomeo Domenico, as he bade her a last farewell, "Be assured that if I die, the sole cause of my death is the zeal that burns and consumes me for Holy Church." Yet she did not relax her efforts for unity and peace.

Almost daily she was consulted by the Banderesi, sometimes dragging herself to the capitol to meet them. Even the captains of Urban's troops came when in Rome to ask her advice. The Pope showed her such absolute confidence as his predecessor had never done, and thanks to her good offices with King Louis of Hungary, Venice had peace. Every voice praised her, and all eyes turned reverently to follow her, as she went to Mass at Saint Peter's, going there fortified by the joy of expecting to communicate, with steps so light that those who knew her real condition were filled with wonder, and remaining several hours in prayer, but too often returning so exhausted that she could only drop prone on a bed, which her friends feared she would never again leave. Yet when a new dawn broke, her wonderful vitality, both spiritual and physical, enabled her to rise and face the heavy work that each day brought.

Still, it was evident to those about her that each day lessened it, and dark spiritual experiences began to agonize her, which, as in the case of the Dominican mystic Suso, appeared to her to be the work of some evil power outside her, and, as Raimondo

knew from Alessia dei Saracini or Catherine's letters, she thought that she saw all the city full of fiends exciting the inhabitants to murder Urban, and threatening her with a dreadful death, a vision easily understood when we recollect the terror and horror that the late revolt had caused her.

Even her prayers brought her only distress, for she thought that they caused Christ only to answer, "Leave this people alone who blaspheme My name daily; when they have committed this crime I will destroy them in My wrath, for My justice will no longer endure their sins and guilt." She only prayed the more fervently, pleading, "If this great misfortune happen, not only the Romans, but all the faithful will suffer greatly. Be appeased, Lord. Despise not Thy people for whom Thou hast paid such a ransom."

Long was it before she could feel that there was an answer to her prayers. "God opposed His justice to them," writes Raimondo. The whole account vividly recalls a scene in a medieval French poem, of which there are traces in Dante's *Inferno*, called *Saint Pol le Ber*, otherwise *Saint Paul the Baron*, this being a kind of honorable title, found in the *Divina Commedia* and elsewhere. The writer describes how Saint Paul was led through hell by an angel and saw all the agonies that medieval writers describe with ruthless and sickening detail, as men to whom torture was a familiar thing. In the last scene, the lost souls implore a little truce to their anguish, on which Christ appears, and with exactly the air and tone of a deeply offended seigneur addressing rebellious vassals, demands how they who had despised and thwarted him on earth had the audacity to ask a favor from Him? Yet, for the sake of His good apostle and the angels who have mediated for them, some alleviation they shall have.

No wonder that those before whom the Redeemer was held in such a light should regard Him chiefly as a relentless Judge,

who must be propitiated by the Virgin and the saints! — Catherine, in her natural mood, was indeed incapable of looking thus on Him whom she adored and trusted with all her heart. It is a remarkable feature of her teaching, so far as it is known to us, that she rarely used fear as a motive for rousing men from their sins. Most of the sermons of medieval writers are full of awful descriptions of the fate awaiting sinners, and their purgatory can hardly be distinguished from hell. Catherine lived and taught love. To her it was the great motive power, so great that it made lover and beloved one. Her doctrine was that nothing can be effected without love, since all the powers of the soul are moved by it; every virtue receives life from it, nor without it can the soul live. Such also was the teaching of Dante a century earlier.

She found some relief in writing to Raimondo and telling him her troubled thoughts and experiences, describing how she had fallen into convulsions while in the chapel of her house and was helped back to her own room with great difficulty. But there unspeakable horror crushed her, and she had a strange conviction that her soul stood apart from her body, which seemed dead, and that she had longed to comfort Barduccio Canigiani, who stood watching her in great distress. But she could neither speak nor move, though she could and did pray passionately and for a moment felt comforted, and those kneeling around the beloved form that they thought dead saw her breathe again.

But for two days and nights, the dreadful mental conflict continued, and though she regained strength enough to creep to Saint Peter's, she never recovered its effects, and wrote a letter of farewell to Raimondo, the confessor whom she loved and respected so greatly, though sometimes he disappointed, and sometimes he misunderstood her. She commended her spiritual family to him, bidding him guard against their finding themselves like

sheep without a shepherd. She bids him collect the manuscripts of her *Dialogue* and other writings, and do with them whatever he thinks best, and, in the pathetic way in which the dying sometimes unconsciously wring the hearts of those whom they are leaving, begs him to forgive all disobedience and ingratitude of which she has been guilty, and all pain and distress she has caused him, and to forgive also that she had not cared better for his health.

At such a time, her letters could be but few, but as long as she could do so, she occupied herself with Urban's affairs and those of Siena. Soon after the victory of Marino, she had appealed to her native city for men and money, reminding the magistrates that they owed him much gratitude for having removed the interdict laid on it because it persisted in keeping up friendly relations with Florence, and had sent soldiers to the aid of Bologna and Perugia when they joined the Tuscan League. As in Florence, the interdict had greatly troubled all religious men. Stefano Maconi had written to tell her how some of the citizens had caused themselves to be enrolled as part of the household of the bishop of Narni, then in Siena, as his retinue had the privilege of hearing Mass; Stefano himself had done so.

To Catherine's straightforward mind there seemed to be a dishonest quibble in this method of evading the interdict. She told him that she would not have allowed any of her followers to do so if she had been in Siena, and Stefano would do better to wait patiently until the prohibition was removed. Still, if the bishop was clear that the thing was right, it might be allowable. The permission is hesitatingly given; Catherine cannot convince herself that all is right in this evasion of the papal interdict, but she will not question the authority of the bishop, and she takes refuge in supposing that he may have exceptional powers and can give special leave, in which case there is no more to be said.

Last Days in Rome

Stefano was quite ready to submit to her judgment in cases of conscience and attend Mass or not in the bishop's chapel as she thought right, but he could not altogether accept her point of view with regard to the city and Urban, nor could the magistrates, to whom she wrote on the subject.

Already the city had paid a heavy sum to recover Talemone, which, after all, was rightly theirs, and her reminder to be grateful to the Pope fell flat. As usual, she saw the matter from a religious point of view only. Stefano was a citizen as well as her disciple, and in a letter addressed to his friend Neri di Landoccio, but meant for her eye, he recalled what a strain there was on the resources of Siena at that moment. As far as he could say, the Sienese were loyal to Urban except perhaps a few who were looked on as thieves, but as to men and money, the Free Lances exacted blackmail monthly to the amount of six thousand golden florins, and had just raised their terms to fifteen hundred more, and even so could not be held from raiding the surrounding country. Something should certainly be sent; he had argued the matter with the Signoria often, and with outsiders also; something must be done, even if the property of the city were pledged for it.

Then, in his more usual tone of banter, he complains that his grave correspondent in Rome, Fra Tomaso, sends him no news except what he already knows. If he only had time, he could tell them all something that had made even Signor Matteo, the rector of the Spedale, split with laughter. Unluckily he had not time, and we are not allowed to know what this good joke was. Signor Matteo chanced to come in while Stefano was writing in the room that was lent him at the Misericordia and took the opportunity to send a message to "our Mother," explaining that he had so many letters to write that he could get through

no more, but begged her and Neri and all the rest to remember him in prayer. And with an exhortation to his friend either to write himself or to make Barduccio Canigiani or Cecca do so, Stefano concludes by signing himself Neri's useless and unworthy brother, poor in all virtues, epithets often found as a heading in Catherine's letters to him, added doubtless by himself when he copied them in a more earnest spirit than when he used them in writing to his friend.

Featherheaded as his serious friends in Rome considered him, he was Catherine's most trusted agent. He forwarded letters from her, whether to special correspondents or intended as a kind of general epistle to be passed from one to another; he took the matter vigorously in hand when a certain Migliorino settled himself in Lapa's empty house while she was in Rome and would not depart; it was he who had to recover a book, probably the *Dialogue*, lent to Contessa Bianchina Salimbeni, who had not returned it, as is the manner of borrowers of books in all ages. Catherine was anxious to recover it and wrote urgently on the subject. Again, it was Stefano who was to clear up the mystery of a horse that Catherine was asserted to have ordered, while she on her side declared that she knew nothing about it, and so on with various commissions, one of which has puzzled all readers of her letters, since why he should procure and send to Rome a *capretto raso* for the household in Via di Papa — a skinned or shaven kid — no one can guess. It must surely have been a skin; he has inquired what and how much to get and found that one would suffice, and it was to be conveyed by the son of the wood master, who was not, as might be supposed, the head forester, but the artist who carved the woodwork in the Duomo. Stefano's letters are quite modern in their gaiety and lightness of touch — charming, impulsive, and loving, and his grumbles at being in Siena instead

of Rome are delightful. The "college" in Via di Papa missed him as much as he missed them; in one of the last letters he received from Catherine, she writes,

> Most dear son ... I do not ask you to come, but right glad should I be if you were here or could come, if you could do so without giving offense. But with offense or trouble to your father and mother, no, unless it were a necessary thing. That I desire you to avoid at the present time as much as you can; I am certain that if Divine Goodness sees it best, objections will cease, and you will come in peace.

"Come if you can," she adds, her longing for this loved and lovable follower overcoming her prudence. A message from Barduccio follows, perhaps inserted by himself as he wrote from Catherine's dictation.

> Your negligent brother says you are to come soon; there is something he has to do, and he wants your company. It seems difficult to find how to do it unless you are with him, so much so that if you do not come, he will go to you before doing it.

The letter ends with a message about the missing book, which ought to have come several days earlier. "If you go there [to Rocca d'Orcia], say that it is to be sent at once, and order whoever goes there to say this without fail."[35]

It must indeed have been impossible for Stefano to break through the obstacles that detained him at Siena if he did not at once respond to the call in this letter, and still more to the

[35] Letter 365.

cry in another of "When wilt thou come? Ah, come soon," al-
though at this time he had not realized her condition. She had
so often seemed hopelessly ill and yet had rallied that perhaps
even those who saw her daily could not believe death near, and
her indomitable energy made her continue her usual occupations
in defiance of pain and feebleness. Just before the almost fatal
attack of which she tells Raimondo, she had written to Urban
and to three cardinals, whose names are not given, and one last
letter she wrote to Giovanna of Naples, probably rather earlier,
full of sorrow and warning, appealing to her to have pity on her
own soul, and on the people whom she had for years governed
wisely—a testimony worth much—but who now were rending
one another like wild beasts. "One holds for the white rose and
one for the red; one for truth and one for falsehood. Yet all were
created by the stainless rose of God's eternal will, and all were
regenerated to grace in the red rose of Christ."

Tommaseo, commenting on this, says that the arms in one
branch of Urban's family were six red roses, and that the allu-
sion seems to imply a red rose being the badge of the party of
Urban and a white one of the Clementines, and Burlamacchi
conjectures that the Free Lances of Hawkwood's band wore one
of them and carried the badges back to England, to become those
of York and Lancaster, but this seems little likely.

The letter to Urban bears traces in its broken and sometimes
incoherent sentences of the great effort made to write it.[36] Al-
though not placed as the last dictated or written by her in the
edition of Tommaseo, it surely must have been so. The one he
places after it, to "Signor Carlo della Pace," otherwise Charles
of Durazzo, must have been written at an earlier time, when she

[36] Letter 371.

had full command of her powers. It is as clear, urgent, and direct as any of those written years before this last stage in her history, while that intended for Urban is rather a mystical outpouring than a letter in the usual sense. How greatly she suffered in mind and body at this time is betrayed by a prayer made not long before she broke down altogether, which concludes, after a passionate entreaty that at any endurance of agony she may be allowed to see the Church reformed, with a most touching petition that if indeed it should please God to keep her yet longer "in this vessel," He would heal and uphold it so that it should not be utterly torn to pieces. Catherine had reached the limit of endurance when she prayed thus.

Chapter 14

⚜

A Good Fight Won

Before Catherine was entirely unable to leave the house, she sometimes went to sit in the garden of a friend, and here on one occasion she was found by Tomaso Petra. Death was plainly seen in her countenance, and the question suggested itself to his legal mind whether she had settled her worldly affairs. "Mother," he said, "it would seem as if Christ your Bridegroom would withdraw you from this life. Have you made your last arrangements?"

Catherine asked in surprise what a woman who possessed nothing could have to arrange. He answered that she ought to indicate in her will what each one of her spiritual family was to do after her spirit was released from the body, adding that he had a request to make, namely, that when that time came, he should be permitted to see her spirit.

"That does not seem possible," she said. "Either the soul is saved, and then her perfect bliss makes her forget the small things of this world, or she is lost, and the infinite pains that she suffers forbid such a favor. If in Purgatory she partakes of both conditions, the difficulty is the same."

But she promised to pray that Petra's wish might be granted, and his words as to her followers sank into her mind. She gave

many charges and directions to her friends and disciples. The Mantellate who had accompanied her to Rome were placed under the guidance and care of Alessia dei Saracini; the mantle that she prized so much she left to Della Fonte; her writings, as we know, were bequeathed to Raimondo da Capua. She silenced her longing to see him again by telling herself that he was serving the Church better than if he had been at her bedside.

A great joy came to her in the arrival of Fra Bartolomeo Domenico, who was sent to Rome on business by his monastery in Siena, and who entered her room unexpectedly at the end of Lent. Unprepared for the change in her since they had last met, he burst into tears. She tried to tell him how glad she was that he had come, but he could barely hear her voice. The next day was Easter Sunday and her birthday, and at dawn she received the Eucharist at his hands. She had seemed too feeble to move on her bed, but to the joyful surprise of all she suddenly rose, and knelt with closed eyes and clasped hands, in a rapture of prayer. The temporary strength vanished with the occasion; she had to be carried back to her bed of planks, and lay unable to move hand or foot.

She rallied enough to have several conversations with Fra Bartolomeo, who spent every spare moment with her, but when the business on which his provincial had sent him was finished, the friar who had accompanied him, and who does not seem to have known Catherine, pressed him to return to Siena. He could not make up his mind to do so and told her that it was impossible for him to leave Rome until she was better.

"How can I leave you when you are dying?" he exclaimed. "Were I away I should leave everything to hurry here."

"My son, I should like to have you," she answered, "and I should like to have Fra Raimondo, but it is not God's will that I should have this, and I want His will, not mine. You must go."

"Then promise that you will pray to be healed before I leave here," he said.

Neither he nor any around her could believe that such a misfortune as losing her could really come to pass. She smiled and promised, and when he came to bid her farewell, she seemed so cheerful that his hopes of her restoration to health rose. She stretched out her arms to him, kissed him and bade him go, knowing well that they should not meet on earth again. But Fra Bartolomeo went back to Siena full of hope, and the news of her death, which soon reached him, was a cruel blow. "*Seducisti me, Domine, et seductus sum, fortior me fuisti, et invaluisti,*" he exclaims with Jeremiah in bitterness of soul.

From this time Catherine grew weaker and weaker, but still, against her will, her wonderful vitality kept death at bay. "I die and yet cannot die," she had said at an earlier time, nor, as it seemed, could she do so even now, but the time was near. Stefano Maconi broke through all that detained him, to come to her bedside, warned, as he said, by a voice he heard while praying in the chapel of the Spedale bidding him hasten to Rome, as her departure was at hand. When he stood by the bed where she had lain for more than two months in intense suffering, her greeting was characteristic. "Thou art come at last, my son, and hast obeyed the voice of God, who will not fail to show thee His will. Go and confess thy sins, and prepare with thy companions to give thy life for the Sovereign Pontiff, Urban VI."

Perhaps the joy of seeing him had lent her a little strength, for she was able to dictate at least one letter to him, and spoke words of loving advice and direction, carefully treasured by those who heard them, and written down by Caffarini, who gives them as a connected discourse, a thing impossible in Catherine's feeble state, suffering as she did such pain that she who never

complained and who had endured so much joyfully was heard to say that she believed fiends were permitted to torture her, though she added immediately, "Nevertheless I leave both life and death to the will of my Creator. If by abiding here I can be of any use to any one, I refuse neither labor nor pain nor torment but am ready for the salvation of my neighbor to give my life a thousand times, and, were that possible, in even greater suffering."

Wasted as she was, and reduced to utter weakness, Caffarini describes her expression "as if it had been that of an angel." Once, seeing the tears of those standing around her bed, she said:

> Dear children, let not this [her death] sadden you. Rather, rejoice and be exceeding glad to think that I am leaving a place of many sufferings to go to rest in the quiet sea, the Eternal God, and to be united forever with my most sweet and loving Bridegroom. And I promise to be more with you, and more useful, since I leave darkness to pass into the true and everlasting light.

As she looked around on her disciples, the same touching fear crossed her mind as she had felt with regard to Raimondo; perhaps in her anxiety for their spiritual need she had too much overlooked due care for those that were physical; if it were so, she asked their forgiveness, and also for any fault she had committed toward them. With what tears and protestations they answered may be imagined. Then she blessed each, and turning her eyes to her mother, who stood weeping beside her, begged her blessing for herself. Lapa could only reply by tearful requests that she would beg God to give her strength to enable her to submit to losing her child. "I would you could have seen," wrote Barduccio Canigiani to his sister, a nun in a convent near Florence,

with what respect and humility she repeatedly asked for the blessing of her old mother, who in turn besought the prayers of her daughter, and begged her to obtain the grace not to offend God by the greatness of her grief. Catherine prayed again out loud for us all, and so tender and humble were her words that we thought our hearts would break in twain.

Caffarini mentions other particulars of these last days, among which is her declaration that she had never lost her childhood's longing for a hermit life, and had prayed to be allowed to undertake it, but it had been clearly revealed to her that her work was to be in the world.

Though steadfast in faith and assured that her deep penitence for all shortcomings was accepted, peace was not yet won. From every biography of her, it appears that always after an exhausting strain of soul she was haunted by the terrible visions that tortured her in the early days of her vocation. Her strength, such as it was, suddenly failed altogether, and the prior of Saint Antonio, who was in Rome, administered extreme unction. All through the Sunday before Ascension Day there had seemed no sign of life except the painful breathing too well known to those who have watched dying beds, but suddenly those around her perceived with infinite distress that with reviving consciousness her mind was wandering in some region of indescribable horror. That it must be so they saw from the movements of her hands and the expression of her dimmed eyes, and from her broken words. Sometimes she seemed listening intently to awful things unheard by anyone else; sometimes she cried aloud.

"*Peccavi, Domine, miserere mei,*" she moaned repeatedly, each time lifting her arm and dropping it heavily. Once, as if the

memory of Raimondo's warning had recurred to her, she exclaimed, as if vehemently repelling an accusation, "Vainglory? Never, but the true glory of Christ crucified." Alessia supported her in her arms, but she was beyond mortal help. Suddenly her eyes kindled, and her face took such an expression of peace that it was a joy only to look upon her, and the sight and certainty that she had emerged from this dread abyss of horror "somewhat comforted the grief of her afflicted children, who stood weeping around her in a grief that may be imagined," and words of prayer and penitence fell from her lips, "high things which for our sins we were not worthy to understand," wrote Barduccio, and often so feebly uttered as to be hardly audible. "We caught a few words by bending over her lips, but my grief hindered me from hearing much," but he distinguished enough to know that she was praying for Urban and the Church, "and also with great fervor she prayed for all her beloved children whom God had given her, and whom she loved with a very great love, using many of the words wherewith our Lord prayed to His Eternal Father, and so praying for us, signed and blessed us."

They had set a reliquary on a little table by her bed, but it was noticed that she looked only at the cross surmounting it. This reliquary passed into the keeping of Stefano Maconi, who treasured it to the day of his death. The long strife was over. Feeling death close at hand, she was heard to say, "Lord, Thou callest me to Thee, and I come, not in mine own merits, but only in Thy mercy, which I ask in virtue of the most precious blood of Thy dear Son." A few minutes later she murmured, "Lord, into Thy hands I commit my spirit," and with these words on her lips Catherine of Siena went to her rest.

Those who had most loved and reverenced her longed for a few quiet hours before all Rome was stirred by the knowledge

of her death. Stefano Maconi himself bore her body to Santa Maria sopra Minerva, laying it wrapped in the white robe and black mantle of the Mantellate within a coffin of cypress wood. All the lines of pain were gone from the calm face, and she lay like one asleep, every limb pliable, and so Stefano saw her during the long hours that he watched beside her. The coffin was placed behind the iron grille which shuts in the chapel of Saint Dominic, so that it could not be touched by the throng who pressed into the church as soon as her death was known, those who had sick friends struggling to bring them as near to the coffin as they could, hoping that they might be miraculously healed.

Such was the press and excitement that the attempts of now one, now another preacher to speak her praises were useless, and at last one called out as loudly as he could, "This holy virgin has no need of our panegyrics; she preaches sufficiently herself" and so came down from the pulpit.

Although, strangely enough, there is no indication that Urban took any special heed of her while she lay ill, he ordered her a magnificent funeral, which all the clergy of Rome attended, and a yet more stately ceremony was organized by Giovanni Cenci, to show the gratitude of the city for all that she had done in its behalf, a ceremony "worthy of a queen," and truly few if any queens ever ruled with so wide a sway or turned so many to good as did Catherine of Siena. All the greatest men of Rome, ecclesiastical and secular, all the people of every class attended her obsequies and told of her saintly life and how it had ended when she was but thirty-three years old.

There was weeping too in Siena, though when William Flete came there to preach her funeral sermon, he told his hearers, "It is with hymns of joy, not tears, that we should celebrate the death of Catherine." But to those who are left, "not all the

preaching from Adam can make death other than death," and though they knew how joyfully she had laid down the burden of life, her disciples' sorrow was a lifelong one.

In old age Stefano Maconi had no greater pleasure than to speak of Catherine to his monks in the Certosa di Pavia, of which he became the prior. It had been her dying wish that he should enter the Carthusian Order, and although he had until then had no desire to do so, and encountered great opposition from his family, a year after her death, he began his novitiate. It is pleasant to know that in old age he often saw Saint Berna-dino, and told him much of Catherine, who died the same year as that in which the eloquent young preacher was born, and a welcome glimpse of several of her disciples and friends is found in a letter written eleven years after her death by Maconi to Neri di Landoccio. Maconi had risen with remarkable rapidity in his order, of which he was already general. He had been visiting various Carthusian monasteries and had dined at Genoa, "with our common father, Signor Raimondo," and Caffarini, "and our venerable mother, Madonna Orietta Scotti, with great loving-ness recognized me as her son, and many other things I could tell you which no doubt you would like to hear," writes Stefano, and so should we, but like the joke that so greatly amused Signor Matteo, they remain untold.

To the last, everything concerning Catherine was dear to Maconi. There is a tradition that at every Easter Sunday he caused dishes of beans to be set on the table of his refectory, in memory of a long past Easter when he and Catherine had noth-ing else to eat, so low were her resources, and apparently his also. He could recall the least details of the time they spent together, and once when some trifle suddenly reminded him in old age of her loving tenderness and kindness, he burst into tears and wept

as he might have done beside her coffin. The monks who were with him helped him to a place where he could sit with the soft air blowing on his face, and he gradually recovered composure.

What the grief for Catherine's loss was to the rough old hermit of Vallombrosa, Don Giovanni delle Celle, may be gathered from the letter, so moving in its simplicity, to his former disciple, Barduccio Canigiani, who had left him with his full approval, to follow her. The old man sits desolate, his eyes dim with tears, and implores Barduccio to come to him, for they both loved and respected Catherine above all else, and now she is gone, and has taken all the gladness of his life with her. Had he not been comforted by a vision of her, he would have gone down into utter darkness. The letter is the more affecting that it has not a word of commonplace consolation in it, nothing of what a venerable hermit might have thought himself called on to say. It is a simple outburst of feeling, and a greater testimony to what Catherine was to those who knew her best than is the studied oration of Flete, though he too grieved profoundly. Don Giovanni always wrote out of the fullness of his heart, whether moved by anger or by love. Barduccio's letter to his sister is almost equally touching, and besides these there is one from Nigi di Doccio to Neri di Landoccio, who was in Naples at the time of Catherine's death and, though he hurried back for her funeral, was obliged to return there.

"How wretched were we," he exclaims with the vain regret known to so many mourners, "to have so much of her company, and yet never know her rightly, nor deserve her presence." He gives no particulars of her last days; Neri would have heard these when he came to Rome, and Stefano Maconi would not fail to write or tell them to so close a friend. He did not enter the cloister but lived as a hermit for nearly twenty-four years outside

Porta Nuova at Siena, taking with him his love of reading and poetry, especially Dante, and not always returning the books that he borrowed. And he wrote verses in praise of Saint Catherine, of which, according to Caffarini, he made copies for his friends. One of his poems, not on Saint Catherine, but on Saint Giossaffa, may be seen in the Bodleian Library. Though himself withdrawn from active life, he influenced not a few who were in it, and who corresponded with him and asked his advice, among whom were Maconi, Malavolti, and Caffarini. He died in the Spedale in 1406, an old man.

A list exists made by a friend of his among the monks of Oliveto of such possessions as he had at the time of his death, and certainly he had kept his vow of poverty to the letter and was sadly in want of someone to mend his garments, all of which except two hoods and a pair of new stockings are entered as torn, except a robe, which he or some kind friend had patched. All the furniture mentioned consists in two beds, both much in need of repair, and an old chair. In money he had seventy-two *soldi*, sixty-two of which his friend distributed among the monks of Oliveto. The *soldo* was worth more then than now, but the sum is certainly not large! The Olivetans also had a more valuable legacy in his books and writings, together with a portrait of Catherine that he had had painted.

But the one to whom her declaration that she would be more helpful absent than present was most fully verified was Raimondo da Capua. Hitherto he had been a timid man, shrinking from responsibility, rather backward in undertaking any difficult work. Now we find him general of the Friars Preachers, not willingly indeed, but accepting the post submissively, and then throwing himself vigorously into the heavy duties of his office, and fearlessly, though gently and discreetly, reforming all that needed

reform, ungrateful and even dangerous work though it was, a labor in which he was greatly aided by Fra Bartolomeo Domenico. His delight and refreshment during fifteen long years was to write that *Legenda*, with the help of Caffarini, which is the chief source of our information regarding Catherine. Dry and colorless as much of it is, it nevertheless became extremely popular and was translated into many languages, and excited a general desire for further details, a desire strongly urged upon Caffarini by the Camaldolesi of Florence, who begged him to set down all the ways and daily doings of Catherine, and, knowing the ways of copyists, they also bade him keep a watchful eye on any whom he might employ, lest they should omit or alter anything.

This was the origin of the *Legenda minore*, but the art of memoir writing was not one known to the Middle Ages, even when the work was one of love, and both Caffarini and Raimondo forget the woman who influenced kings and republics too much in the saint to give a complete portrait.

The prior of the Camaldolesi adds that he can let him see some books that he has about Catherine; it would be interesting to know what they were, and if they are still preserved in any monastery of the order. Caffarini circulated to the utmost of his power all the writings left by her, sending an Italian translation to Henry IV, "cankered Bolingbroke," who, though he asked for it, does not seem exactly the person to appreciate it. The *Dialogue* was already in the Camaldolesi library at Florence, for the prior says that he had read it repeatedly. The custom that prevailed in Venice for many years of keeping April 29, the day on which Catherine died, as a festival in her honor was introduced by Caffarini. He spent nearly half a century there, and that anniversary was always marked by her praises being solemnly told, while her portrait was displayed, surrounded by wreaths and crosses and a

crown of blossoms, in memory of her well-known love of flowers, an appropriate setting, he would say, "since she was destined to collect a multitude of souls as a sweet nosegay to offer to God, while her own words and works were like so many bouquets, and she herself bloomed in the eternal Paradise in the month which is the season of flowers."

That Siena should take no share in the honors accorded to her *beata popolana* would have been strange indeed, and Raimondo was bent on her possessing, if not Catherine's entire body, at least a part of it. To the modern mind the dismemberment of a loved and revered form is altogether repugnant, but in the Middle Ages, when the cult of relics had become a passion, no such feeling existed. Stefano Maconi had felt no hesitation in detaching some of Catherine's teeth to be carried away and held as inestimable treasures, and when Raimondo went again to Rome in 1381 he obtained leave from the Pope to have her head enclosed in a reliquary and sent to her native city. The Romans might have protested, and the two friars to whom it was entrusted were bidden to carry it away in great secrecy and place it in safe keeping in Siena, where it remained without the knowledge of any but the few immediately concerned.

Some years later, Raimondo went to Siena and held counsel with those whose advice was likely to be most judicious, Maconi and Landoccio being of the number, as to what steps to take in honoring Catherine. Since Venice kept the twenty-ninth of April as her festival, it was not fitting that her own city should be behindhand. The authorities, on being informed that the precious relic was in Siena, at once seized the opportunity, and a great ceremony was organized, preceded by a week of preparation, during which sermons were preached setting forth her beautiful life and great deeds. Raimondo's was naturally the first,

other Italians followed; England was represented by a Dominican named Brother John, "a man greatly renowned as learned, holy, devout, and full of faith," and Ireland too, in the person of another Dominican, who had taken the name of Peter Martyr, after that too famous persecutor of heretics whom the Roman Church counts as having the honors of martyrdom.

The city was thronged with visitors from all parts of Italy, and one Sunday in early May all Siena was astir, eagerly expecting the hour at which from the Porta Romana the procession was to start. It passed slowly through the city, with solemn chanting, headed by two hundred girls all in white, adorned with all the jewels their families could furnish and carrying flowers, both in memory of Catherine's love of them "and of her words, for she was accustomed to say that everyone should wear white garments and bear flowers, meaning thereby that they should be pure and innocent in their life, and adorned with virtues."

Next appeared a number of men from the guilds and confraternities of Siena, who represented some event in Catherine's life, each company preceded by their banner, and with lighted torches borne before them. Next, following a great crucifix, came the hermits of Sienese territory in great numbers, holy men, "all supported by the Republic, to the end that they might with less distraction pray, meditate, and afflict their bodies."

The religious communities came after them, and then the secular priests and canons, each man carrying a wax taper, and after them the gentlemen, magistrates and officials of the city in robes of office, two and two, according to their rank. These were followed by "the illustrious consistory in their richest robes of state; after these the abbots and other dignitaries, followed by the bishops in their pontificals, all with their pastoral staves in their hands."

And then came the prioress and Sisters of the order that had hesitated so long whether to receive Catherine Benincasa among them and had misjudged her so harshly and who now regarded her as their glory. A few had envied and slandered her, and many had loved her greatly, and now all exulted in the thought that however much others might claim in her, she belonged especially to them. The Mantellate too had come from all parts of Italy and were moving in a long double line before the baldachino of gold brocade, embroidered with jewels borne above the sacred relic in its splendid tabernacle of gold, in which Raimondo had caused to be placed a portrait of Catherine. He himself was walking on the left of the tabernacle, and on the right was the bishop of Siena. But the figure on which all eyes rested was that of Lapa Benincasa, to whom in advanced old age it was given to see the honors paid to her daughter by their city, and as she walked amid the Mantellate, many wept, and others crowded around, exclaiming, "O happy are you to have thus beheld the triumph of your child!"

Arrived at the Church of San Domenico, Raimondo gave a short address; the bishop blessed all present, and the head of Catherine was placed in the sacristy, and for a fortnight afterward another course of sermons was preached on her life and death by Dominicans, Italian, French, Spanish, and English.

Siena keeps the memory of that day five hundred years ago in an annual festival in which all the citizens take part, and crowds pass all day long in and out of the Fullonica, and pray in the church that now forms part of it, and invoke Saint Catherine. The disorder and troubles connected with the schism delayed her canonization until 1461, though practically she had been counted as a saint from the time of her death. Then Pope Pius II, the famous Aeneas Sylvius Piccolomini, a Sienese by birth,

published the bull that recognized her formally as one. A fresco in the library of the Duomo records this event, and another shows how he proclaimed a crusade, as vainly as she did herself, but the coincidence is appropriate.

One more honor shown to her memory remains to be recorded. When Santa Maria sopra Minerva was reopened after being restored in 1865, her ashes were carried through the streets of Rome in a silver urn on a bier covered with crimson velvet, borne by four bishops, while the regular clergy, the collegiate chapters, the theological students, and the Sisters of Penance, as the Mantellate of the fourteenth century are now called, walked in procession. Her statue lies under the high altar of Santa Maria with lamps ever burning before it, the most interesting of all the many objects of interest in the great Dominican church.

That Catherine of Siena was one of the three greatest figures of the fourteenth century is beyond dispute, though her character and her work have been very variously judged, too often with an estimate colored by prejudice that does not sufficiently allow for the age in which she lived or consider the facts of her life. Again, she has been too much considered by some of her biographers as simply a saint, by others as chiefly concerned with politics, so that in either case only a partial view of her is obtained. That her plans too often failed is true; the tragic fate of great plans that came to nothing that pursued her native city was hers also, but such failures are greater than not a few successes. It may freely be admitted that as a politician she was often mistaken. It is not even sure that Italy might have been stronger and better had the popes never returned to Rome. But it is not by what Catherine did, but by what she was that she influenced her own and the following generations. When Dante speaks of the Florentine whom he utterly despised and hated, he can find no words more

scathing than *"Bontà non è che sua memoria fregi."*[37] In the eulogium that Pius II pronounced at the canonization of Catherine of Siena, the most pregnant sentence is that which declares that "none ever approached her without going away better."

[37] *Inferno*, Canto VIII, line 47.

Sophia Institute

Sophia Institute is a nonprofit institution that seeks to nurture the spiritual, moral, and cultural life of souls and to spread the Gospel of Christ in conformity with the authentic teachings of the Roman Catholic Church.

Sophia Institute Press fulfills this mission by offering translations, reprints, and new publications that afford readers a rich source of the enduring wisdom of mankind.

Sophia Institute also operates two popular online Catholic resources: CrisisMagazine.com and CatholicExchange.com.

Crisis Magazine provides insightful cultural analysis that arms readers with the arguments necessary for navigating the ideological and theological minefields of the day. *Catholic Exchange* provides world news from a Catholic perspective as well as daily devotionals and articles that will help you to grow in holiness and live a life consistent with the teachings of the Church.

In 2013, Sophia Institute launched Sophia Institute for Teachers to renew and rebuild Catholic culture through service to Catholic education. With the goal of nurturing the spiritual, moral, and cultural life of souls, and an abiding respect for the role and work of teachers, we strive to provide materials and programs that are at once enlightening to the mind and ennobling to the heart; faithful and complete, as well as useful and practical.

Sophia Institute gratefully recognizes the Solidarity Association for preserving and encouraging the growth of our apostolate over the course of many years. Without their generous and timely support, this book would not be in your hands.

www.SophiaInstitute.com
www.CatholicExchange.com
www.CrisisMagazine.com
www.SophiaInstituteforTeachers.org

Sophia Institute Press® is a registered trademark of Sophia Institute.
Sophia Institute is a tax-exempt institution as defined by the
Internal Revenue Code, Section 501(c)(3). Tax I.D. 22-2548708.